MICHELLE OBAMA

A PHOTOGRAPHIC JOURNEY

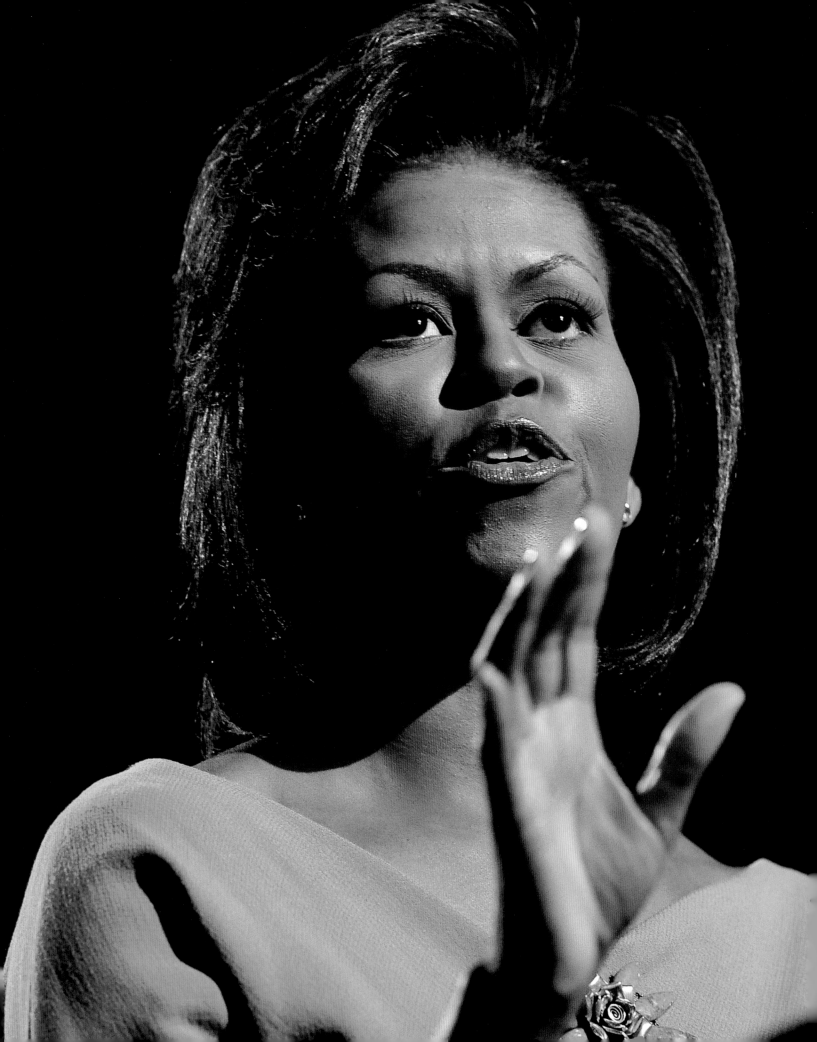

MICHELLE OBAMA

A PHOTOGRAPHIC JOURNEY

Introduction & Text by ANTONIA FELIX

Photo Editor CHRISTOPHER MEASOM

STERLING
New York

STERLING
New York

An Imprint of Sterling Publishing Co., Inc.
1166 Avenue of the Americas
New York, NY 10036

ISBN 978-1-4549-2636-8

Distributed in Canada by Sterling Publishing Co., Inc.

C/o Canadian Manda Group, 664 Annette Street

Toronto, Ontario, M6S 2C8, Canada

Distributed in the United Kingdom by GMC Distribution Services

Castle Place, 166 High Street, Lewes, East Sussex, BN7 1XU, England

Distributed in Australia by NewSouth Books

45 Beach Street, Coogee, NSW 2034, Australia

For information about custom editions, special sales, and premium and corporate purchases, please contact Sterling Special Sales at 800-805-5489 or specialsales@sterlingpublishing.com.

Manufactured in the United States of America

6 8 10 9 7 5

sterlingpublishing.com

Design by Timothy Shaner, NightandDayDesign.biz

Picture Credits see page 202

(Previous pages) Michelle Obama speaking at the 2008 Democratic National Convention in Denver, Colorado, August 25, 2008.

CONTENTS

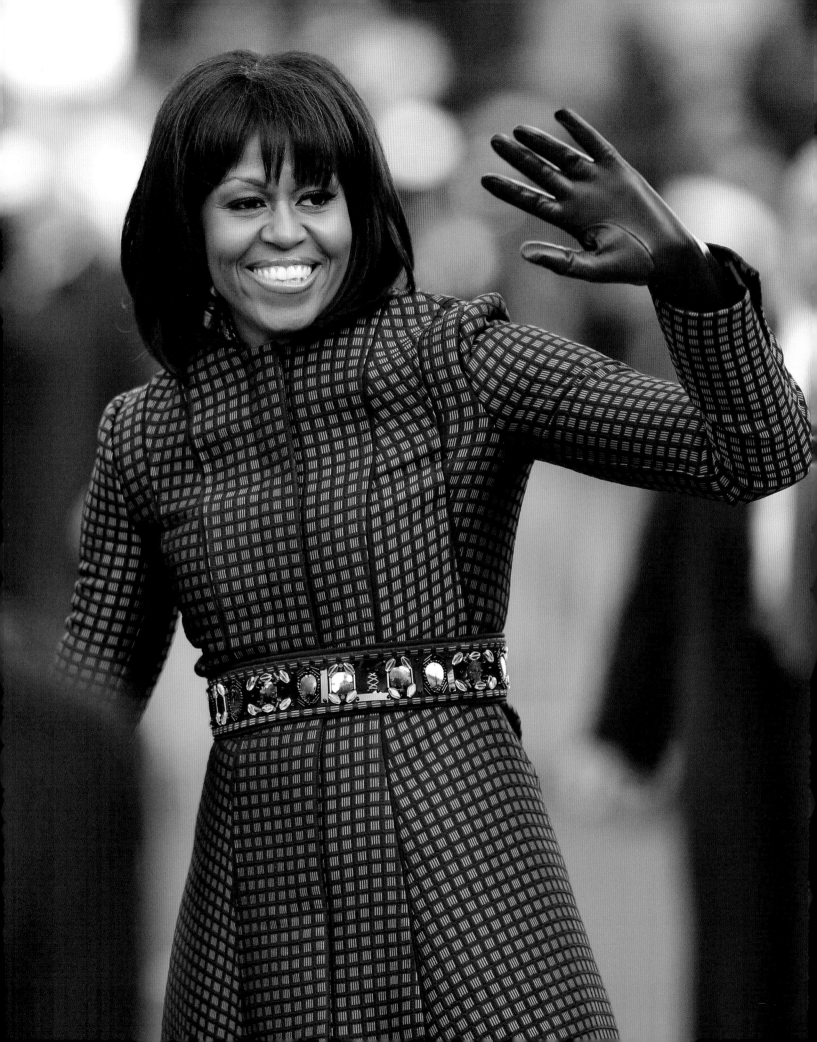

INTRODUCTION

by ANTONIA FELIX

WHEN MICHELLE Obama moved into the White House in 2009, she stepped away from a rising career as a University of Chicago hospital executive and into a role noted for its lack of official status or job description. The position has also been known for inviting superficial coverage in the press with an emphasis on hairstyles and shoes, and biting criticism if the president's wife ventures beyond dinner parties and decorating. But the First Lady also inherits a platform broader than that of any other woman in the country—or the world.

In modern times, some first ladies have used that platform to continue the tradition of first lady as first hostess, decorator, or, in the case of Lady Bird Johnson, beautifier of our public spaces and highways. Others, like Eleanor Roosevelt, turned that tradition on its head by becoming a powerful political player and human rights activist behind the scenes. Jacqueline Kennedy directed the process of giving the White House museum status and ushered in a period of style and glamour that entranced the world. And Hillary Rodham Clinton continued her public service work by moving her office into the West Wing and tackling health care reform.

With such a variety of predecessors, how did Michelle Obama envision her role in the White House? She heard discussions that as a first lady she may be "too loud, or too angry, too emasculating," or the other end of the spectrum "too soft, too much of a mom, not enough of a career woman." During the first presidential

◀ The presidential inaugural parade in Washington, D.C., January 21, 2013.

campaign, a caricature of her as a radical, Afro-wearing militant on a magazine cover stopped her in her tracks, forcing her to ask herself how people saw her.

Ultimately, she chose to be true to herself, a woman who is, she said, first and foremost a mom, and left the rest of her options open: "No one can predict what Americans will need from their First Lady a year from now," she said in 2007, "so I will be whatever I need to be for the country."

As it turned out, the country needed her to be a lot of things. A role model for girls and women, an advocate for healthier food in an age of epidemic obesity and its diseases, a champion of veterans and their families, a crusader for teachers and improved education, and a voice for the voiceless in a nation embroiled in issues of race. She would not need lessons in public speaking to make the full use of her platform, because speaking out comes easily to a woman raised to think for herself and to take action on her beliefs.

Michelle LaVaughn Robinson, known in the family as "Miche," was born to Fraser Robinson and Marian Shields Robinson on the South Side of Chicago on January 17, 1964. Her brother, Craig, was two years older, and her parents both came from Chicago families. Marian was a stay-at-home mother until her children were in high school, and Fraser worked at the city's water plant, operating the pumps and boilers.

Fraser Robinson was a gregarious, kind, and generous man often called upon by friends and neighbors for advice. He had developed multiple sclerosis as a young man, and his lack of complaining as he became increasingly disabled made him a hero in his children's eyes. Disappointing their father was the most devastating thing they could imagine. When Craig and Michelle expressed their concerns about their father's disability, Marian would tell them that "their father was overflowing with so much joy and pride just from being their dad that he felt like the luckiest person to walk the earth."

The Robinsons lived in a small apartment in a bungalow owned by Michelle's great aunt and uncle, who lived on the first floor.

> "Do not ever let anyone make you feel like you don't matter, or like you don't have a place in our American story—because you do. And you have a right to be exactly who you are."

—MICHELLE OBAMA

Fraser and Marian used a wooden divider to convert the living room into two tiny bedrooms for Michelle and Craig, each with a twin bed and desk. "We didn't have much space," Michelle said, "but we had a whole lot of love." The house often bustled with cousins, aunts, uncles, and other members of the extended family who lived just blocks away.

While her brother aced his classes by barely opening a book, Michelle worked hard for her grades. Fraser and Marian infused their children with the belief that an education was the key to their future, the most important goal of their young lives, and Michelle developed a strong work ethic. "It seemed like every paper was life or death, every point on an exam was worth fighting for," she said. That attitude paid off when she graduated from Whitney M. Young Magnet High School at the top of her class and as a member of the National Honor Society.

Michelle then enrolled at Princeton, where Craig was a junior, and drew upon her work ethic to make it through the culture shock and intense academic challenge of her tough freshman year. The life lessons of that time stayed fresh. "What I learned was that when something doesn't go your way, you've just got to adjust," she said in a commencement speech for the Martin Luther King, Jr., Magnet High School in Nashville, Tennessee, in 2013. "You've got to dig deep and work like crazy. And that's when you'll find out what you're really made of, during those hard times."

After graduating from Princeton and entering Harvard Law School, Michelle impressed her classmates as a warm and

> ❝Our glorious diversity—our diversities of faiths and colors and creeds—that is not a threat to who we are, it makes us who we are.❞
>
> —MICHELLE OBAMA

unpretentious young woman with a quick wit and sharp intellect who never forgot where she came from. And just as she had done at Princeton, she found her community in law school. Michelle and her fellow members of the Black Law Students Association at Harvard often talked about their future roles, asking themselves, "What are you going to do for black folks when we get out of here?"

Michelle began her career at Sidley & Austin, one of Chicago's most prominent corporate law firms, where she handled marketing and intellectual property work. During that first year she was tasked with supervising a new summer intern, a handsome Harvard Law School student named Barack Obama. When he asked her out on a date a month into his internship, she held off, uncertain about dating someone from work. But when she finally changed her mind they went on their now-famous first date at the Art Institute of Chicago, followed by a stroll along Michigan Avenue. The story is the stuff of Chicago legend and a plaque now marks the spot where they had their first kiss. They got married three years later.

In spite of the prestige of her corporate job, Michelle did not find the work satisfying. She wrestled with her conscience, remembering her law school conversations about obligations and purpose as she asked herself, "If I died in four months, is this how I would have wanted to spend this time?" She left the law firm in 1991, four months after her father died, and began a new career path in Mayor Richard M. Daley's office. Her public service work evolved into a career at the University of Chicago, where she

advanced to vice president for community and external affairs at the University of Chicago Medical Center.

By the time she moved to Washington as first lady in 2009, Michelle had clearly defined her purpose. "She was very committed to using every bit of her skills and her talent to lift others up," one of her Harvard professors said. And she brought all of that commitment to the White House.

First Lady Michelle Obama will be remembered not only for the programs illustrated in this book—raising awareness about childhood obesity, the importance of educating girls, and the needs of veterans' families—but also for tackling those issues head-on. She did not settle for making eloquent, even impassioned speeches, but challenged herself to create real change.

And Michelle Obama's impact goes deeper than her initiatives. When her historic legacy begins to form, I believe she will be remembered most for expanding the conversation about race in America. When she spoke about the everyday experiences of African-Americans in a country in which racism is ordinary, so deeply embedded in society that it is simply the way things are, she made a powerful impact by using examples from her and Barack's own lives. "We've both felt the sting of those daily slights," she said in her speech at Tuskegee University in 2015, "the folks who crossed the street in fear of their safety; the clerks who kept a close eye on us in all those department stores; the people at formal events who assumed we were the 'help'—and those who have questioned our intelligence, our honesty, even our love of this country."

In her last official speech in January 2017, Michelle shared the spirit of hope that has been the first couple's response to the experiences described above. She believes in the hope that allowed her and her husband to rise above the voices of division and fear that they and others have faced throughout their lives. "If we work hard enough and believe in ourselves," she said, "then we can be whatever we dream, regardless of the limitations that others may place on us."

May her dream live on in generations to come.

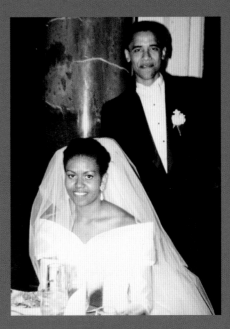

SUCCESS
STORY

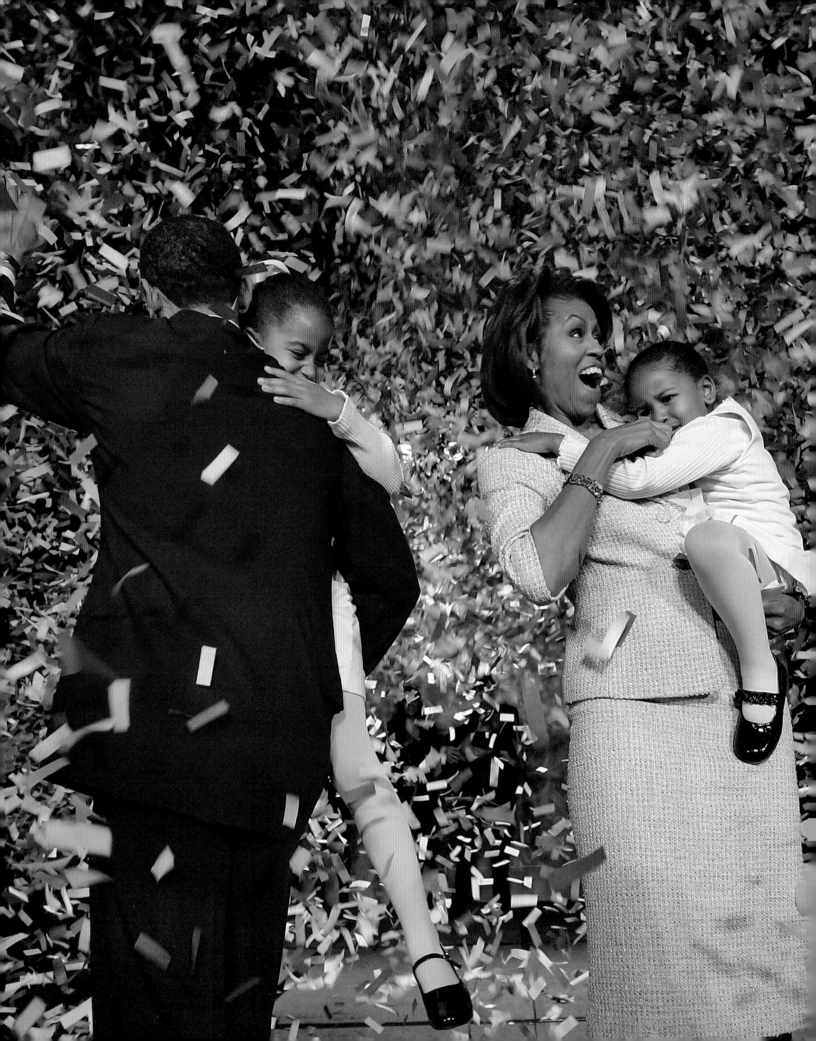

> "Being your first lady has been the greatest honor of my life, and I hope I've made you proud."
>
> —MICHELLE OBAMA

THE self-disciplined, reflective, and innovative thinking that marks many successful people often starts early, nurtured at home. Growing up on Chicago's South Side, Michelle LaVaughn Robinson and her older brother, Craig, were destined to become natural leaders who, from their earliest years, learned to think for themselves. Their parents, Fraser Robinson and Marian Shields, taught their children to not only respect their teachers (and their parents), but also to question them, to ask "why" instead of simply accepting everything they were told. The knowledge and confidence this instilled would be reflected throughout Michelle's life, including in her ability as first lady to speak freely and courageously about racism in America.

(Previous page) Michelle and Barack on their wedding day, October 3, 1992.

◄ The Obama family (Sasha in Michelle's arms, Malia in Barack's arms) celebrating Barack's election to the U.S. Senate, November 2, 2004.

"Some of my teachers straight up told me that I was setting my sights too high. They told me I was never going to get into a school like Princeton. . . . So it was clear to me that nobody was going to take my hand and lead me to where I needed to go. Instead, it was going to be up to me to reach my goal."

—MICHELLE OBAMA

MICHELLE grew up in Chicago's middle-class South Shore neighborhood, in the top-floor apartment of a bungalow owned by her great aunt and uncle, who lived downstairs. The flat was very small, but the neighborhood had a large park, good schools, and yards and streets full of children riding bikes and playing games. Michelle's brother called it "the Shangri-La of upbringings," and Barack said that visiting the Robinson place was like stepping onto the set of *Leave It to Beaver*.

Marian Shields Robinson, Michelle's mother, stayed home to raise her children until they were in high school. Michelle's father, Fraser Robinson, was a boxer, swimmer, painter, and sculptor in high school, and served in the U.S. Army, Illinois National Guard, and as a Democratic precinct captain. When Michelle was born he had just begun his job in the Chicago water plant, where he would work for the rest of his life. Fraser developed multiple sclerosis in his early thirties, and although his condition worsened over the years, he rarely missed a day of work. He walked with crutches, then a walker, and finally used a wheelchair. Barack, who considered Fraser his mentor, described him as a "sweet and kindhearted man." Fraser was outgoing, generous, and, in his wife's words, the family "story-teller, motivator, and philosopher-in-chief." Michelle often speaks of her father's influence on her life: "It's his compassion and his view of the world that really inspires who I am, who I want my girls to be, and what I hope for the country."

Michelle attended Princeton University, where she majored in sociology, and then Harvard Law School. She and fellow members of the Black Law Students Association at Harvard often talked about their future roles, asking themselves, "What are you going to do for black folks when we get out of here?"

▶ Michelle Robinson's Princeton yearbook photo, 1985.

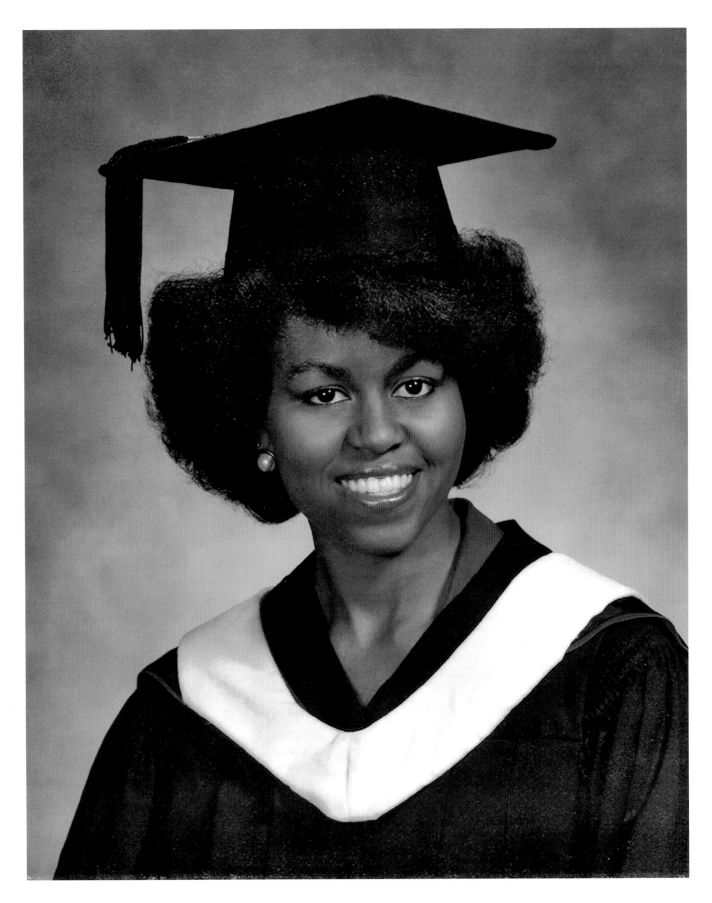

"Six months after Michelle and I met, her father died suddenly of complications after a kidney operation. I flew back to Chicago and stood at his gravesite, Michelle's head on my shoulder. As the casket was lowered, I promised Fraser Robinson that I would take care of his girl."

—BARACK OBAMA

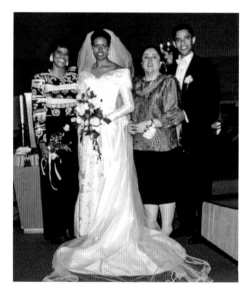

MICHELLE met Barack when he became a summer intern at the Chicago law firm Sidley & Austin, where Michelle was a first-year lawyer. Barack had just finished his first year of law school, and Michelle was assigned as his advisor. Barack asked her out on a date a month later, but she held off, concerned that it wasn't appropriate. When she finally changed her mind, their first date—the now infamous first date that was made into a movie, *Southside with You* (2016)—included a tour and lunch at the Art Institute, walk down Michigan Avenue, and a movie, Spike Lee's *Do the Right Thing*. They got married three years later.

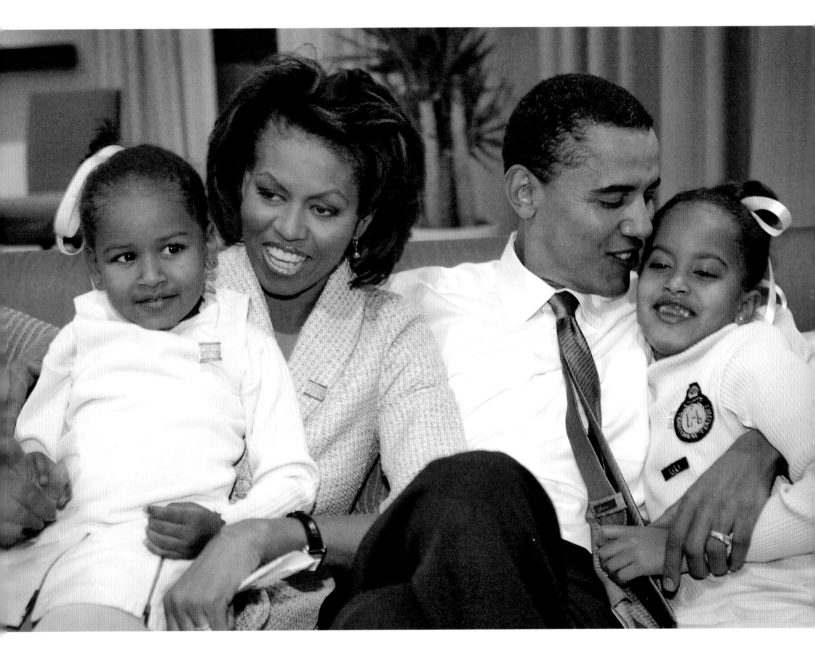

◀ On their wedding day, October 3, 1992, with mother of the bride, Marian
Robinson (left), and mother of the groom, Ann Dunham (second from right).
▲ The Obama family (left to right: Sasha, Michelle, Barack, and Malia)
awating election returns, November 2, 2004.

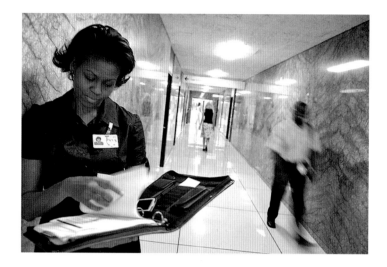

"No matter how liberated I liked to see myself as—no matter how much I told myself that Michelle and I were equal partners, and that her dreams and ambitions were as important as my own—the fact was that when children showed up, it was Michelle and not I who was expected to make the necessary adjustments."

—BARACK OBAMA

▲ Michelle Obama at the University of Chicago Medical Center in Chicago, Illinois, 2006. ▶ U.S. Senate candidate Barack Obama with Michelle speaking to reporters after voting in Chicago, November 2, 2004.

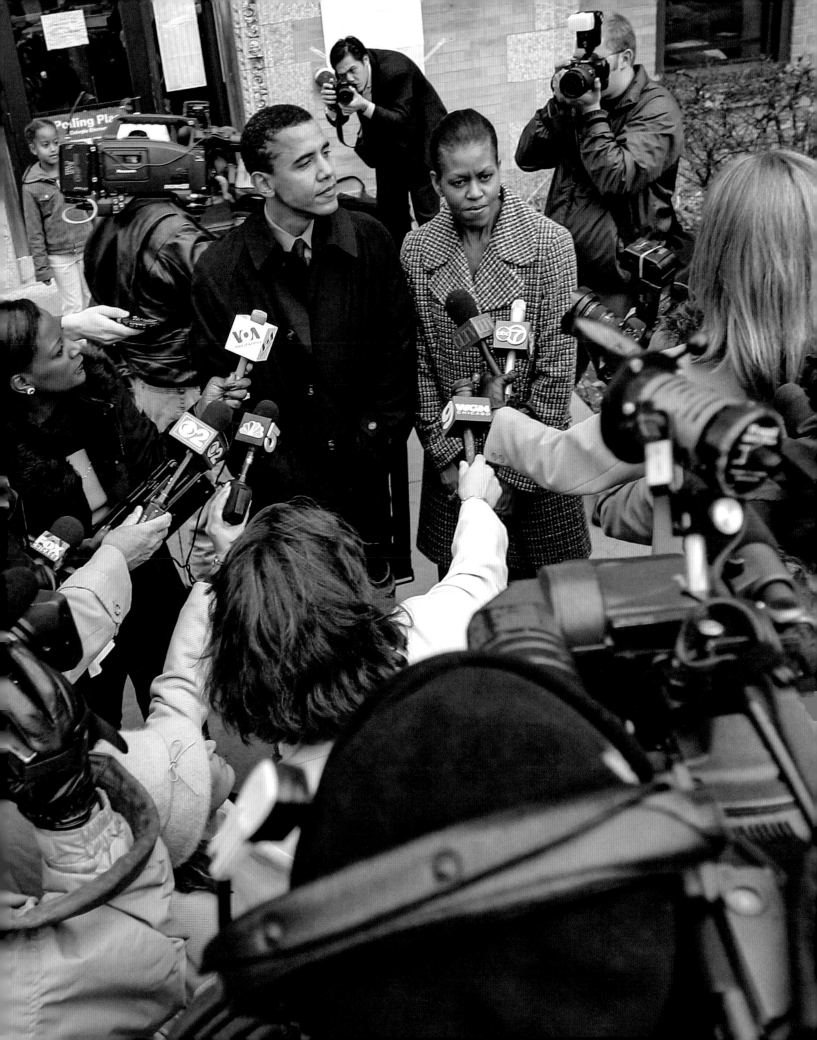

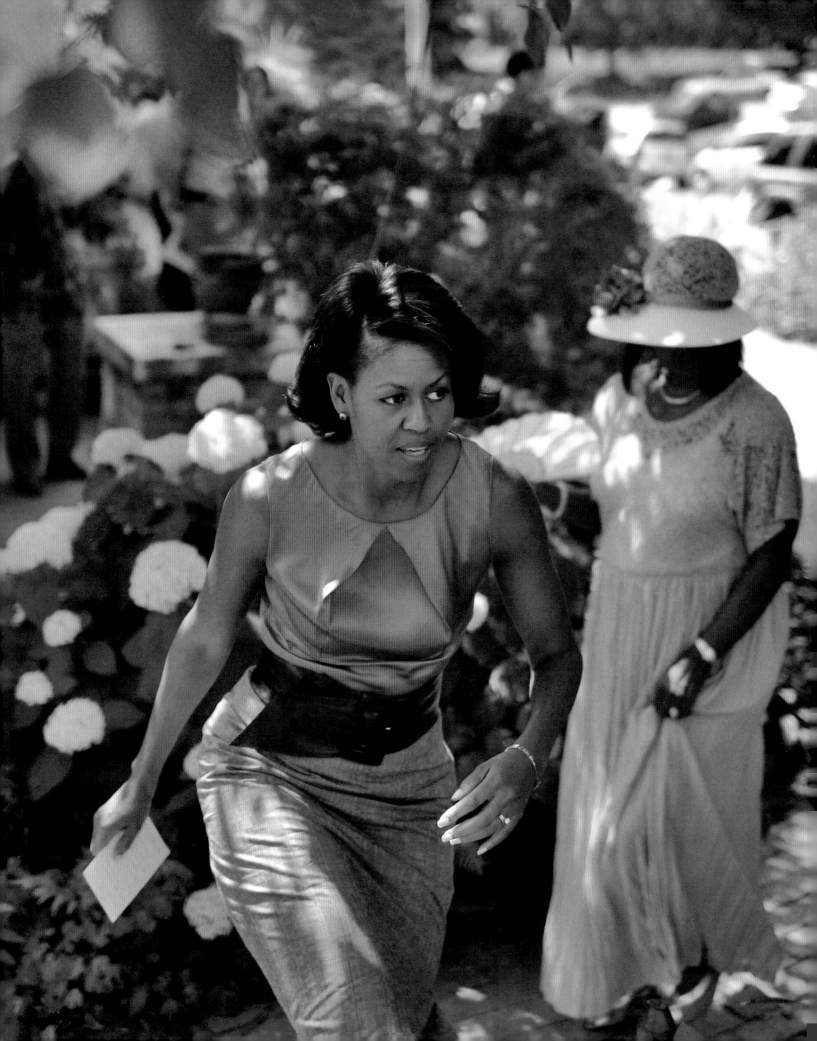

"When we were young kids, our parents divided the bedroom we shared so we could each have our own room.

Many nights we would talk when we were supposed to be sleeping.

My sister always talked about who was getting picked on at school, or who was having a tough time at home.

I didn't realize it then—but I realize it now—those were the people she was going to dedicate her life to: the people who were struggling with life's challenges."

—CRAIG ROBINSON, MICHELLE'S BROTHER

◄ Campaigning for Barack at a garden party event in Sioux City, Iowa, June 22, 2007.

"To have a family, which we did, who constantly reminded you how smart you were, how good you were, how pleasant it was to be around you, how successful you could be, it's hard to combat. Our parents gave us a little head start by making us feel confident."

—CRAIG ROBINSON

▲ Presidential candidate Barack Obama with Malia, Sasha, and Michelle, at the Iowa State Fair, August 16, 2007. ▶ President-elect Obama, Sasha, Malia, and Michelle onstage for his presidential victory speech, November 4, 2008.

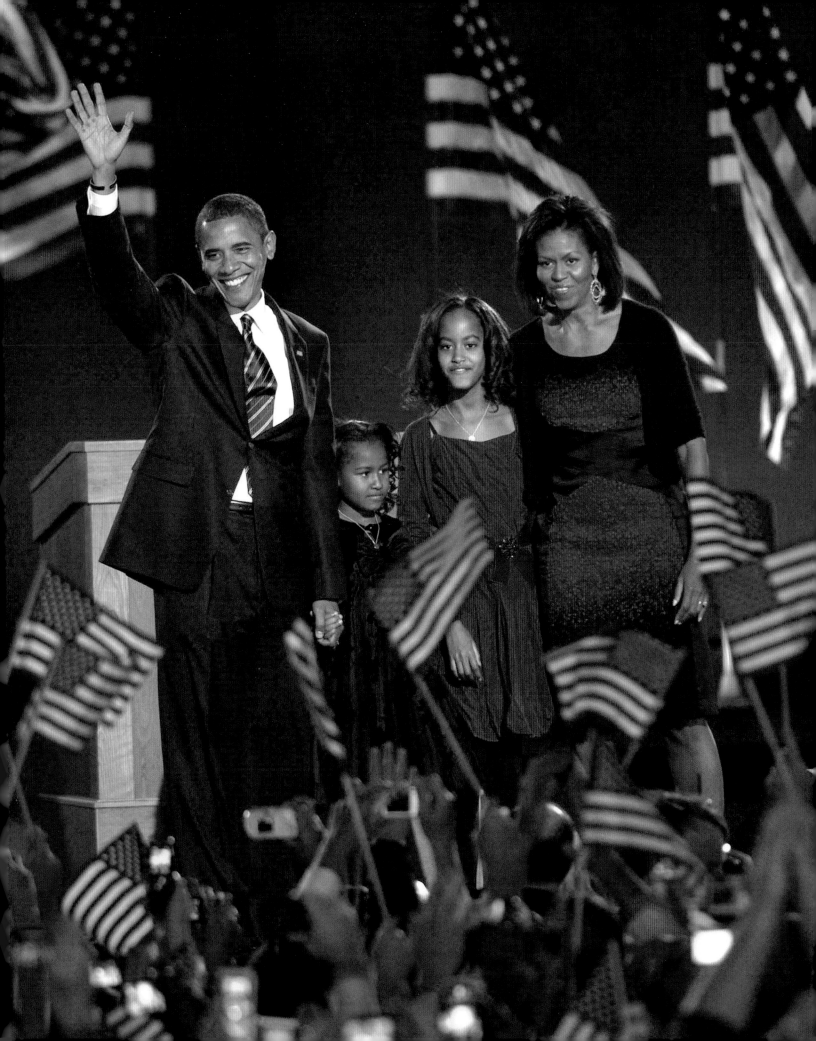

SPEECH AT THE DEMOCRATIC NATIONAL CONVENTION [abridged]

Pepsi Center
Denver, Colorado
August 25, 2008

Michelle was introduced by her brother, Craig Robinson, head basketball coach at Oregon State University, who shared a story about playing basketball with Barack.

AS YOU MIGHT IMAGINE,

for Barack, running for president is nothing compared to that first game of basketball with my brother, Craig. I can't tell you how much it means to have Craig and my mom here tonight. Like Craig, I can feel my dad looking down on us, just as I've felt his presence in every grace-filled moment of my life.

At 6-foot-6, I've often felt like Craig was looking down on me too . . . literally. But the truth is, both when we were kids and today, he wasn't looking down on me. He was watching over me.

And he's been there for me every step of the way since that clear February day 19 months ago, when—with little more than our faith in each other and a hunger for change—we joined my husband, Barack Obama, on the improbable journey that's brought us to this moment.

But each of us also comes here tonight by way of our own improbable journey.

I come here tonight as a sister, blessed with a brother who is my mentor, my protector, and my lifelong friend.

I come here as a wife who loves my husband and believes he will be an extraordinary president.

I come here as a mom whose girls are the heart of my heart and the center of my world—they're the first thing I think about when I wake up in the morning, and the last thing I think about when I go to bed at night. Their future—and all our children's future—is my stake in this election.

And I come here as a daughter—raised on the South Side of Chicago by a father who was a blue-collar city worker and a mother who stayed at home with my brother and me. My mother's

"Barack and I were raised with so many of the same values: that you work hard for what you want in life; that your word is your bond and you do what you say you're going to do; that you treat people with dignity and respect, even if you don't know them, and even if you don't agree with them."

love has always been a sustaining force for our family, and one of my greatest joys is seeing her integrity, her compassion, and her intelligence reflected in my own daughters.

My dad was our rock. Although he was diagnosed with multiple sclerosis in his early 30s, he was our provider, our champion, our hero. As he got sicker, it got harder for him to walk, it took him longer to get dressed in the morning. But if he was in pain, he never let on. He never stopped smiling and laughing—even while struggling to button his shirt, even while using two canes to get himself across the room to give my mom a kiss. He just woke up a little earlier and worked a little harder.

He and my mom poured everything they had into me and Craig. It was the greatest gift a child can receive: never doubting for a single minute that you're loved, and cherished, and have a place in this world. And thanks to their faith and hard work, we both were able to go on to college. So I know firsthand from their lives—and mine—that the American dream endures.

And you know, what struck me when I first met Barack was that even though he had this funny name, even though he'd grown up all the way across the continent in Hawaii, his family was so much like mine. He was raised by grandparents who were working-class folks just like my parents, and by a single mother who struggled to pay the bills just like we did. Like my family, they scrimped and saved so that he could have opportunities they never had themselves. And Barack and I were raised with so many of the same values: that you work hard for what you want in life; that your word is your bond and you do what you say you're going to do; that you treat people with dignity and respect, even if you don't know them, and even if you don't agree with them.

And Barack and I set out to build lives guided by these values, and pass them on to the next generation. Because we want our children—and all children in this nation—to know that the only limit to the height of your achievements is the reach of your dreams and your willingness to work for them.

And as our friendship grew, and I learned more about Barack, he introduced me to the work he'd done when he first moved to Chicago after college. Instead of heading to Wall Street, Barack had gone to work in neighborhoods devastated when steel plants shut down and jobs dried up. And he'd been invited back to speak to people from those neighborhoods about how to rebuild their community.

The people gathered together that day were ordinary folks doing the best they could to build a good life. They were parents living paycheck to paycheck; grandparents trying to get by on a fixed income; men frustrated that they couldn't support their families after their jobs disappeared. Those folks weren't asking for a handout or a shortcut. They were ready to work—they wanted to contribute. They believed—like you and I believe—that America should be a place where you can make it if you try.

Barack stood up that day, and spoke words that have stayed with me ever since. He talked about "The world as it is" and "The world as it should be." And he said that all too often, we accept the distance between the two, and settle for the world as it is— even when it doesn't reflect our values and aspirations. But he reminded us that we know what our world should look like. We know what fairness and justice and opportunity look like. And he urged us to believe in ourselves—to find the strength within ourselves to strive for the world as it should be. And isn't that the great American story?

It's the story of men and women gathered in churches and union halls, in town squares and high school gyms—people who stood up and marched and risked everything they had—refusing to settle, determined to mold our future into the shape of our ideals.

It is because of their will and determination that this week, we celebrate two anniversaries: the 88th anniversary of women winning the right to vote, and the 45th anniversary of that hot

▶ Michelle and daughter Sasha onstage at the Democratic National Convention, in Denver, Colorado, August 25, 2008.

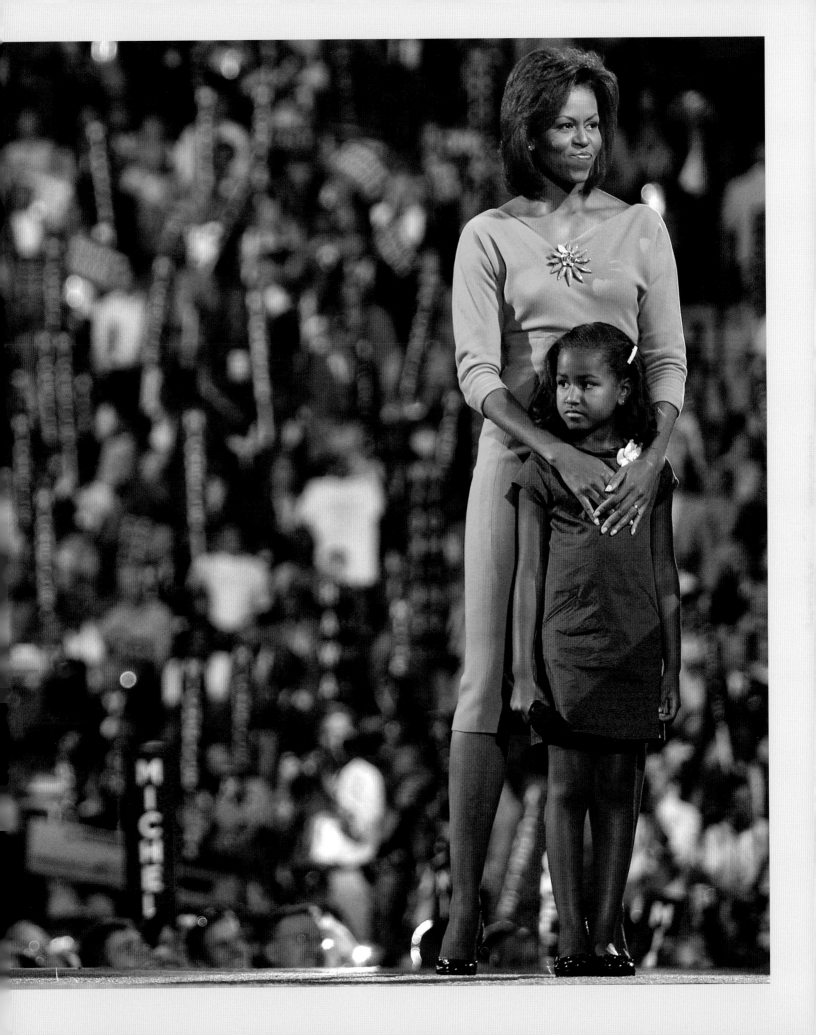

summer day when [Dr. Martin Luther King Jr.] lifted our sights and our hearts with his dream for our nation.

I stand here today at the crosscurrents of that history—knowing that my piece of the American dream is a blessing hard won by those who came before me. All of them driven by the same conviction that drove my dad to get up an hour early each day to painstakingly dress himself for work. The same conviction that drives the men and women I've met all across this country:

People who work the day shift, kiss their kids good night, and head out for the night shift—without disappointment, without regret—that good-night kiss a reminder of everything they're working for.

The military families who say grace each night with an empty seat at the table. The servicemen and women who love this country so much, they leave those they love most to defend it.

The young people across America serving our communities—teaching children, cleaning up neighborhoods, caring for the least among us each and every day.

People like Hillary Clinton, who put those 18 million cracks in the glass ceiling, so that our daughters—and sons—can dream a little bigger and aim a little higher.

People like Joe Biden, who's never forgotten where he came from and never stopped fighting for folks who work long hours and face long odds and need someone on their side again.

All of us driven by a simple belief that the world as it is just won't do—that we have an obligation to fight for the world as it should be.

That is the thread that connects our hearts. That is the thread that runs through my journey and Barack's journey and so many other improbable journeys that have brought us here tonight, where the current of history meets this new tide of hope.

That is why I love this country.

And in my own life, in my own small way, I've tried to give back to this country that has given me so much. That's why I left a job at a law firm for a career in public service, working to empower young people to volunteer in their communities. Because I believe that

▼ Michelle backstage with her brother, Craig Robinson, after her speech at the 2008 Democratic National Convention in Denver.

"All of us [are] driven by a simple belief that the world as it is just won't do — that we have an obligation to fight for the world as it should be."

each of us—no matter what our age or background or walk of life—each of us has something to contribute to the life of this nation.

It's a belief Barack shares—a belief at the heart of his life's work. . . .

Millions of Americans who know that Barack understands their dreams; that Barack will fight for people like them; and that Barack will finally bring the change we need.

And in the end, after all that's happened these past 19 months, the Barack Obama I know today is the same man I fell in love with 19 years ago. He's the same man who drove me and our new baby daughter home from the hospital 10 years ago this summer, inching along at a snail's pace, peering anxiously at us in the rearview mirror, feeling the whole weight of her future in his hands, determined to give her everything he'd struggled so hard for himself, determined to give her what he never had: the affirming embrace of a father's love.

And as I tuck that little girl and her little sister into bed at night, I think about how one day, they'll have families of their own. And one day, they—and your sons and daughters—will tell their own children about what we did together in this election. They'll tell them how this time, we listened to our hopes, instead of our fears. How this time, we decided to stop doubting and to start dreaming. How this time, in this great country—where a girl from the South Side of Chicago can go to college and law school, and the son of a single mother from Hawaii can go all the way to the White House—we committed ourselves to building the world as it should be.

So tonight, in honor of my father's memory and my daughters' future—out of gratitude to those whose triumphs we mark this week, and those whose everyday sacrifices have brought us to this moment—let us devote ourselves to finishing their work; let us work together to fulfill their hopes; and let us stand together to elect Barack Obama president of the United States of America.

Thank you, God bless you, and God bless America.

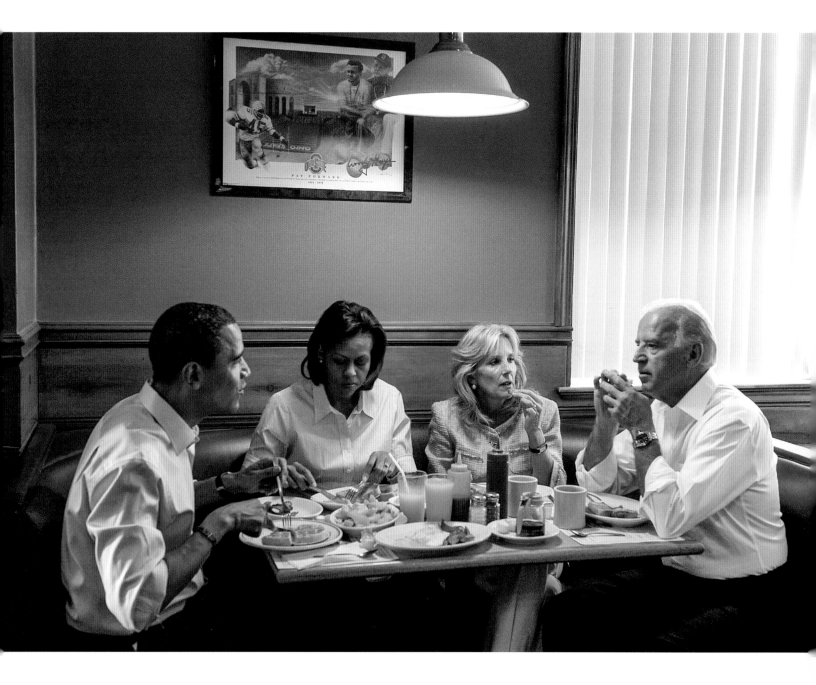

▲ Barack and Michelle having breakfast on the campaign trail with vice presidential running mate Joe Biden and his wife, Jill, in Boardman, Ohio, August 30, 2008.
◀ President-elect Obama and Michelle with their team and friends backstage before a victory rally in Columbia, South Carolina, January 26, 2008.

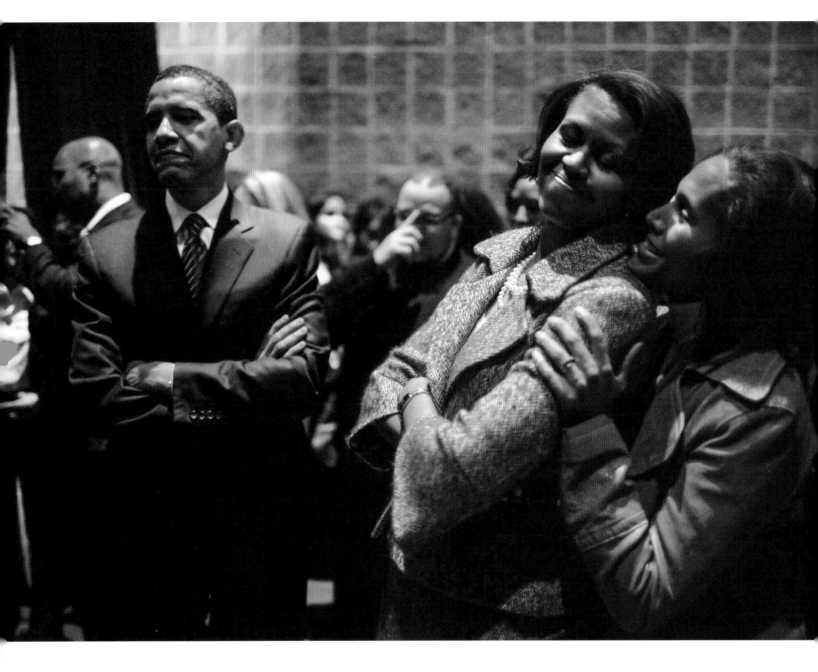

(Following pages) Michelle Obama onstage during the first day of the Democratic National Convention, August 25, 2008, in Denver, Colorado.

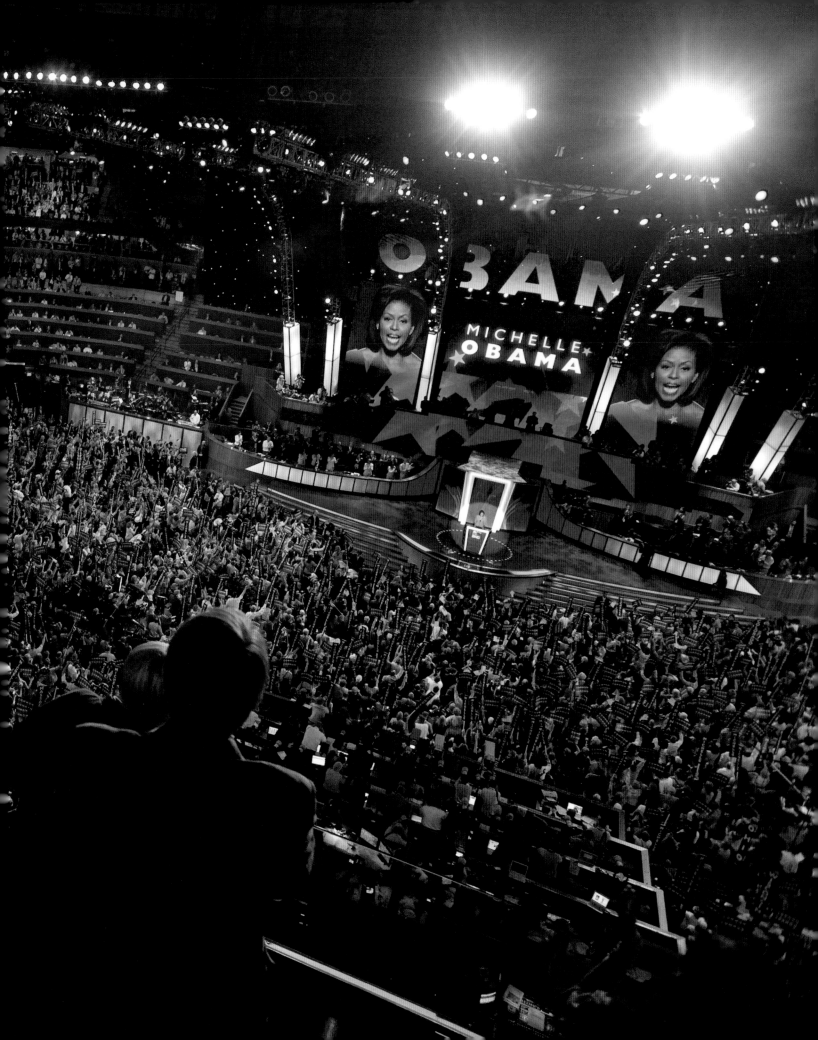

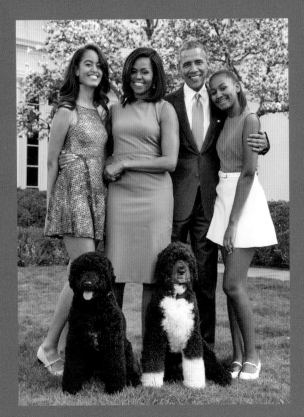

FIRST
FAMILY

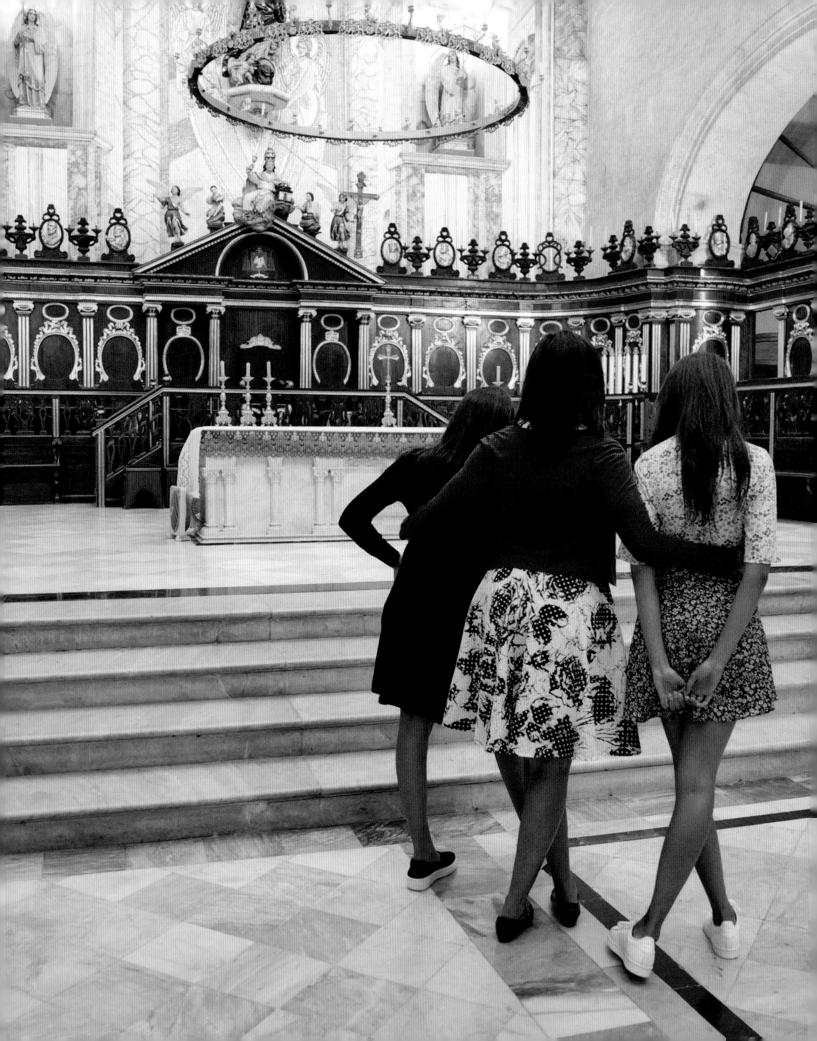

"At the end of the day
my most important title
is still mom-in-chief."
—MICHELLE OBAMA

WHETHER as a high-profile executive or first lady, Michelle Obama has always made her role as a mother come first. Her legacy as first lady will center on her ability to create, by example, a vision of womanhood to which women from all walks of life, from stay-at-home moms to full-time professionals, can aspire. We watched Malia and Sasha grow up in a White House that put their well-being center stage: "The minute those kids come into the world they just rip your heart out of your chest," Michelle said. "They add a whole new set of joy, a whole new set of worries to your life. There is nothing more important to me than my girls."

(Previous page) The First Family: (from left to right) Malia, Michelle, Barack, and Sasha pose with their dogs Sunny (left) and Bo (a gift from Senator Ted Kennedy) in the Rose Garden of the White House, Easter Sunday, April 5, 2015. ◄ Michelle Obama with Sasha and Malia touring La Catedral de la Virgen María de la Concepción Inmaculada in Havana, Cuba, March 2016.

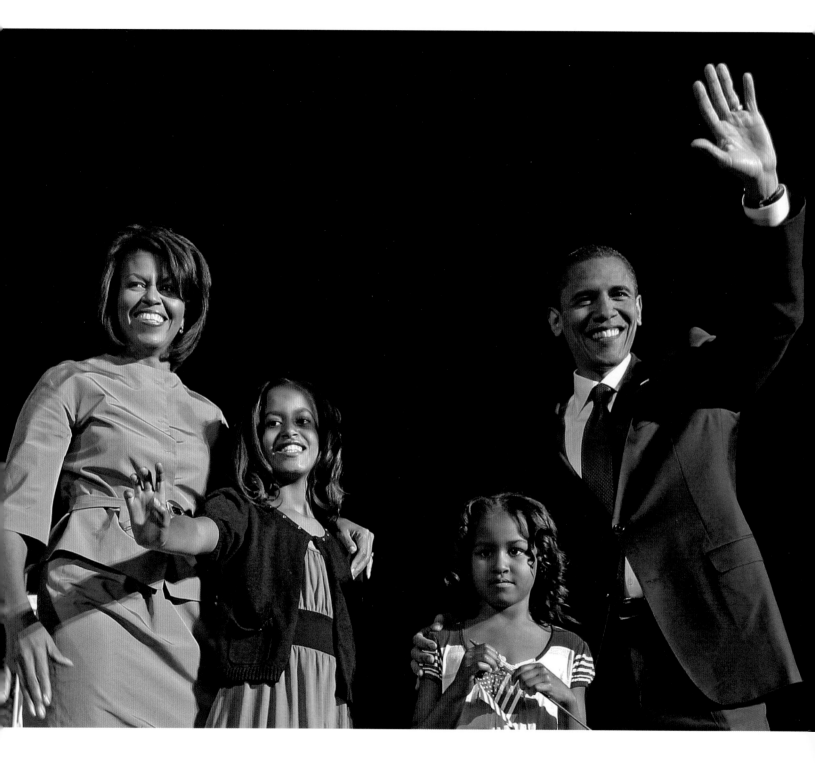

▲ Michelle, Malia, Sasha and, Senator Barack Obama, at a rally
in Des Moines, Iowa, during the Democratic primary, May 20, 2008.

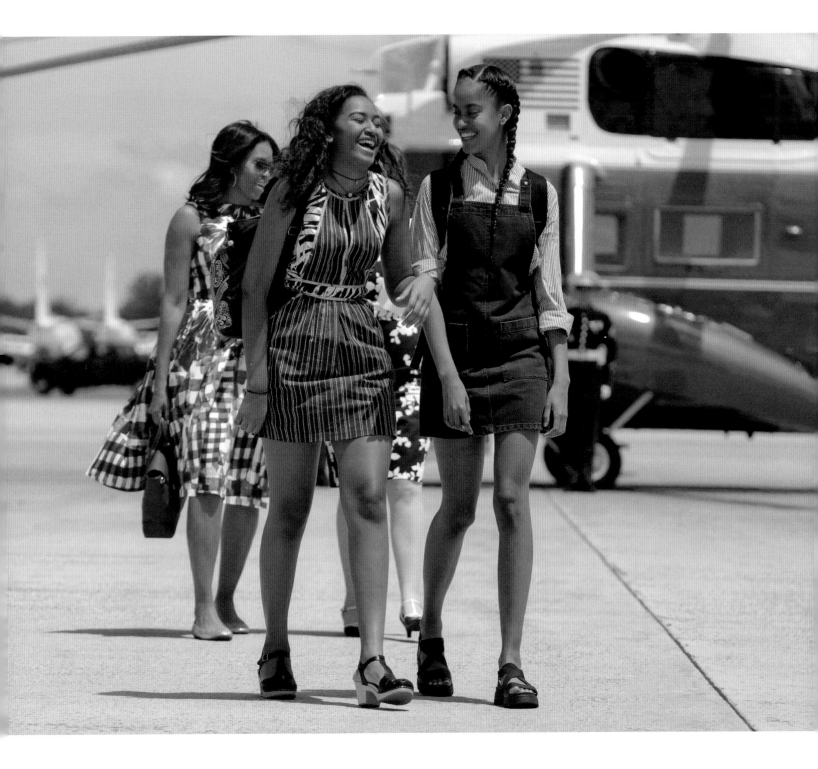

▲ Sasha (left) and Malia Obama with with their mom (in background) on the tarmac at
Joint Base Andrews, June 2016.

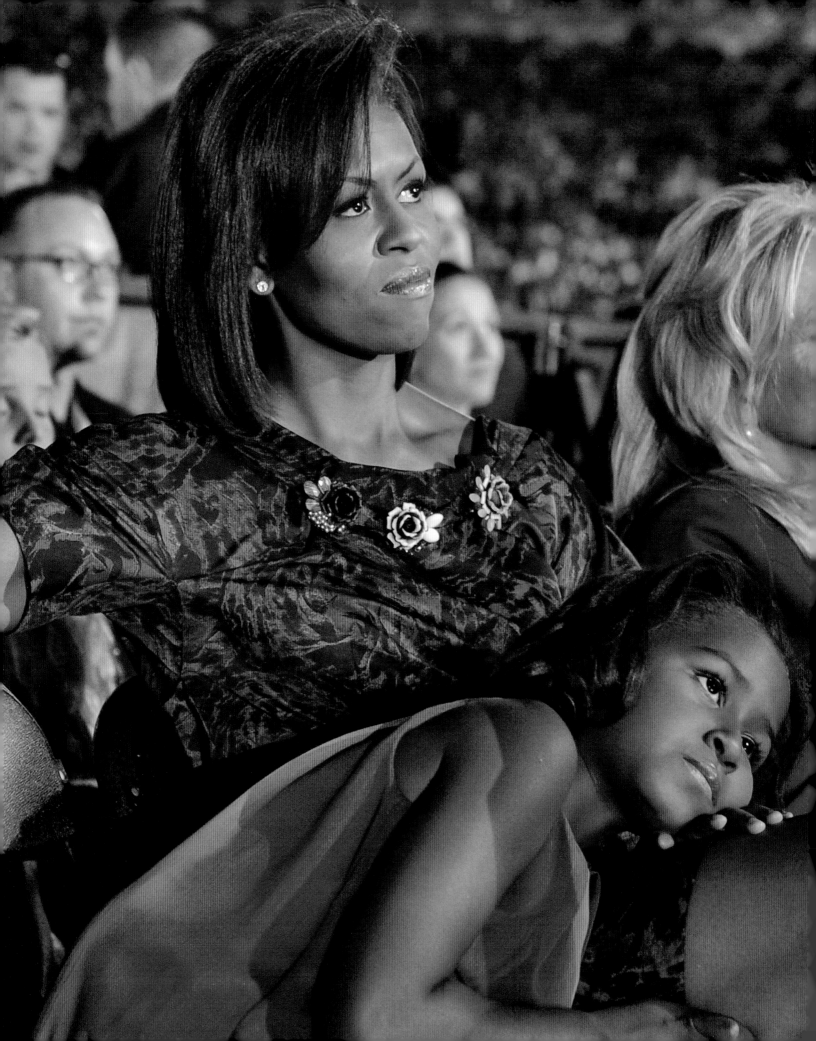

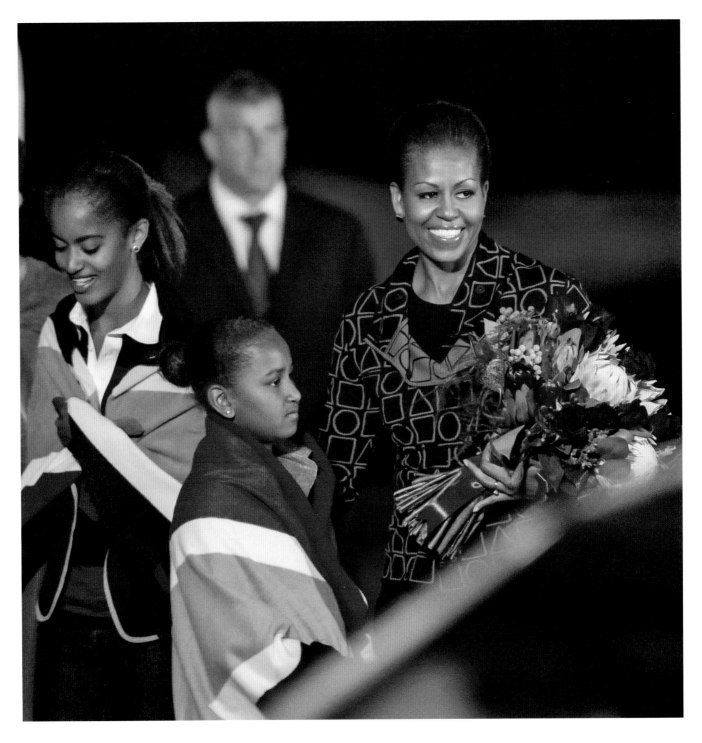

◀ Michelle and daughter Sasha listening as Barack Obama accepts his party's nomination at the Democratic National Convention in Denver, Colorado, August 28, 2008. ▲ Malia (left), Sasha, and the First Lady arriving at the Waterkloof Air Force Base on June 20, 2011, in Pretoria, South Africa.

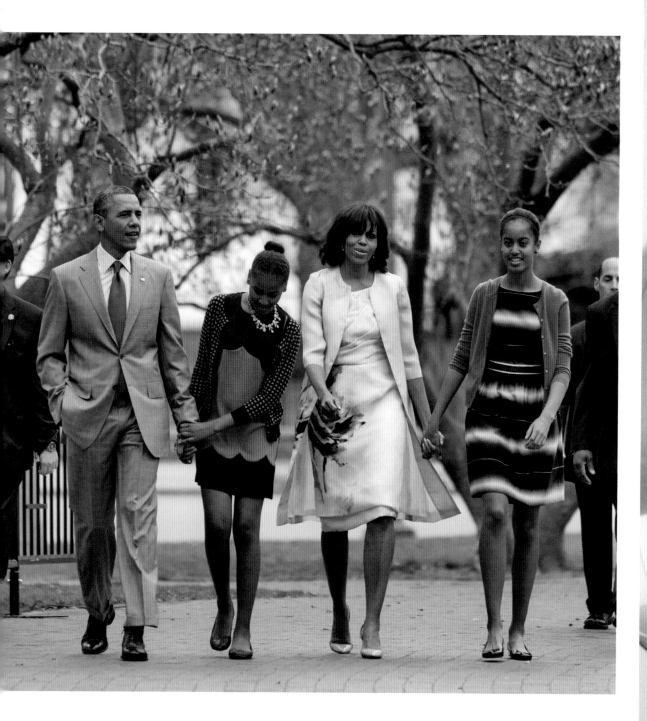

▲ Barack, Sasha, Michelle, and Malia Obama on their way to St. John's Episcopal Church for Easter services in 2013. ▶ Returning from a family vacation in August 2010.

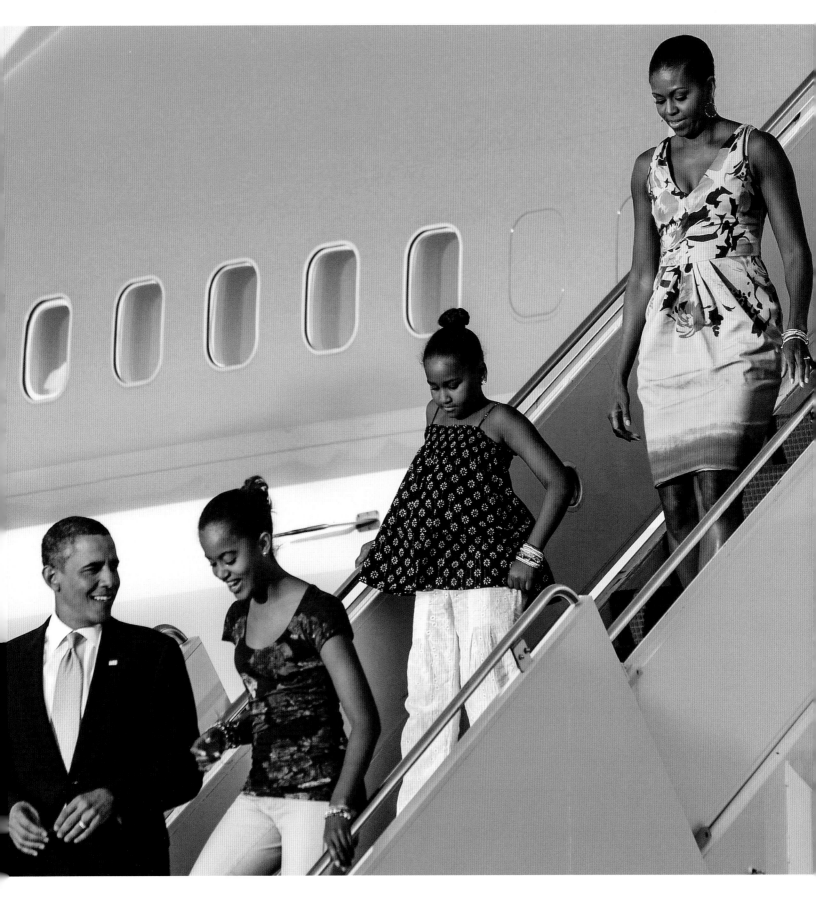

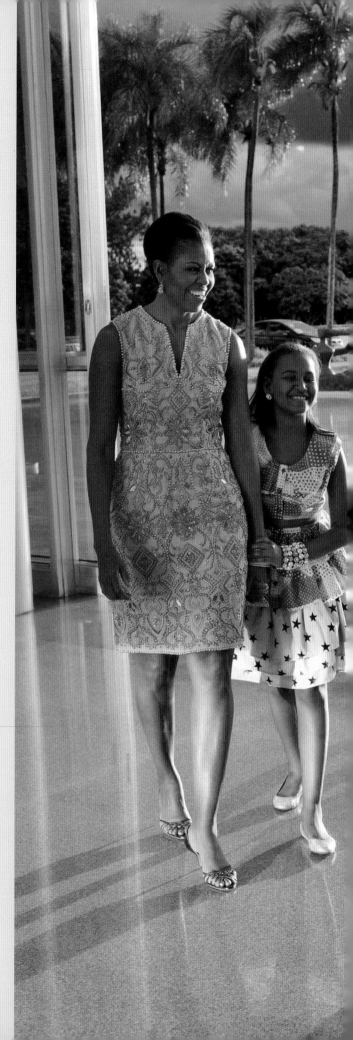

"I am very proud of [Malia and Sasha] and how they've managed this situation and how they have continued to be themselves, regular little girls just trying to figure it out. . . . Every day I cross my fingers and hope that I'm doing right by them, and I'm providing them with a good foundation so that they can be great people.

—MICHELLE OBAMA

▶ At the Palácio da Alvorada in Brasília, Brazil, as President Obama and his family greet President Dilma Rousseff of Brazil and Foreign Minister Antonio Patriota, March 19, 2011.

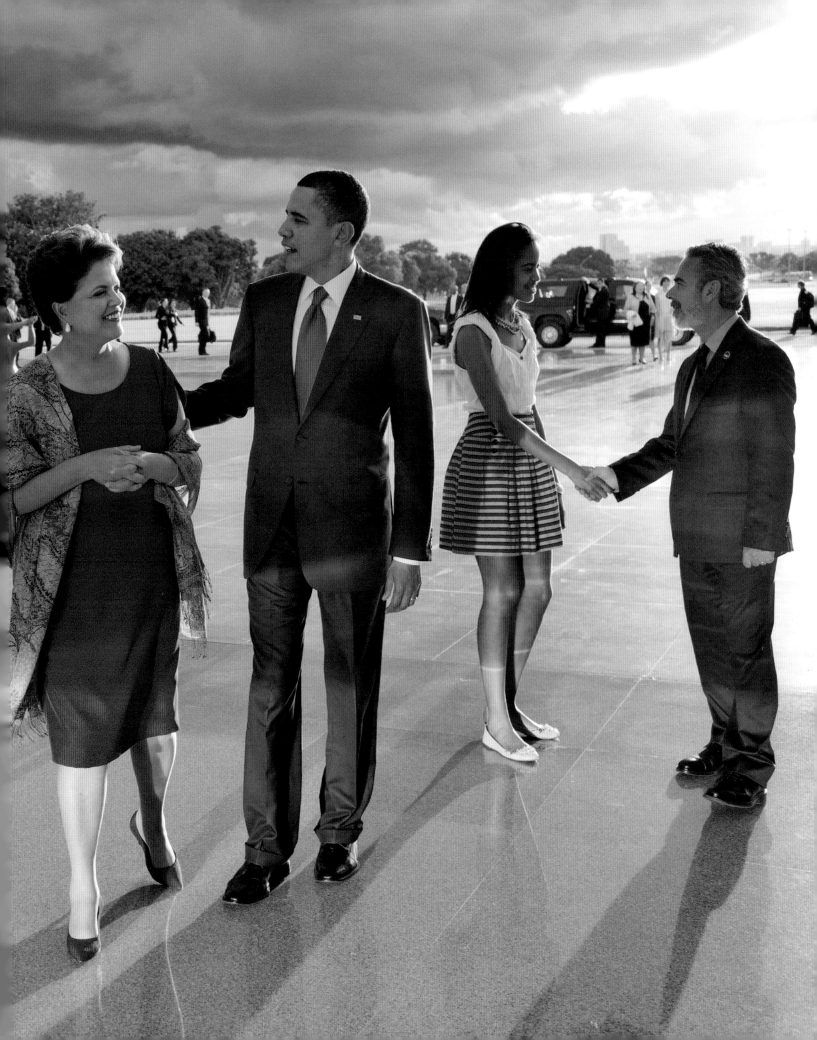

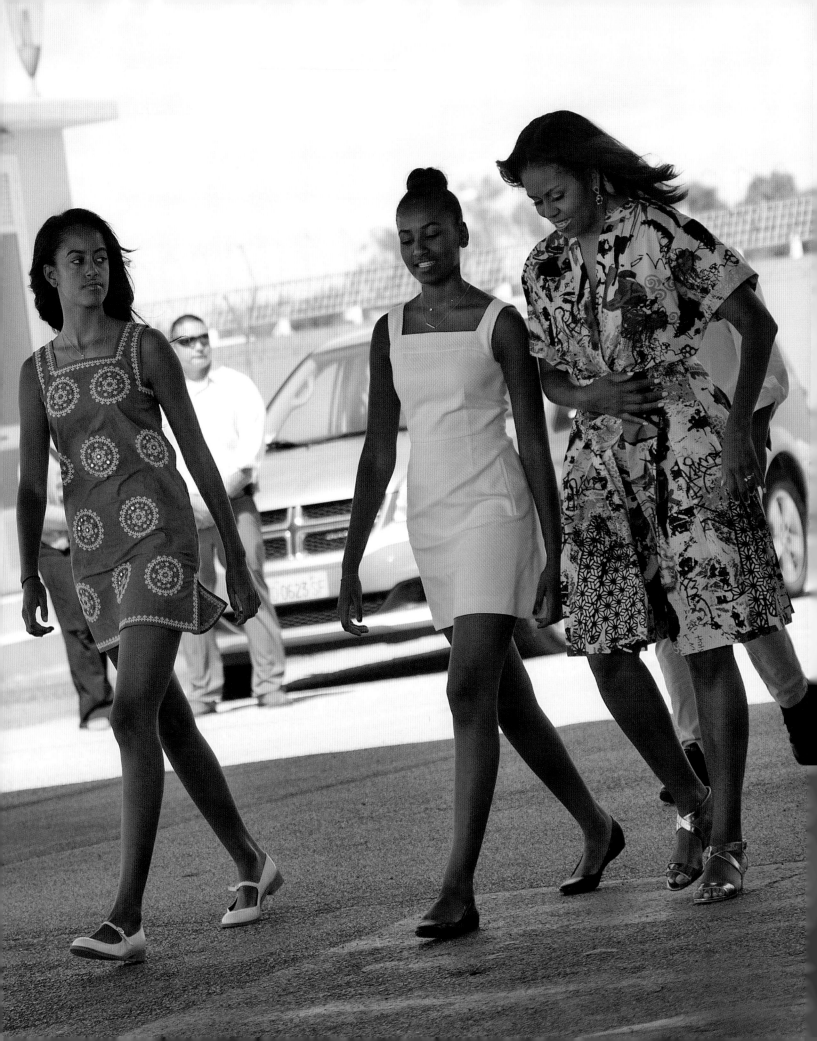

"She's an amazing mom. For her that's what life is all about, her children. The girls are extremely grounded, very loving, very smart, know right from wrong, and it's all about her kids."

—YVONNE DAVILA, FRIEND AND FORMER COLLEAGUE

◄ The First Lady with Malia and Sasha in Venice, Italy, while on a speaking tour for her Let's Move! initiative to combat childhood obesity in June 2015. ▲ The First Family watching the U.S. vs. Japan Women's World Cup match in the Treaty Room at the White House, July 2011.

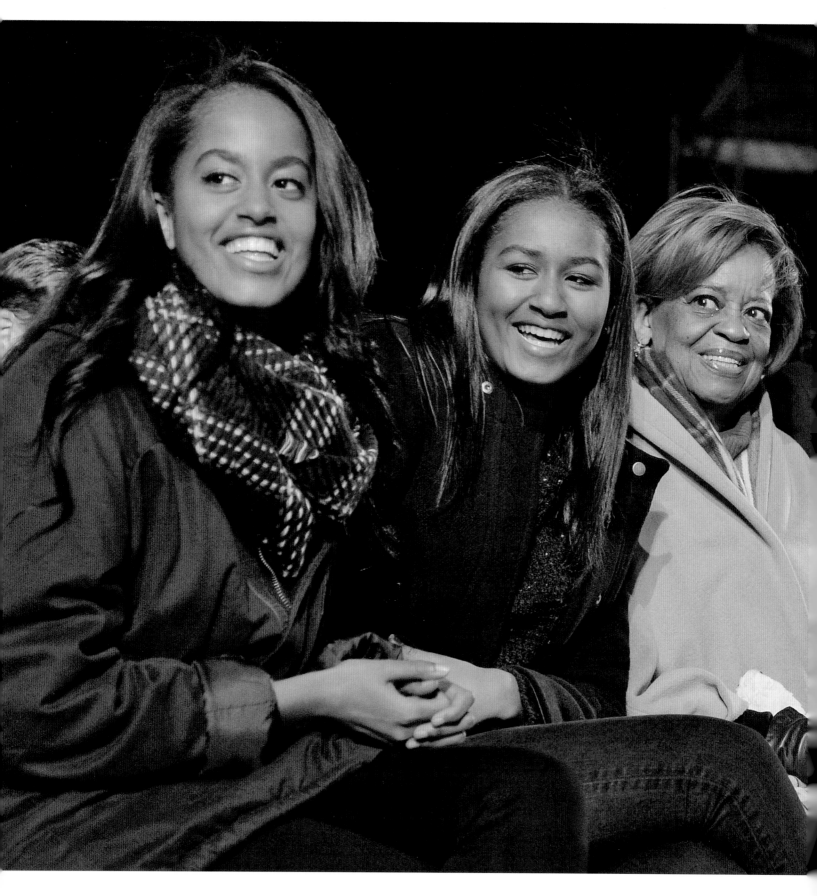

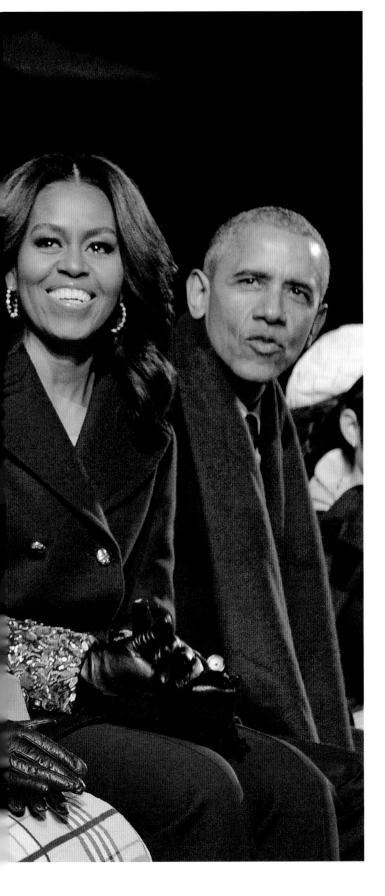

"When I'm unhappy with something . . . I talk a lot, I vent. . . . It's good that I have my mom [here]. I can go up to her little suite of rooms and just say, 'So, what's going on, Mom?' And then I'll start. Eventually we talk our way into a place of comfort."

—MICHELLE OBAMA

WHEN Barack was elected president in 2008, Michelle's mother, Marian, valued the sanctity of family privacy to the extent that she was reluctant to accept Michelle's invitation to live with them in the White House. Her son finally convinced her that it was the best thing to do, since Michelle would need her help in raising Malia and Sasha in as "normal" a household as possible.

◀ (From left to right) Malia, Sasha, Marian Robinson, Michelle, and President Obama at the annual national Christmas tree lighting ceremony on the Ellipse, December 3, 2015.

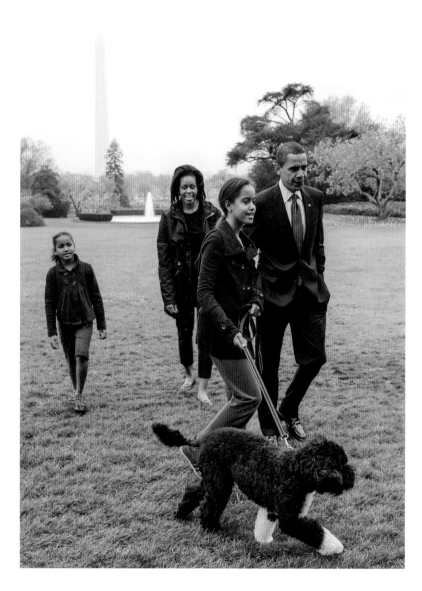

▲ The First Family taking Bo (a Portuguese Water Dog) for a springtime walk in Washington. ▶ The First Lady with family pets Sunny and Bo in the Map Room of the White House, April 2014.

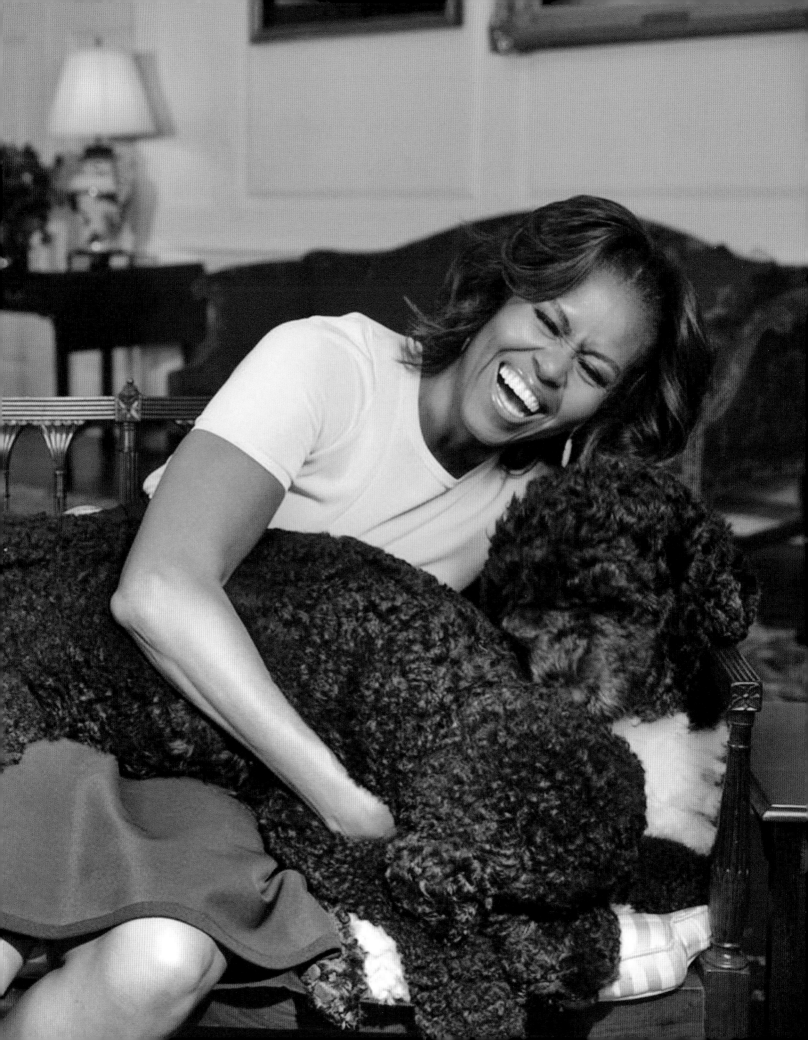

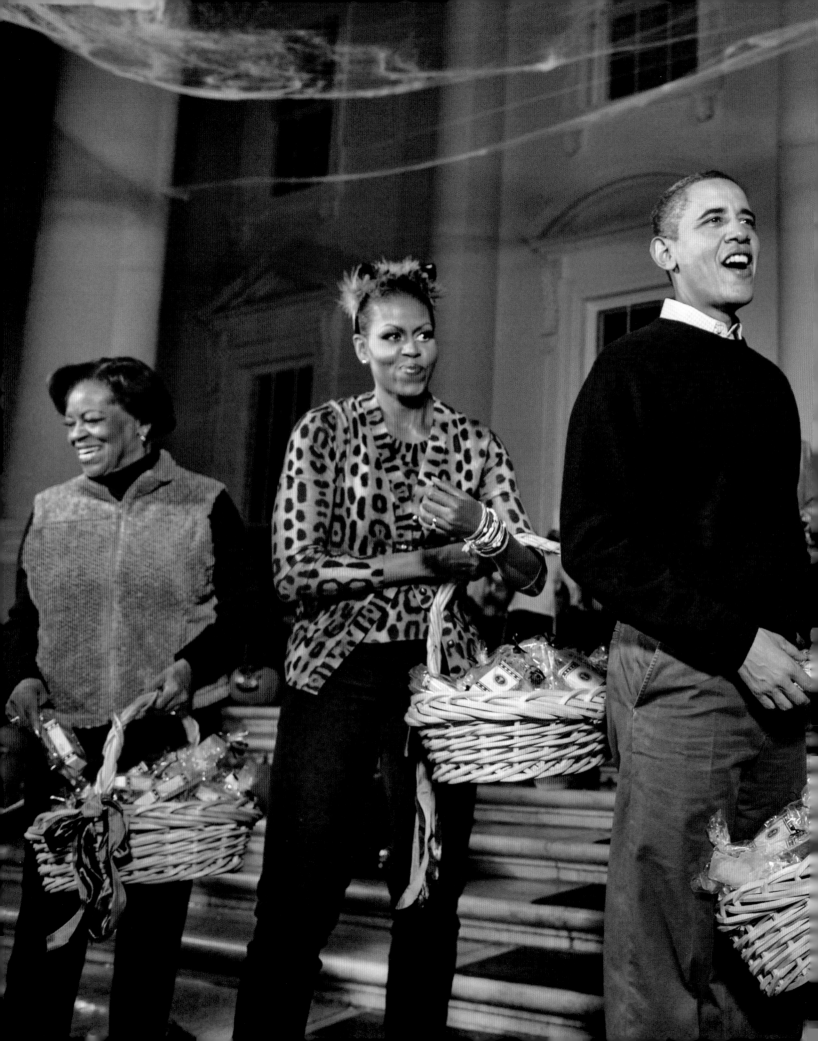

◀ Marian Robinson with her daughter, Michelle, and son-in-law, Barack, welcoming children from local schools to the White House on Halloween, October 31, 2009.

"Who you see is who she is—the brilliant, funny, generous woman who, for whatever reason, agreed to marry me. I think people gravitate to her because they see themselves in her—a dedicated mom, a good friend, and someone who's not afraid to poke a little fun at herself from time to time."

—PRESIDENT BARACK OBAMA

► Michelle Obama is impressed with her husband's ability to quiet a baby in the crowd, Love Field, Dallas, Texas, April 24, 2013.

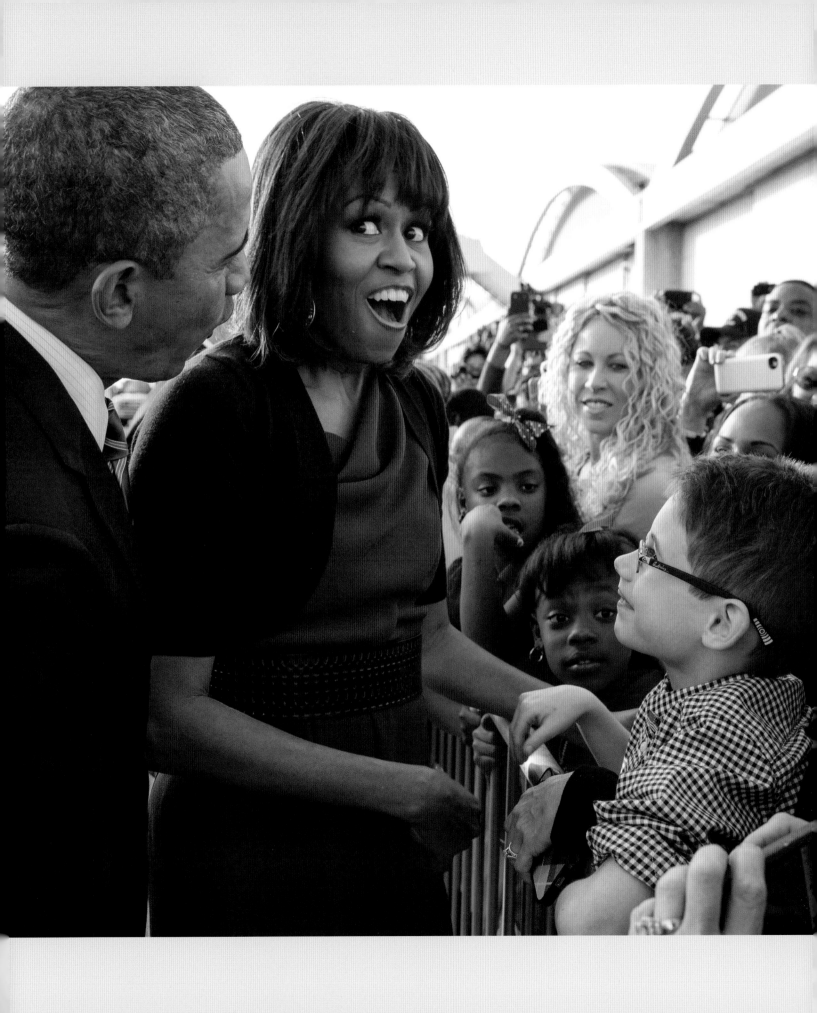

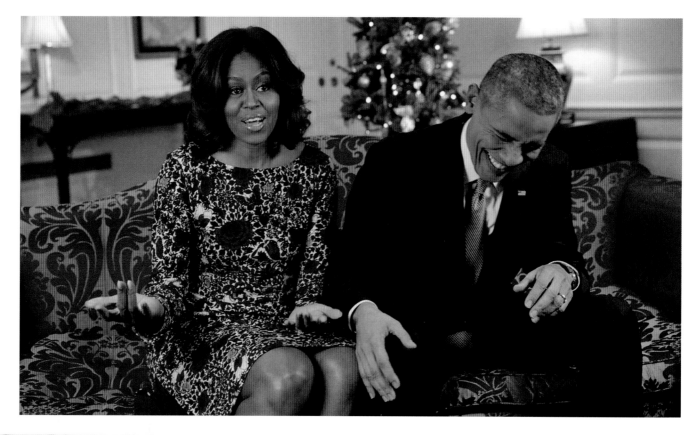

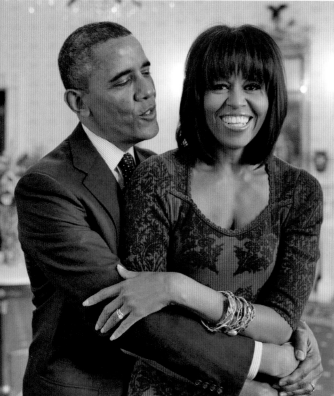

"[An equal partnership] is measured over the scope of the marriage. It's not just four years or eight years or two. We're going to be married for a very long time."

—MICHELLE OBAMA

▲ President Obama bursting out in laughter as he and the First Lady record a holiday video message in the Map Room of the White House, 2014. ◄ Barack Obama singing "Happy Birthday" to Michelle in the Blue Room of the White House, January 17, 2013. ► The couple in the Map Room before welcoming President Felipe Calderón of Mexico and his wife, Mrs. Margarita Zavala, in 2010.

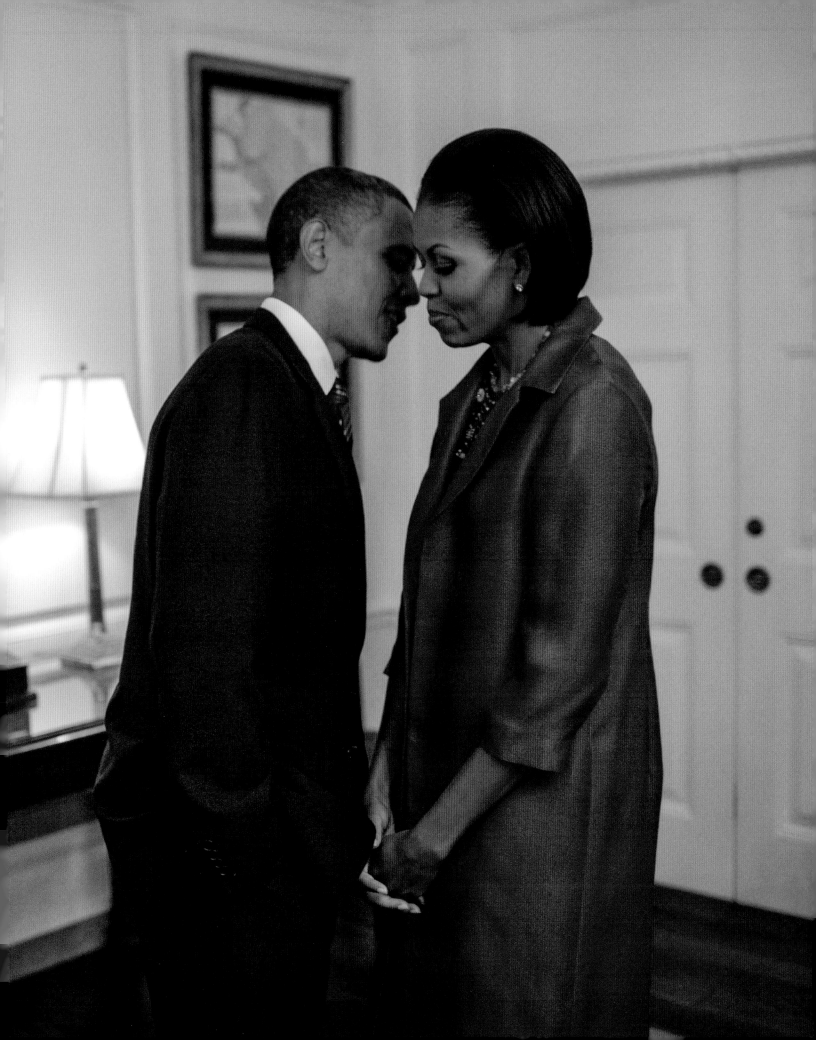

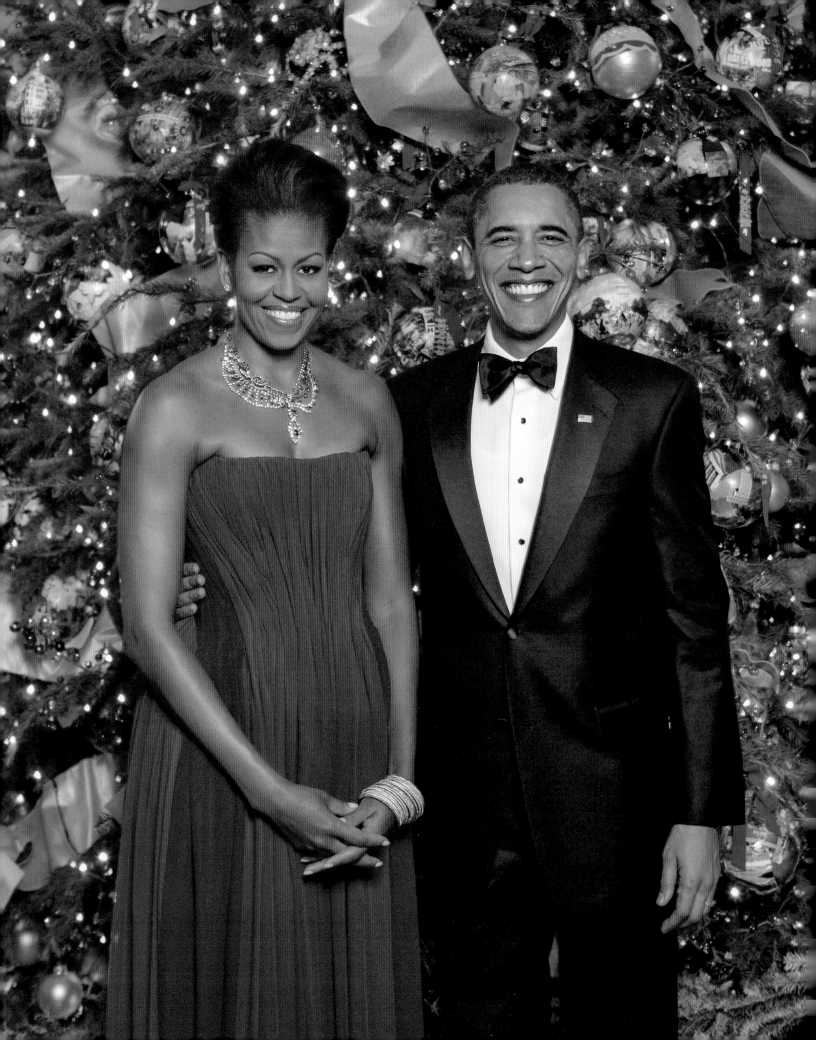

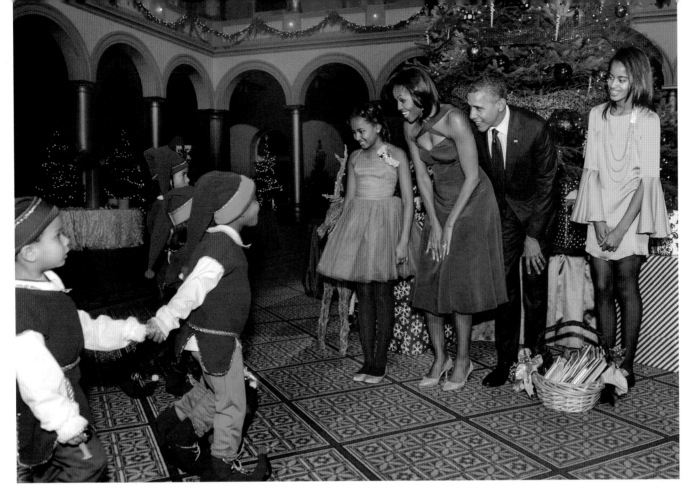

> "Our extended family was so large, people couldn't really afford to buy gifts for everyone. So a couple of my aunts would go out and purchase small gifts. They would put them in a basket and in order to get a gift you had to perform. You could tell a joke, read a poem, do a backflip—anything counted. It's a tradition that we've carried on today."
>
> —MICHELLE OBAMA

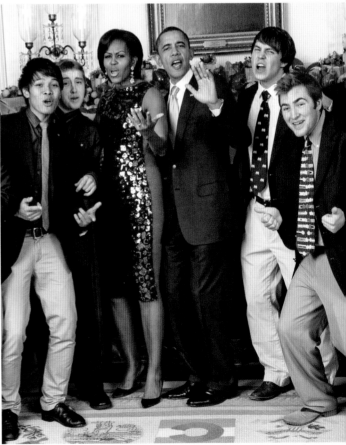

◄ The President and First Lady posing in front of their first official White House Christmas Tree in the Blue Room, December 6, 2009. ▲ The Obama family at the *Christmas in Washington* taping, December 11, 2011. ► Michelle and Barack Obama with the a capella group the Tufts Beelzebubs in the Diplomatic Reception Room of the White House, December 10, 2010.

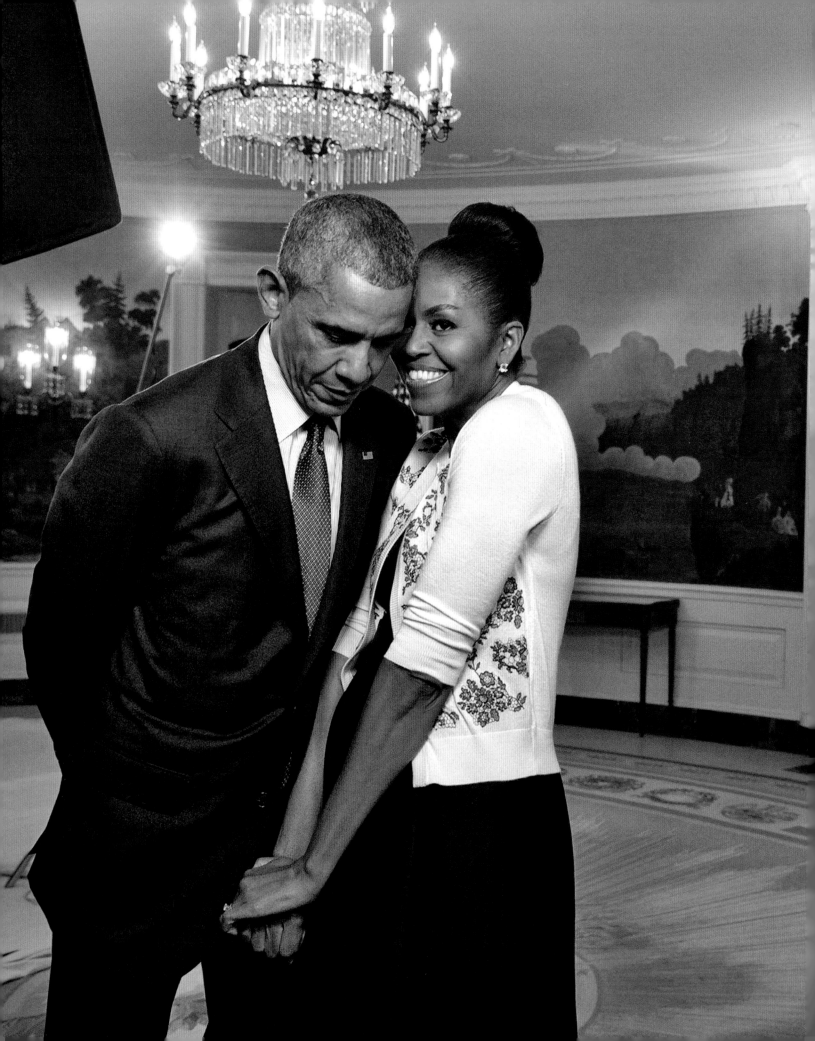

"There's a lot more that unites us than divides us . . . we have a basic connection around a set of values here in this country—decency, honesty, truth matters— that's still what's motivating the American people. . . . And to be reminded of that, and to have the passion to make that everybody's reality, to offer that up to our children, that's a privilege.

—MICHELLE OBAMA

◄ The First Couple snuggling in the Diplomatic Reception Room before a taping for the 2015 World Expo. (Following pages) Barack and Michelle riding in their second inaugural parade, January 21, 2013.

57

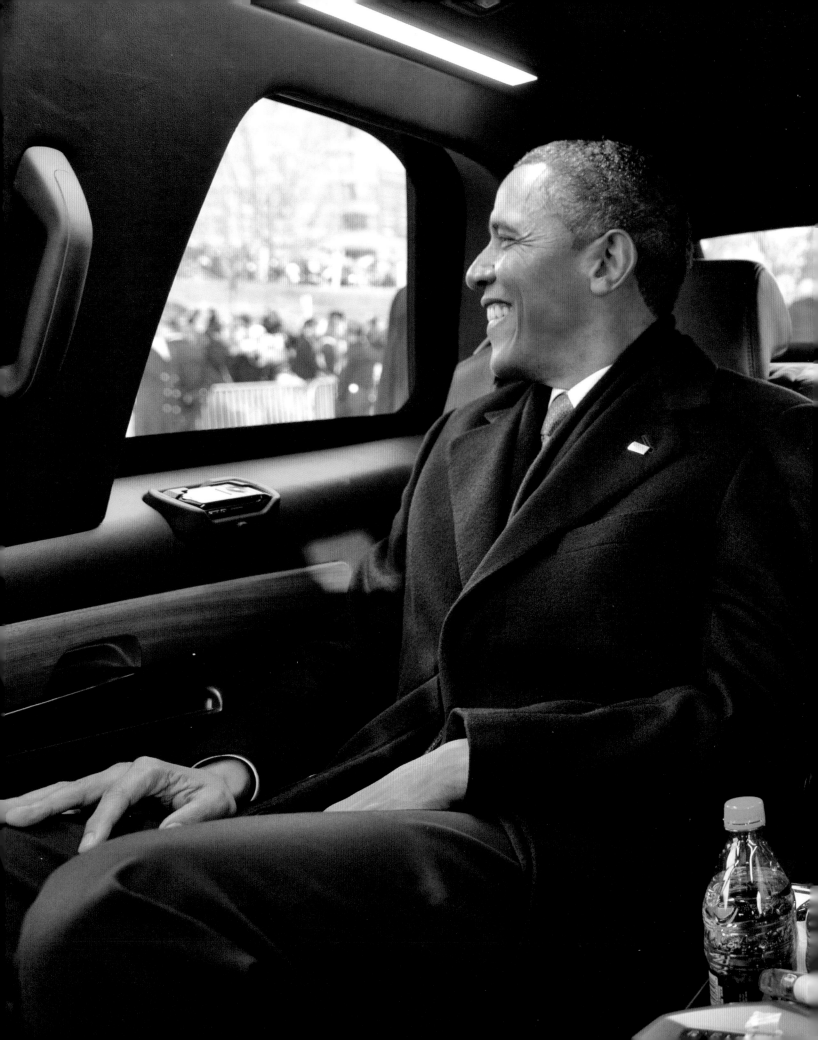

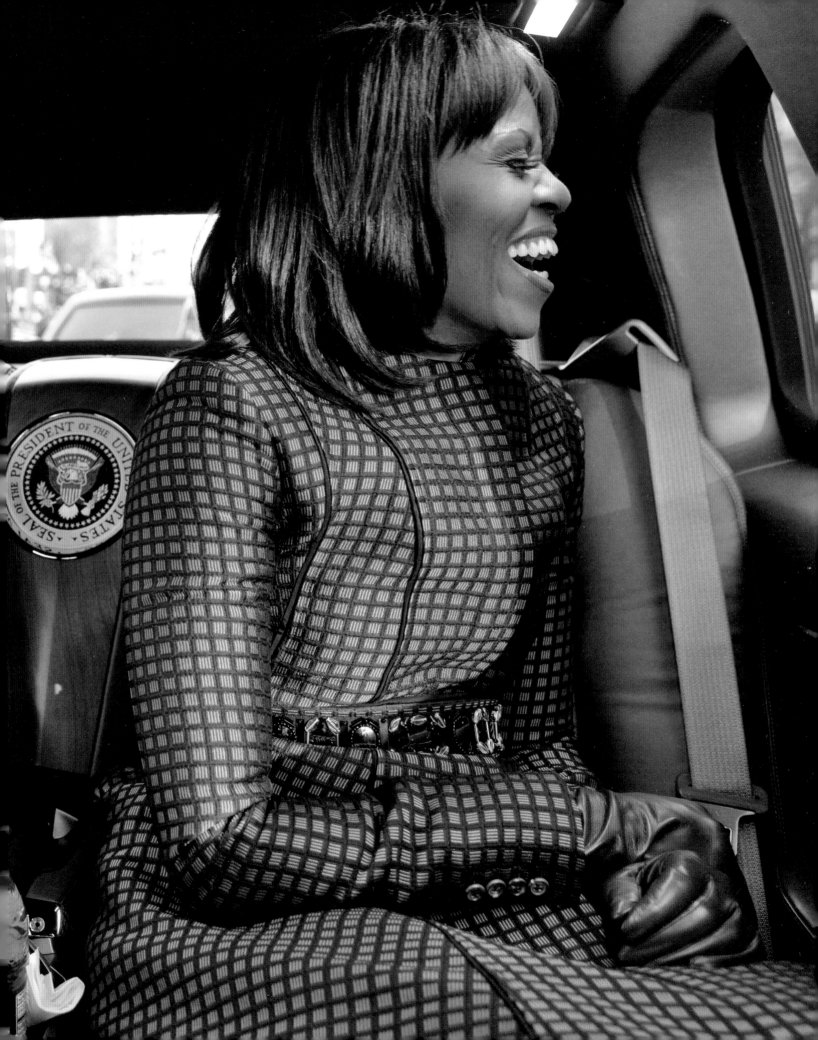

IN THE
SPOTLIGHT

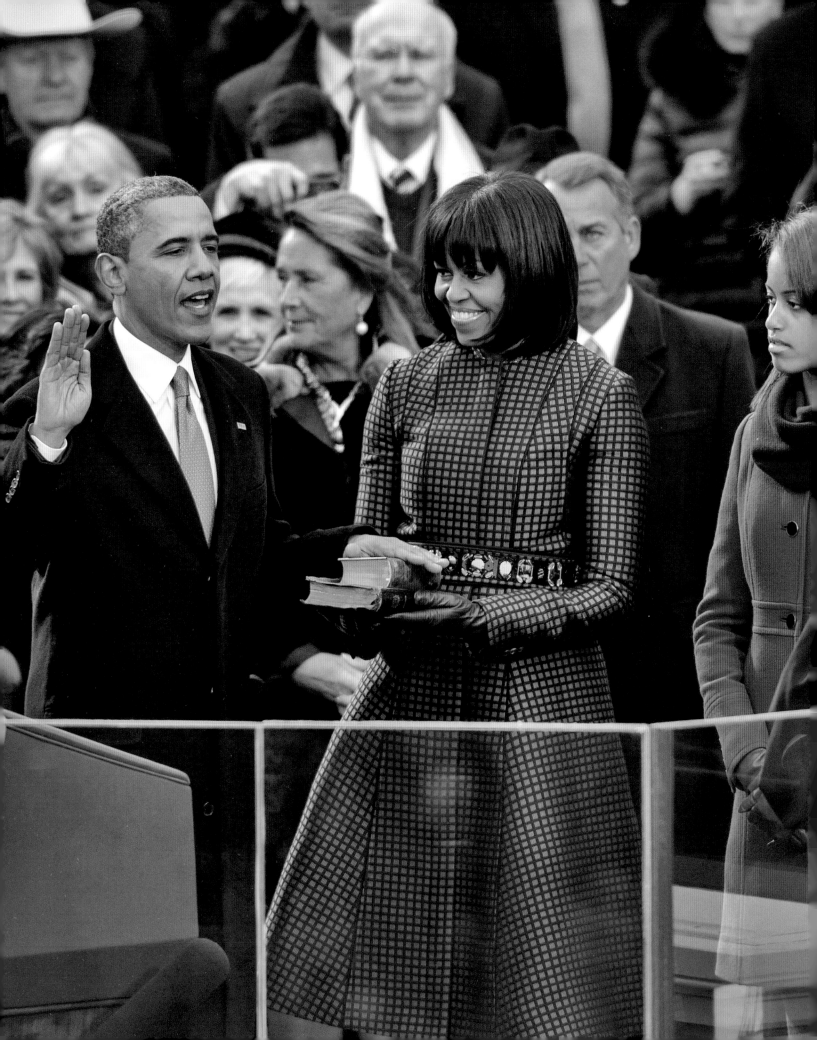

> "By far, the fun that I have in this job far outweighs any challenges that you can imagine."
>
> —MICHELLE OBAMA

AT HARVARD Law School, Michelle impressed

her classmates as a warm and unpretentious young woman with a sharp intellect who never forgot where she came from. She brought each of those qualities to her role as first lady, including honoring her family heritage in significant, inspiring ways. For her husband's second official swearing-in ceremony inside the White House in 2013, for example, she held a family heirloom, the Robinson Family Bible. During the public ceremony held outdoors the next day, the Obamas chose two other symbolic Bibles, owned by Abraham Lincoln and Martin Luther King Jr., to commemorate the nation's struggle for equality.

(Previous page) Supporting veterans at the James J. Peters VA Medical Center in the Bronx on day one of the 2009 World Series, which was dedicated to veterans of the Iraq and Afghanistan wars. ◀ Barack Obama's second inauguration, January 21, 2013.

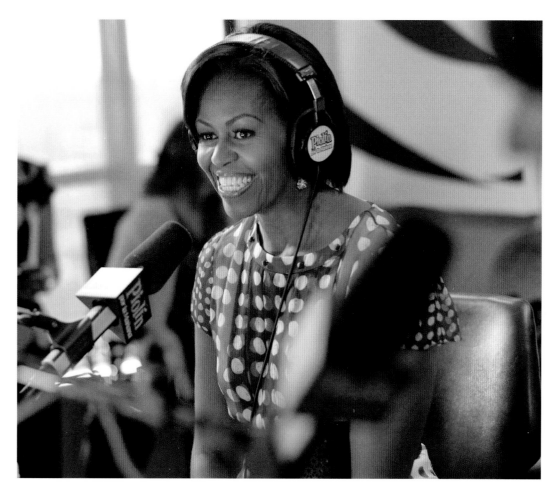

"Every first lady brings their unique perspective to this job. If you didn't, you couldn't live through it. I think to the extent that this feels natural to me . . . it's because I try to make it me. I try to bring a little bit of Michelle Obama into this."

—MICHELLE OBAMA

▲ First Lady Michelle Obama on the radio talk show *Piolin* in 2010.

▶ On the campaign trail in Manchester, New Hampshire, August 2012.

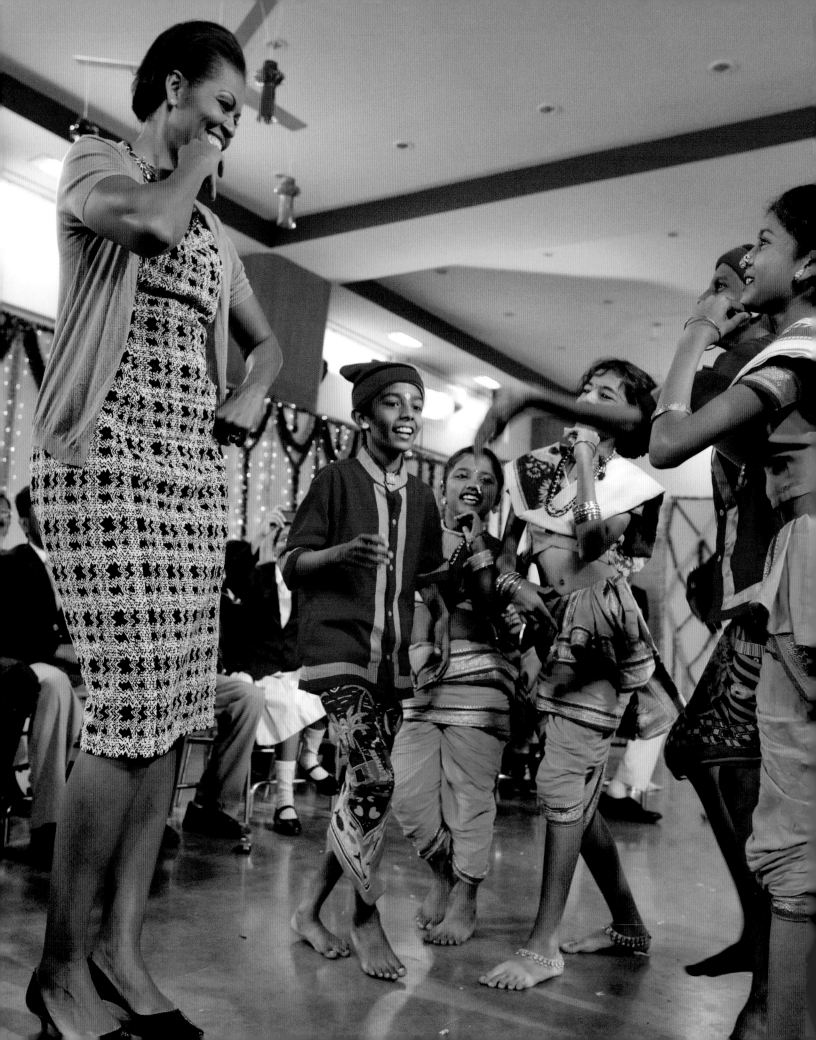

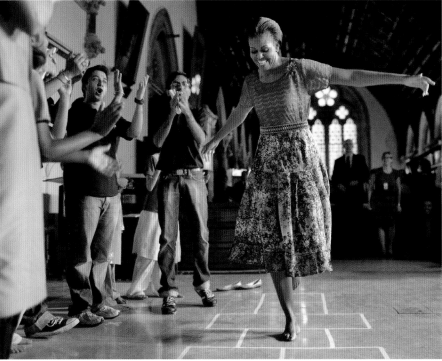

◀ Dancing with students during Diwali at Holy Name High School in Mumbai, India, November 7, 2010. ▲ Playing hopscotch with students and volunteers from the Make a Difference NGO in Mumbai. ▼ Visiting the Siete de Enero Primary School in Mexico City, April 2010.

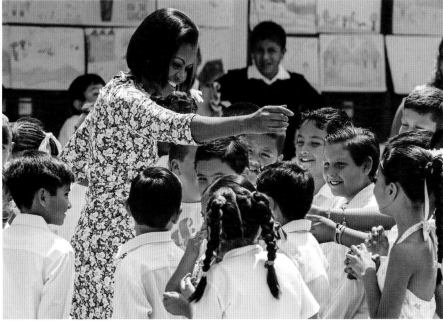

"Soon, the world will be looking to your generation to make the discoveries and build the industries that will fuel our prosperity and ensure our well-being for decades to come. . . . I believe that all of you—and your peers around the world—are more ready than ever to meet these challenges."

—MICHELLE OBAMA

► With schoolchildren on a visit to Mexico in 2010.

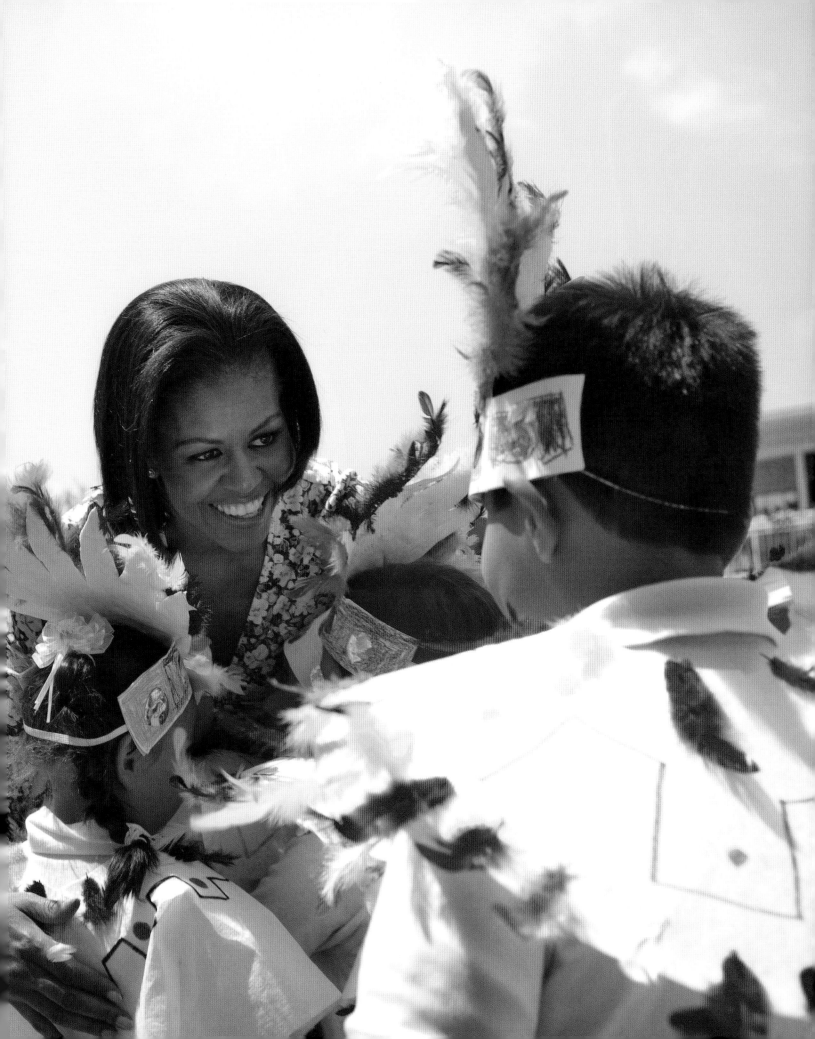

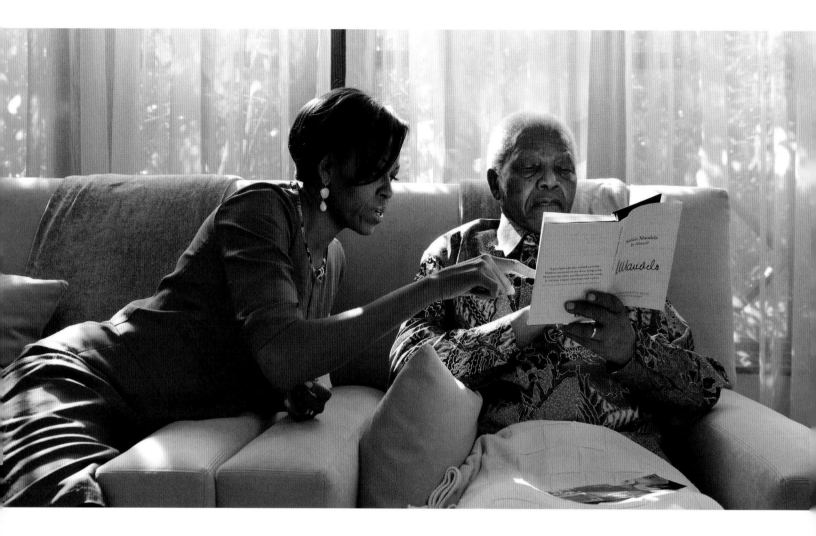

⁶⁶I always touch people . . . I just try to physically hold them and . . . say: 'We're here. I'm just Michelle. . . .' That's what I try to do with my interactions: a hug, a touch. It's like music. It's like friendship.⁹⁹

—MICHELLE OBAMA

▲ The First Lady meets Nelson Mandela at his home in Houghton, South Africa, on June 21, 2011. ▶ With Young African Women Leaders Forum members at the Rosa Parks Library in Soweto, South Africa, June 2011.

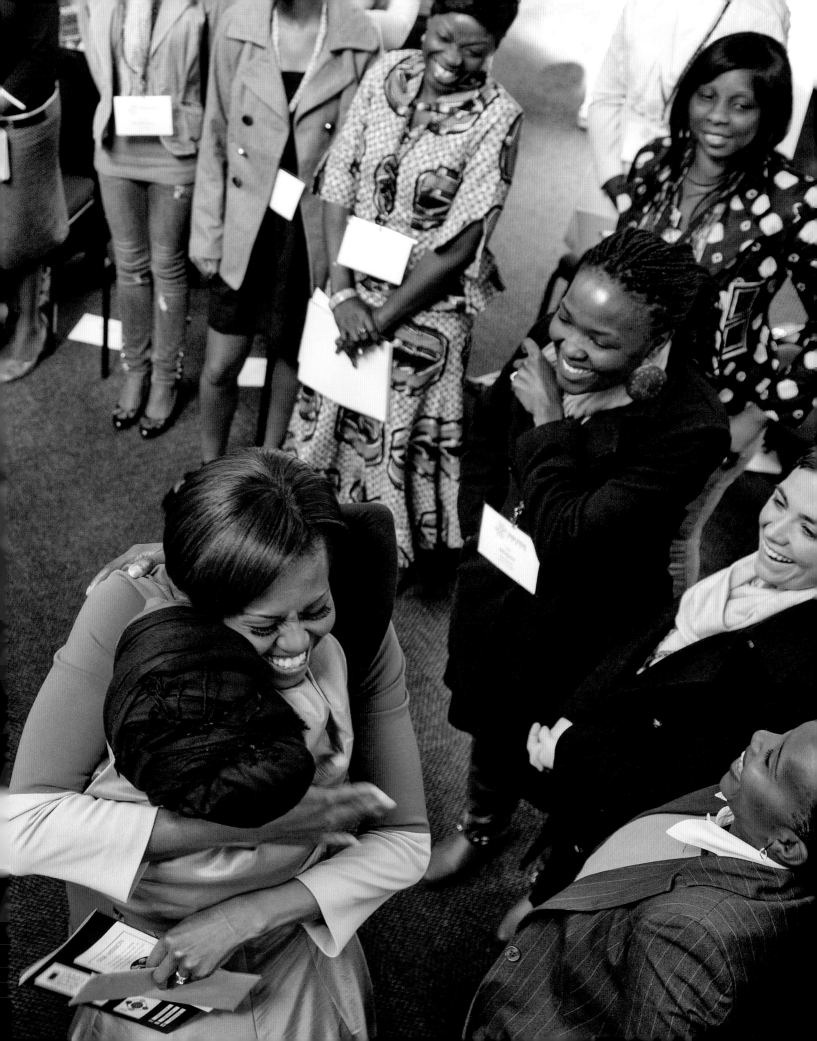

"Words matter—what we say, how we behave, we are modeling to the next generation. So if we want maturity, we have to be mature. If we want a nation that feels hopeful, then we have to speak in hopeful terms. We have to show love and empathy. If we want smart leaders, then we have to be smart voters."

—MICHELLE OBAMA

◀ First Lady Michelle Obama looking over her speech at the Metropolitan Museum of Art in New York, May 18, 2009. ▲ Speaking at Regina Mundi church, which provided shelter to anti-apartheid activists during apartheid, Soweto, South Africa, June 2011.

REMARKS BY THE FIRST LADY AT TUSKEGEE UNIVERSITY COMMENCEMENT [abridged]

Tuskegee University
Tuskegee, Alabama
May 9, 2015

YOU ALL HAVE COME here from all across the country to study, to learn, maybe have a little fun along the way—from freshman year in Adams or Younge Hall—to those late night food runs to the Coop. I did my research. To those mornings you woke up early to get a spot under the Shed to watch the Golden Tigers play. Yeah! I've been watching! At the White House we have all kinds of ways.

And whether you played sports yourself, or sang in the choir, or played in the band, or joined a fraternity or sorority—after today, all of you will take your spot in the long line of men and women who have come here and distinguished themselves and this university.

You will follow alums like many of your parents and grandparents, aunts and uncles—leaders like Robert Robinson Taylor, a groundbreaking architect and administrator here who was recently honored on a postage stamp. You will follow heroes like Dr. Boynton Robinson—who survived the billy clubs and the tear gas of Bloody Sunday in Selma. The story of Tuskegee is full of stories like theirs—men and women who came to this city, seized their own futures, and wound up shaping the arc of history for African Americans and all Americans.

And I'd like to begin today by reflecting on that history—starting back at the time when the Army chose Tuskegee as the site of its airfield and flight school for black pilots.

Back then, black soldiers faced all kinds of obstacles. There were the so-called scientific studies that said that black men's brains were smaller than white men's. Official Army reports stated that black soldiers were "childlike," "shiftless," "unmoral and untruthful," and as one quote stated, "if fed, loyal and compliant."

So while the airmen selected for this program were actually highly educated—many already had college degrees and pilots' licenses—they were presumed to be inferior. During training, they were often assigned to menial tasks like housekeeping or

"Generation after generation, students here have shown that same grit, that same resilience to soar past obstacles and outrages—past the threat of countryside lynchings; past the humiliation of Jim Crow; past the turmoil of the civil rights era."

landscaping. Many suffered verbal abuse at the hands of their instructors. When they ventured off base, the white sheriff here in town called them "boy" and ticketed them for the most minor offenses. And when they finally deployed overseas, white soldiers often wouldn't even return their salutes.

Just think about what that must have been like for those young men. Here they were, trained to operate some of the most complicated, high-tech machines of their day—flying at hundreds of miles an hour, with the tips of their wings just six inches apart. Yet when they hit the ground, folks treated them like they were nobody—as if their very existence meant nothing.

Now, those airmen could easily have let that experience clip their wings. But as you all know, instead of being defined by the discrimination and the doubts of those around them, they became one of the most successful pursuit squadrons in our military. They went on to show the world that if black folks and white folks could fight together, and fly together, then surely—surely—they could eat at a lunch counter together. Surely their kids could go to school together.

You see, those airmen always understood that they had a "double duty"—one to their country and another to all the black folks who were counting on them to pave the way forward. So for those airmen, the act of flying itself was a symbol of liberation for themselves and for all African Americans.

One of those first pilots, a man named Charles DeBow, put it this way. He said that a takeoff was—in his words—"a never-failing miracle" where all "the bumps would smooth off . . . [you're] in the air . . . out of this world . . . free."

And when he was up in the sky, Charles sometimes looked down to see black folks out in the cotton fields not far from here—the same fields where decades before, their ancestors [worked] as slaves. And he knew that he was taking to the skies for them—to give them and their children something more to hope for, something to aspire to.

And in so many ways, that never-failing miracle—the constant work to rise above the bumps in our path to greater freedom for our brothers and sisters—that has always been the story of African Americans here at Tuskegee.

Just think about the arc of this university's history. Back in the late 1800s, the school needed a new dormitory, but there was no money to pay for it. So Booker T. Washington pawned his pocket watch to buy a kiln, and students used their bare hands to make bricks to build that dorm—and a few other buildings along the way.

A few years later, when George Washington Carver first came here for his research, there was no laboratory. So he dug through trash piles and collected old bottles, and tea cups, and fruit jars to use in his first experiments.

Generation after generation, students here have shown that same grit, that same resilience to soar past obstacles and outrages—past the threat of countryside lynchings; past the humiliation of Jim Crow; past the turmoil of the civil rights era. And then they went on to become scientists, engineers, nurses, and teachers in communities all across the country—and continued to lift others up along the way.

And while the history of this campus isn't perfect, the defining story of Tuskegee is the story of rising hopes and fortunes for all African Americans.

And now, graduates, it's your turn to take up that cause. And let me tell you, you should feel so proud of making it to this day. And I hope that you're excited to get started on that next chapter. But I also imagine that you might think about all that history, all those heroes who came before you—you might also feel a little pressure, you know—pressure to live up to the legacy of those who came before you; pressure to meet the expectations of others.

And believe me, I understand that kind of pressure. I've experienced a little bit of it myself. You see, graduates, I didn't start out as the fully formed First Lady who stands before you today. No, no, I had my share of bumps along the way.

▶ Michelle Obama reaching to touch the Hokie Stone before giving the Virginia Tech commencement address, in Blacksburg, Virginia, May 11, 2012.

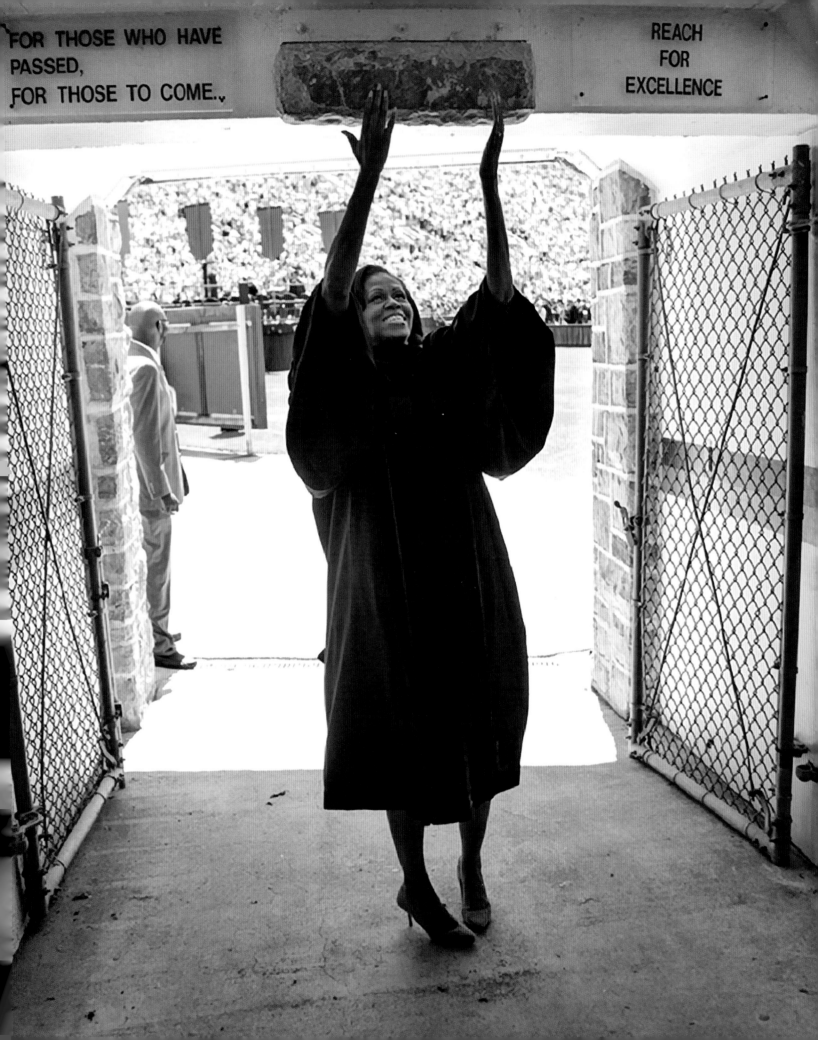

Back when my husband first started campaigning for president, folks had all sorts of questions of me: What kind of first lady would I be? What kinds of issues would I take on? Would I be more like Laura Bush, or Hillary Clinton, or Nancy Reagan? And the truth is, those same questions would have been posed to any candidate's spouse. That's just the way the process works. But, as potentially the first African American first lady, I was also the focus of another set of questions and speculations; conversations sometimes rooted in the fears and misperceptions of others. Was I too loud, or too angry, or too emasculating? Or was I too soft, too much of a mom, not enough of a career woman?

Then there was the first time I was on a magazine cover—it was a cartoon drawing of me with a huge Afro and machine gun. Now, yeah, it was satire, but if I'm really being honest, it knocked me back a bit. It made me wonder, just how are people seeing me.

Or you might remember the onstage celebratory fist bump between me and my husband after a primary win that was referred to as a "terrorist fist jab." And over the years, folks have used plenty of interesting words to describe me. One said I exhibited "a little bit of uppity-ism." Another noted that I was one of my husband's "cronies of color." Cable news once charmingly referred to me as "Obama's Baby Mama."

And of course, Barack has endured his fair share of insults and slights. Even today, there are still folks questioning his citizenship.

And all of this used to really get to me. Back in those days, I had a lot of sleepless nights, worrying about what people thought of me, wondering if I might be hurting my husband's chances of winning his election, fearing how my girls would feel if they found out what some people were saying about their mom.

But eventually, I realized that if I wanted to keep my sanity and not let others define me, there was only one thing I could do, and that was to have faith in God's plan for me. I had to ignore all of the noise and be true to myself—and the rest would work itself out.

So throughout this journey, I have learned to block everything out and focus on my truth. I had to answer some basic questions for myself: Who am I? No, really, who am I? What do I care about?

> "... throughout this journey, I have learned to block everything out and focus on my truth. I had to answer some basic questions for myself: Who am I? No, really, who am I? What do I care about?"

And the answers to those questions have resulted in the woman who stands before you today. A woman who is, first and foremost, a mom. Look, I love our daughters more than anything in the world, more than life itself. And while that may not be the first thing that some folks want to hear from an Ivy League–educated lawyer, it is truly who I am. So for me, being Mom-in-Chief is, and always will be, job number one.

Next, I've always felt a deep sense of obligation to make the biggest impact possible with this incredible platform. So I took on issues that were personal to me—issues like helping families raise healthier kids, honoring the incredible military families I'd met on the campaign trail, inspiring our young people to value their education and finish college.

Now, some folks criticized my choices for not being bold enough. But these were my choices, my issues. And I decided to tackle them in the way that felt most authentic to me—in a way that was both substantive and strategic, but also fun and, hopefully, inspiring.

So I immersed myself in the policy details. I worked with Congress on legislation, gave speeches to CEOs, military generals, and Hollywood executives. But I also worked to ensure that my efforts would resonate with kids and families—and that meant doing things in a creative and unconventional way. So, yeah, I planted a garden, and hula-hooped on the White House Lawn with kids. I did some Mom Dancing on TV. I celebrated military kids with Kermit the Frog. I asked folks across the country to wear their alma mater's T-shirts for College Signing Day.

And at the end of the day, by staying true to the me I've always known, I found that this journey has been incredibly freeing. Because no matter what happened, I had the peace of mind of knowing that all of the chatter, the name calling, the doubting— all of it was just noise. It did not define me. It didn't change who I was. And most importantly, it couldn't hold me back. I have learned that as long as I hold fast to my beliefs and values—and follow my own moral compass—then the only expectations I need to live up to are my own.

"The world won't always see you in those caps and gowns. . . . Instead they will make assumptions about who they think you are based on their limited notion of the world."

So, graduates, that's what I want for all of you. I want you all to stay true to the most real, most sincere, most authentic parts of yourselves. I want you to ask those basic questions: Who do you want to be? What inspires you? How do you want to give back? And then I want you to take a deep breath and trust yourselves to chart your own course and make your mark on the world.

Maybe it feels like you're supposed to go to law school— but what you really want to do is to teach little kids. Maybe your parents are expecting you to come back home after you graduate—but you're feeling a pull to travel the world. I want you to listen to those thoughts. I want you to act with both your mind, but also your heart. And no matter what path you choose, I want you to make sure it's you choosing it, and not someone else.

Because here's the thing—the road ahead is not going to be easy. It never is, especially for folks like you and me. Because while we've come so far, the truth is that those age-old problems are stubborn and they haven't fully gone away. So there will be times, just like for those airmen, when you feel like folks look right past you, or they see just a fraction of who you really are.

The world won't always see you in those caps and gowns. They won't know how hard you worked and how much you sacrificed to make it to this day—the countless hours you spent studying to get this diploma, the multiple jobs you worked to pay for school, the times you had to drive home and take care of your grandma, the evenings you gave up to volunteer at a food bank or organize a campus fundraiser. They don't know that part of you.

Instead they will make assumptions about who they think you are based on their limited notion of the world. And my husband and I know how frustrating that experience can be. We've both felt the sting of those daily slights throughout our entire lives—the folks who crossed the street in fear of their safety; the clerks who kept a close eye on us in all those department stores; the people at formal events who assumed we were the "help"—and those who have questioned our intelligence, our honesty, even our love of this country.

And I know that these little indignities are obviously nothing compared to what folks across the country are dealing with every

▲ The First Lady waiting to be introduced at a fundraising event at the Claremont Hotel Club & Spa in Berkeley, California, 2011.

single day—those nagging worries that you're going to get stopped or pulled over for absolutely no reason; the fear that your job application will be overlooked because of the way your name sounds; the agony of sending your kids to schools that may no longer be separate, but are far from equal; the realization that no matter how far you rise in life, how hard you work to be a good person, a good parent, a good citizen—for some folks, it will never be enough.

And all of that is going to be a heavy burden to carry. It can feel isolating. It can make you feel like your life somehow doesn't matter—that you're like the invisible man that Tuskegee grad Ralph Ellison wrote about all those years ago. And as we've seen over the past few years, those feelings are real. They're rooted in decades of structural challenges that have made too many folks feel frustrated and invisible. And those feelings are playing out in communities like Baltimore and Ferguson and so many others across this country.

But, graduates, today, I want to be very clear that those feelings are not an excuse to just throw up our hands and give up. Not an excuse. They are not an excuse to lose hope. To succumb to feelings of despair and anger only means that in the end, we lose.

But here's the thing—our history provides us with a better story, a better blueprint for how we can win. It teaches us that when we pull ourselves out of those lowest emotional depths, and we channel our frustrations into studying and organizing and banding together—then we can build ourselves and our communities up. We can take on those deep-rooted problems, and together—together—we can overcome anything that stands in our way. . . .

And if you rise above the noise and the pressures that surround you, if you stay true to who you are and where you come from, if you have faith in God's plan for you, then you will keep fulfilling your duty to people all across this country. . . .

God bless you, graduates. I can't wait to see how high you soar. Love you all. Very proud. Thank you.

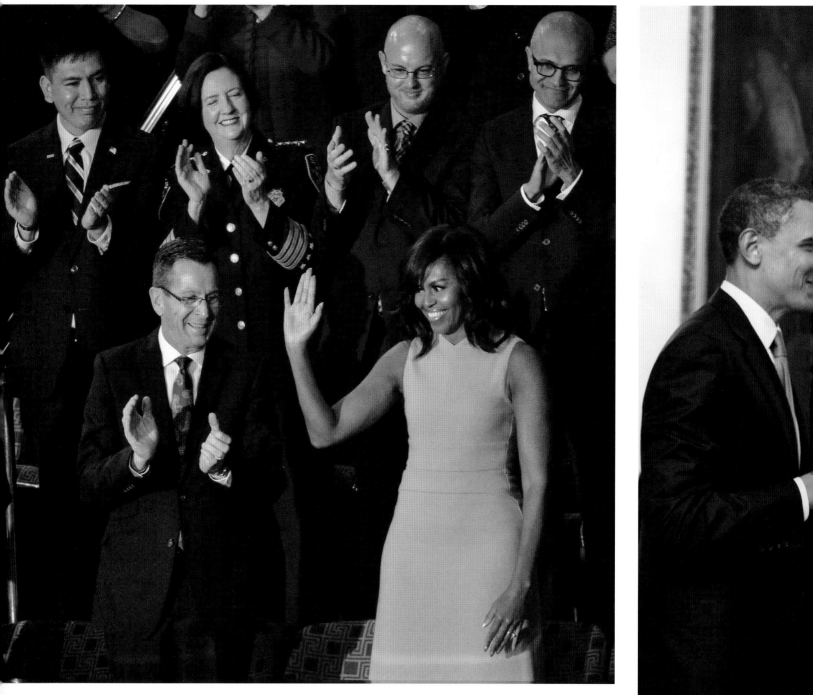

▲ With Governor Dannel P. Malloy of Connecticut at the 2016 State of the Union address. ▶ Offering a toast during an official dinner hosted by Salvadoran president Mauricio Funes in San Salvador, El Salvador, March 2011.

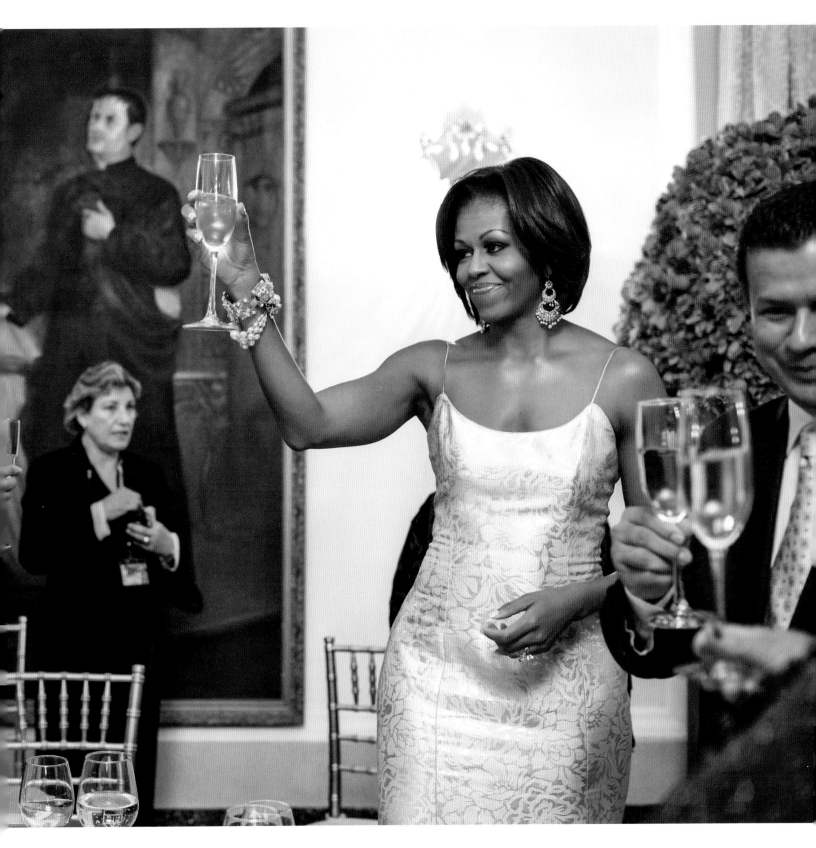

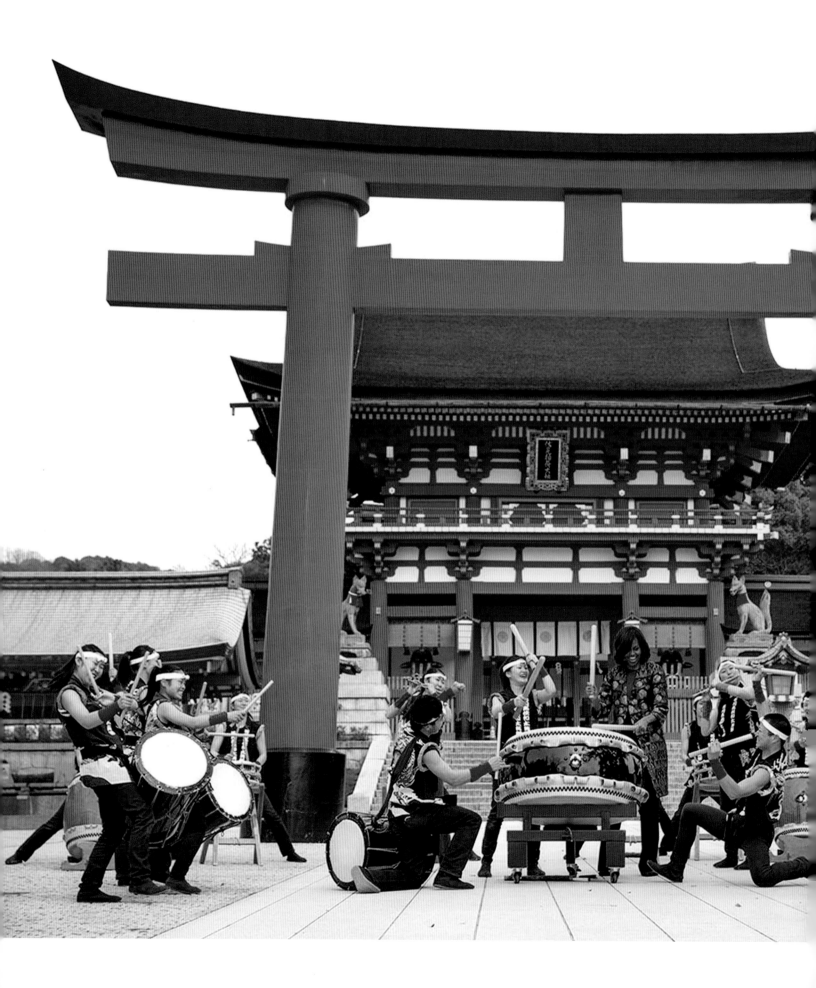

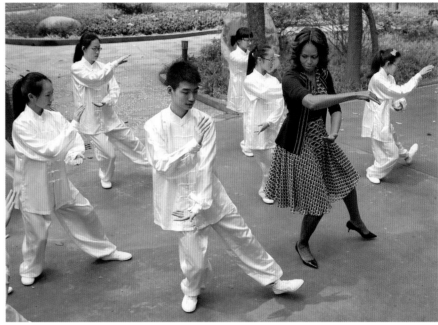

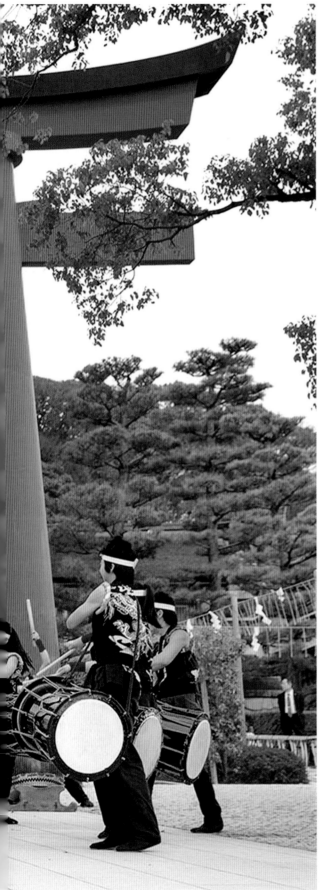

◄ Michelle Obama playing with Taiko drummers before touring the Fushimi Inari Shinto Shrine in Kyoto, Japan, March 2015. ▲ Practicing tai chi with students from Chengdu No. 7 High School in China, March 2014. ▼ On a visit to the Xi'an City Wall in China, March 2014.

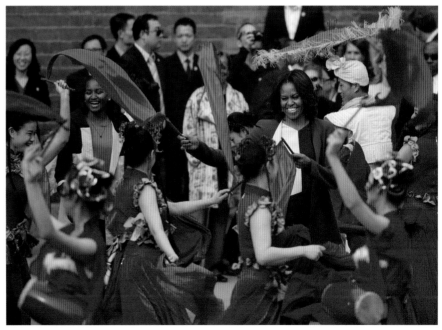

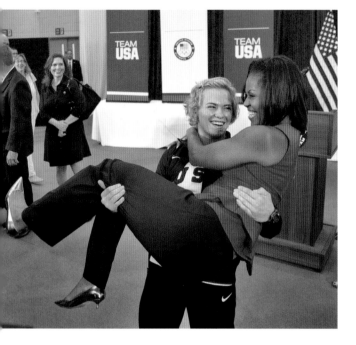

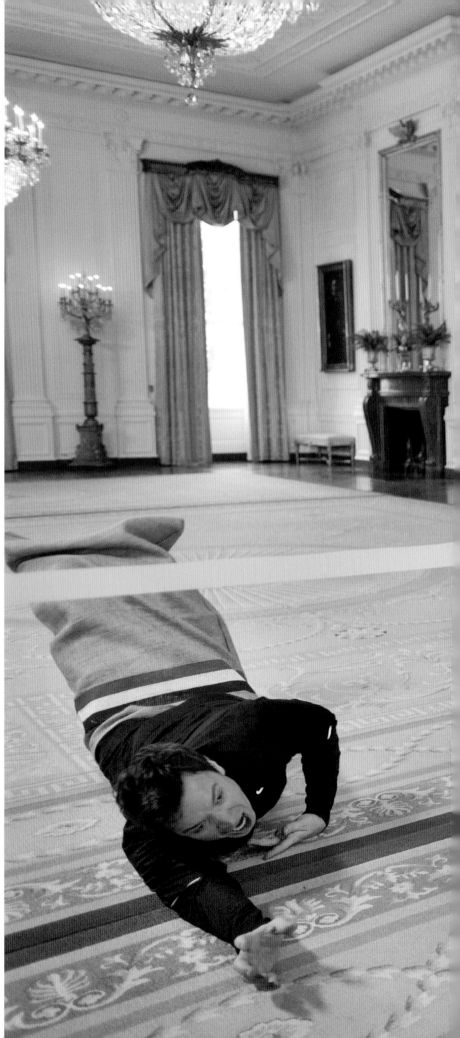

▲ U.S. Olympic wrestler Elena Pirozhkova giving the
First Lady a demonstration of her strength during
a meet-and-greet with Team USA Olympic athletes
competing in the 2012 Summer Olympic Games.
▶ Jimmy Fallon vs. Michelle Obama in a potato sack
race in the East Room of the White House during a *Late
Night with Jimmy Fallon* taping celebrating the second
anniversary of the Let's Move! initiative, January 2012.

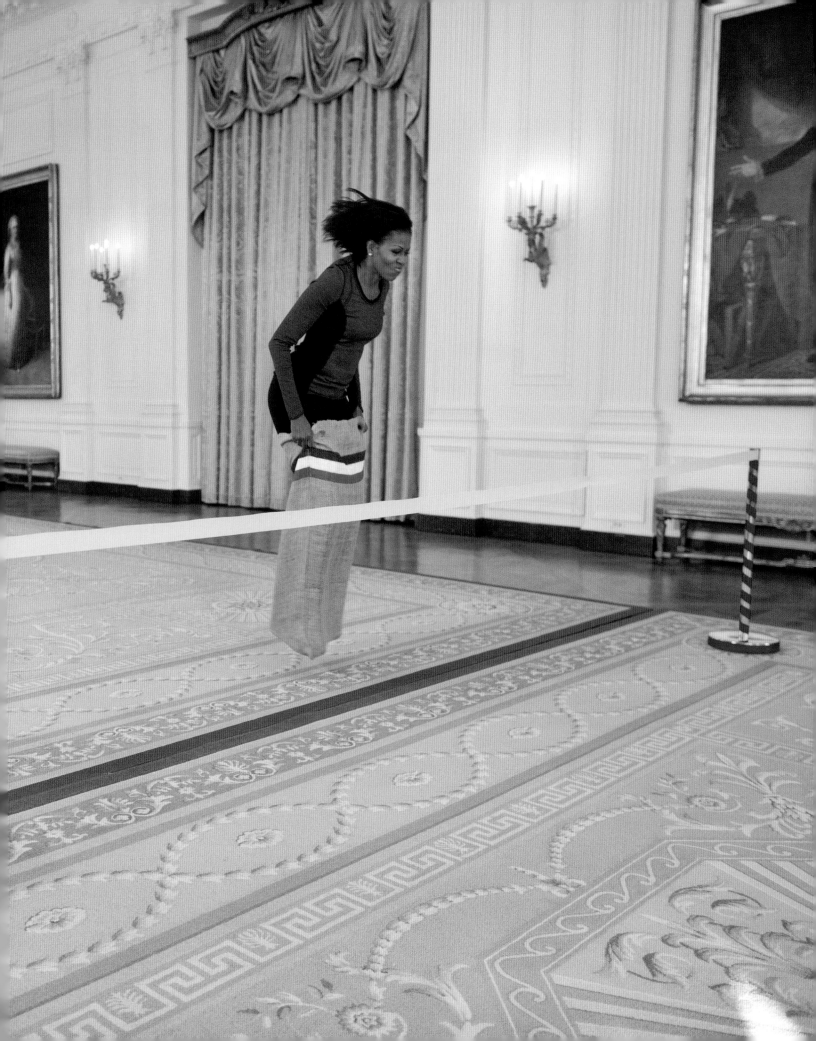

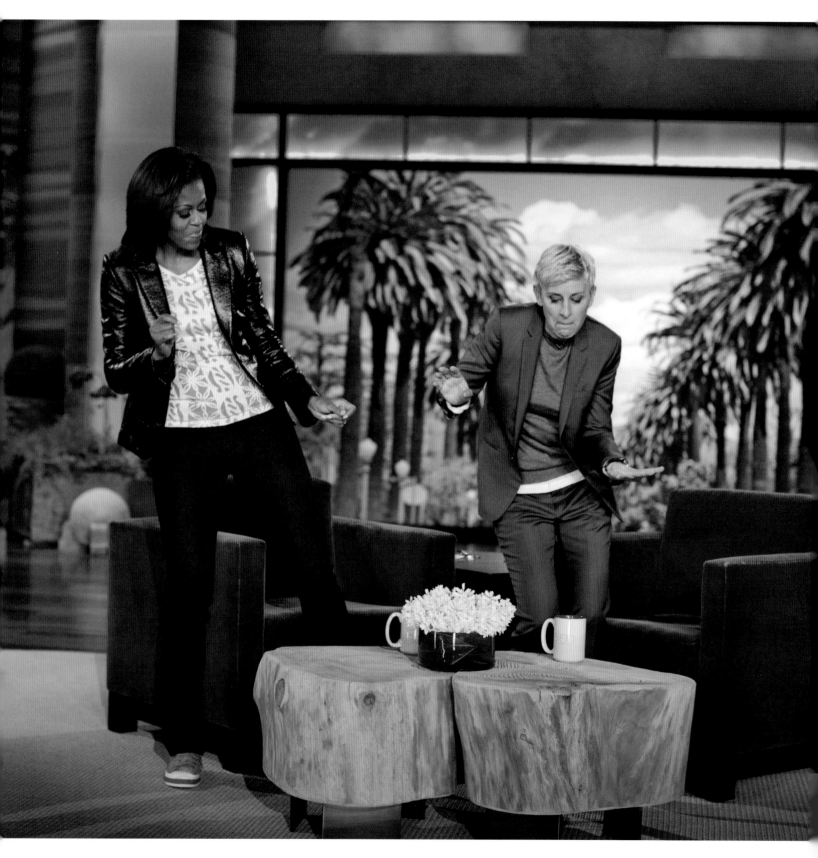

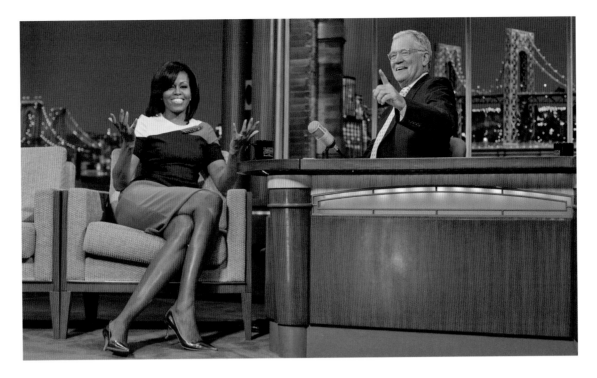

◄ Dancing with Ellen on *The Ellen DeGeneres Show* to mark the second anniversary of the Let's Move! initiative, 2012. ▲ An interview with David Letterman in New York, 2012. ▼ With Kelly Ripa and Michael Strahan on *Live! with Kelly and Michael*, October 2012.

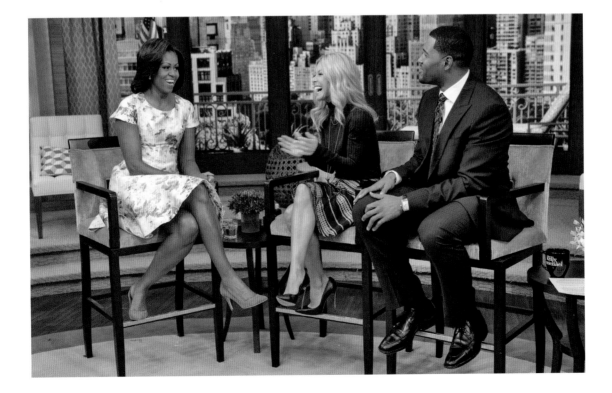

▲ Balloon artist and Guinness Book of World Records holder John Cassidy sharing his craft with the First Lady in the Diplomatic Reception Room following a Let's Move! event, 2011. ▶ Michelle Obama with (from left to right) singers John Legend and Smokey Robinson, Motown founder Berry Gordy, and Grammy Museum Executive Director Bob Santelli at the Motown Music Series student workshop, 2011. ▼ Posing for a selfie with Ryan Seacrest after taping a Let's Move! interview, 2014.

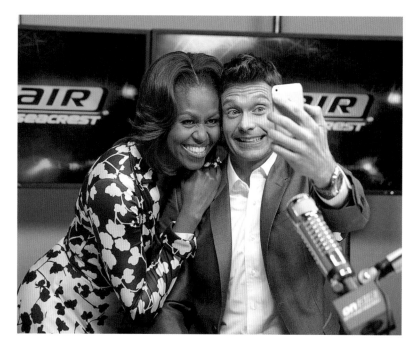

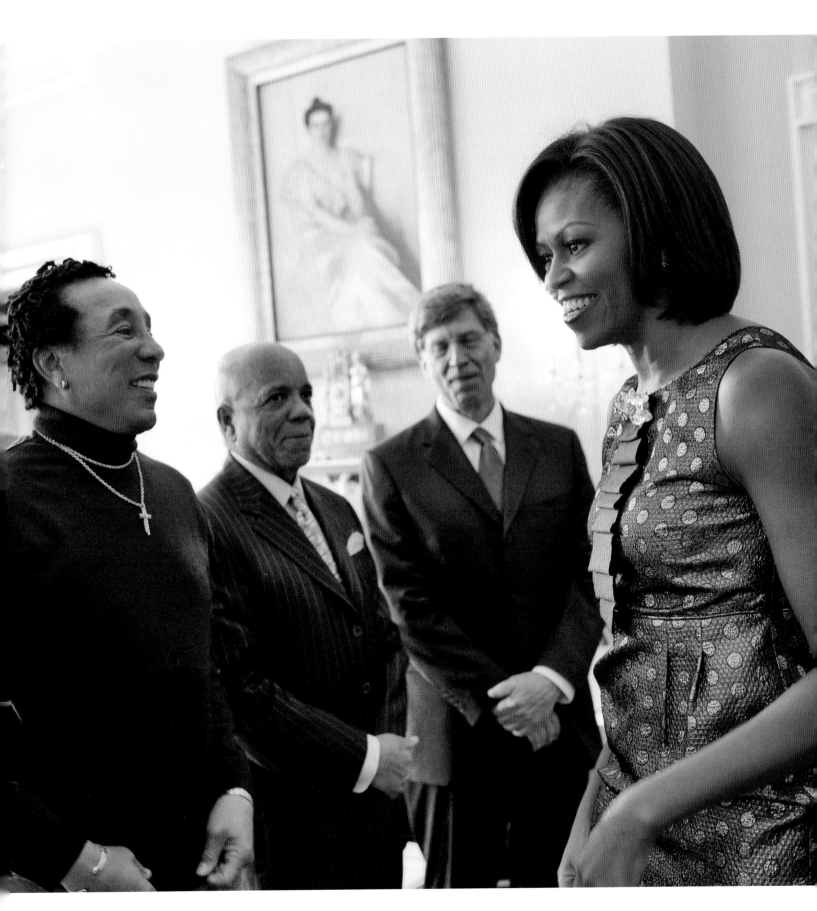

REACHING
HIGHER

> "If kids aren't getting adequate nutrition, even the best textbooks and teachers in the world won't help them learn."
>
> —MICHELLE OBAMA

IN EIGHT YEARS, Michelle Obama impacted the lives of millions of children with initiatives to end childhood obesity, make healthy food mainstream, improve education, and inspire girls to achieve. She made substantial food-policy changes for children and adults by revamping the outdated "food pyramid," championing a law that made school lunches healthier, and convincing food and beverage manufacturers to cut back a whopping 6.4 trillion calories from the American food supply. As a wartime first lady, she worked to help solve some of the most pressing challenges facing our veterans, including homelessness. And as one of the most moving public speakers of our time, she became a powerful role model for women, particularly working mothers, and used her platform to speak out about being black in America.

(Previous page) Michelle Obama speaks at a student workshop titled At the Crossroads—A History of the Blues in America, below a portrait of Abraham Lincoln, February 2012. ◄ Talking about healthy snacks with children at a La Petite Academy child care center in Bowie, Maryland, February 2014.

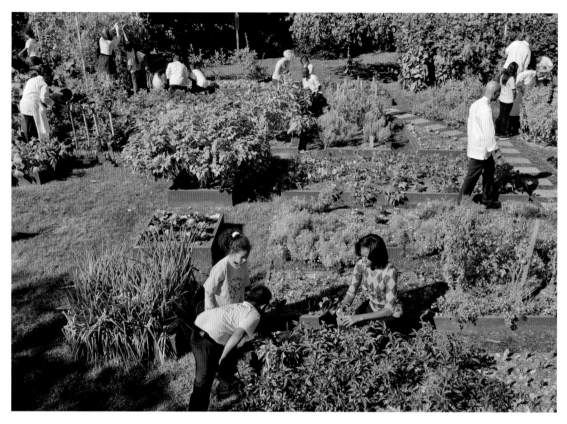

"Our experience with children in the garden is about much more than just planting seeds and harvesting vegetables. Invariably, as we bend down and dig in the soil with the children, we start talking—about our lives and theirs."

—MICHELLE OBAMA

▲ Harvesting vegetables with students from Bancroft and Tubman Elementary Schools during the third annual White House Kitchen Garden fall harvest on the South Lawn, October 2011. ▶ Children from the Bancroft school help the First Lady plant the White House Vegetable Garden, April 2009.

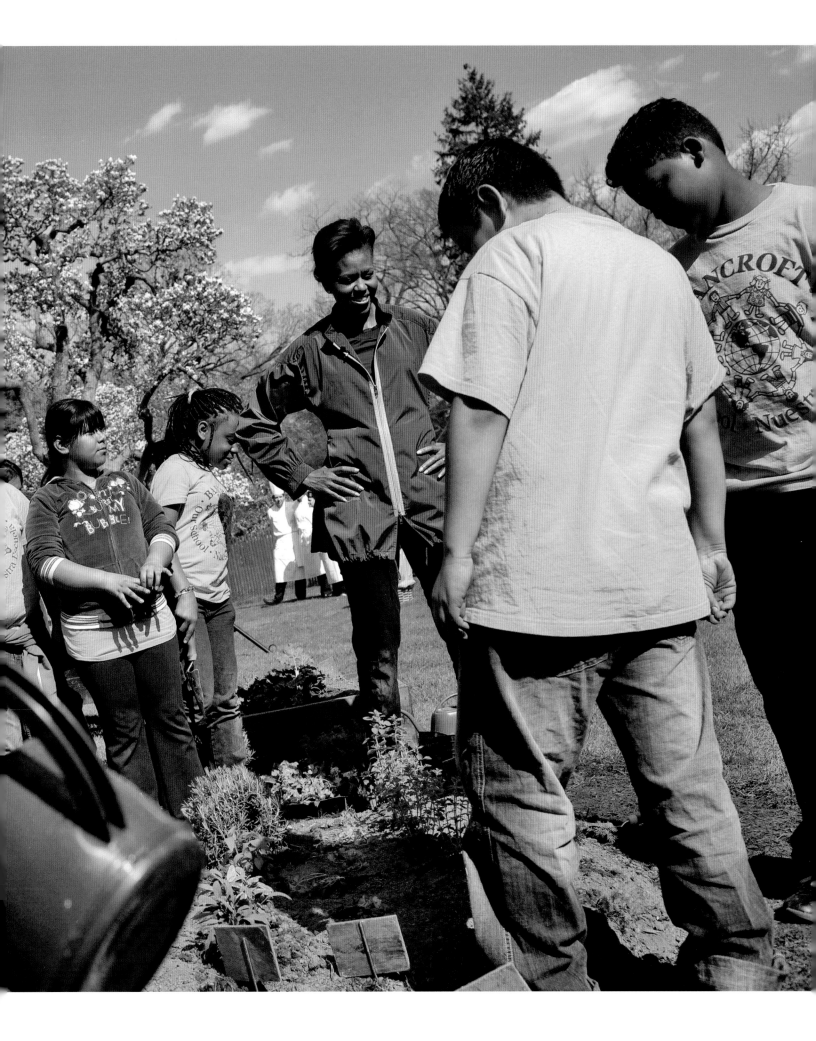

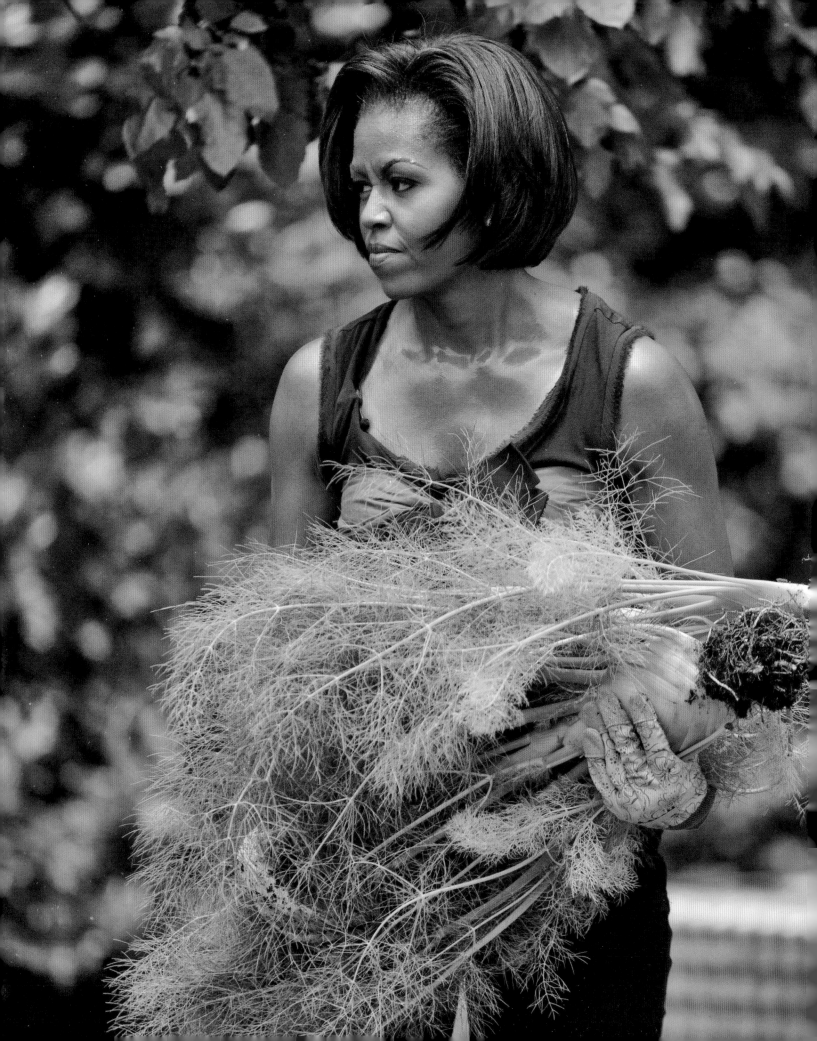

" I've always felt a deep sense of obligation to make the biggest impact possible with this incredible platform. So I took

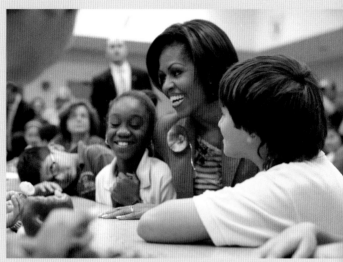

on issues that were personal to me. . . . And I decided to tackle them in the way that felt most authentic to me—in a way that was both substantive and strategic, but also fun and, hopefully, inspiring. "

—MICHELLE OBAMA

◀ The First Lady harvesting fresh vegetables during a Let's Move! chef event on the South Lawn of the White House, 2010. ◀ With students at Riverside Elementary School in Miami for a Let's Move! Salad Bars to Schools event, November 22, 2010.

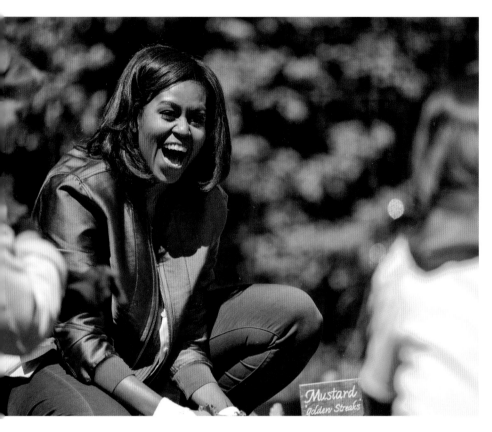

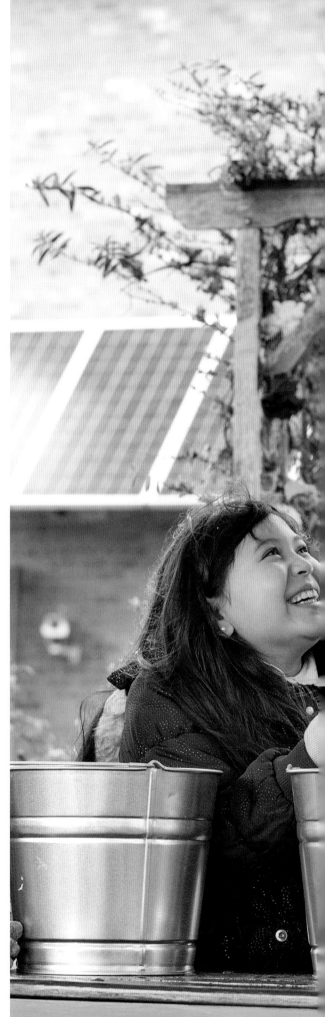

THE First Lady launched Let's Move! to solve the problem of childhood obesity in a generation. Facing down the fact that nearly one in three American children are overweight or obese, she formed alliances with a wide range of organizations and businesses to design programs around healthy eating and exercise.

▲ Students help the First Lady plant the White House kitchen garden using vegetables grown on the International Space Station, 2016. ▶ Discussing the importance of the earthworm and composting with youngsters from Philip's Academy Charter School in Newark, New Jersey, 2016. (Following pages) Making Mother's Day gifts in the State Dining Room of the White House, May 10, 2012.

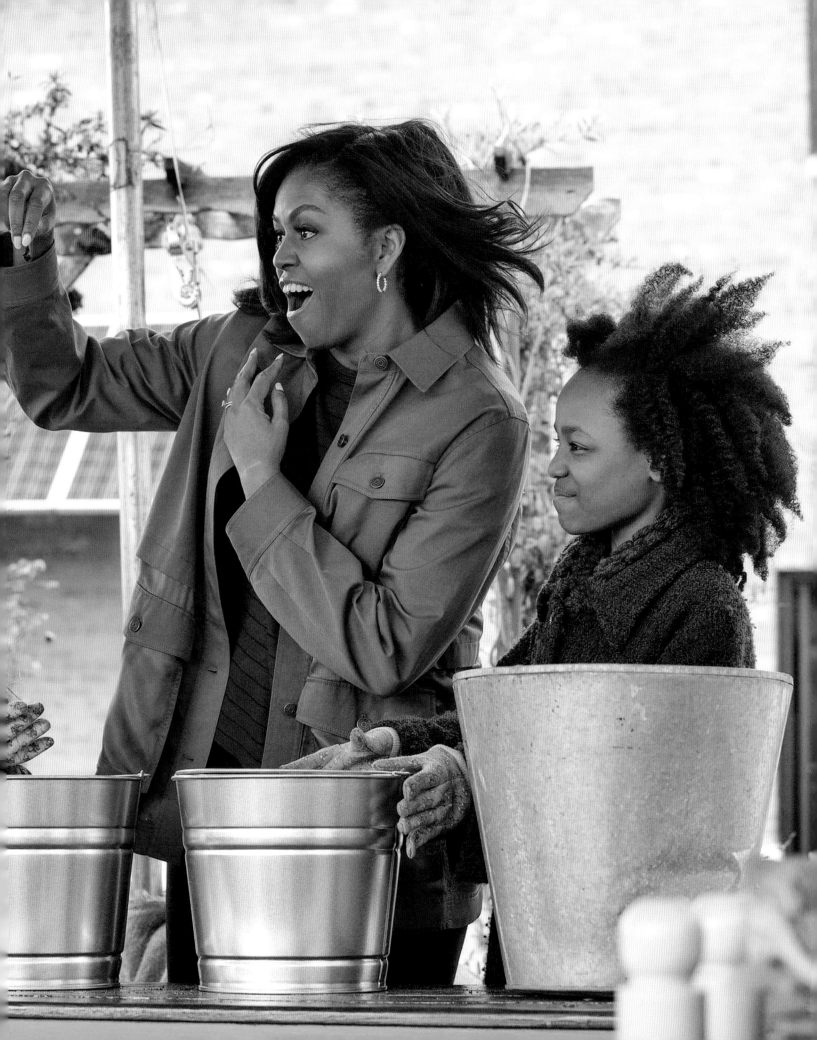

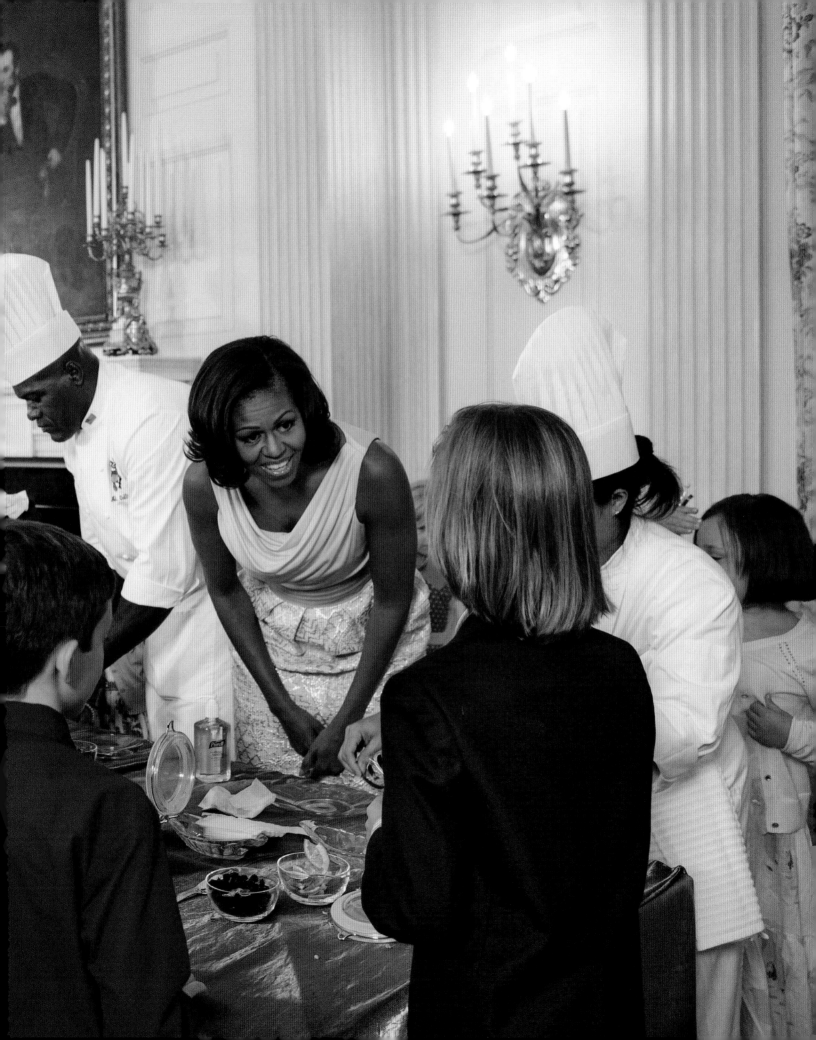

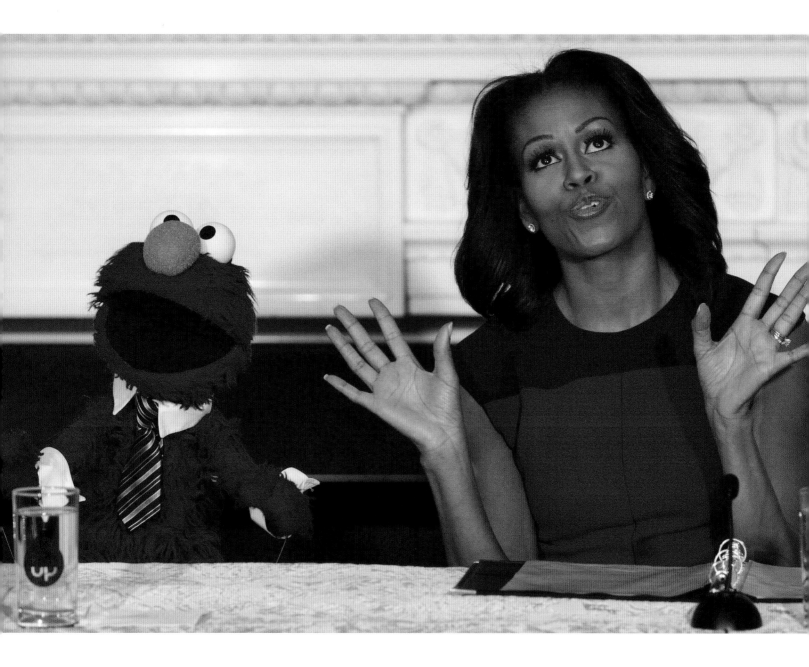

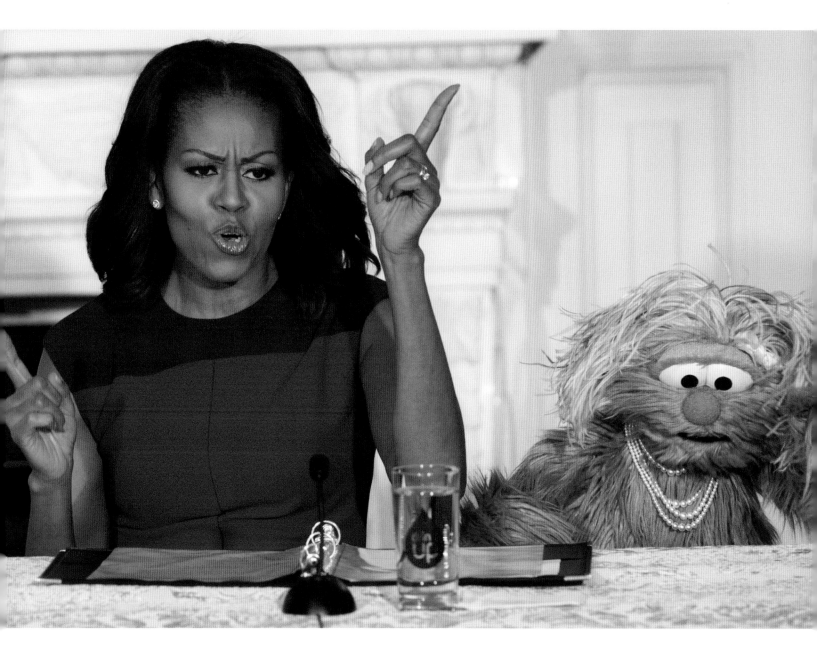

Dancing alongside *Sesame Street* characters Elmo (left) and Rosita (right) during an event promoting fresh fruit and vegetables as part of the Let's Move! initiative in the State Dining Room of the White House, October 2013.

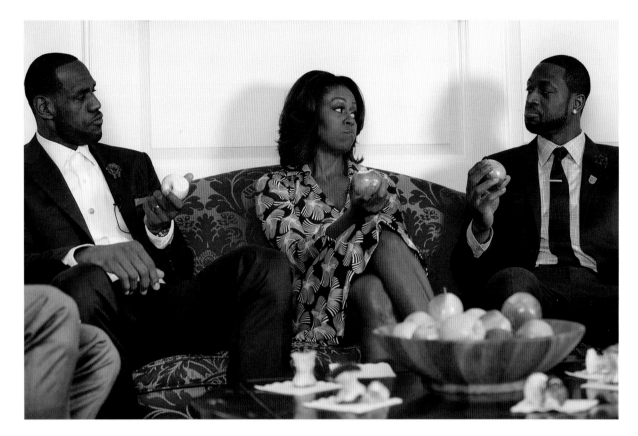

▲ With Miami Heat players—and 2013 NBA Champions—LeBron James (left) and Dwyane Wade taping a Let's Move! public service announcement in the Map Room of the White House. ◄ Dallas Cowboy football players (left to right) Miles Austin, DeMarcus Ware, and Felix Jones join the First Lady for the "Schools and Chefs Working Together" cooking competition to help promote the Let's Move! initiative, February 2012. ▶ Saying hello as she promotes her Fresh Food Financing Initiative at the Fresh Grocer store in Philadelphia, 2010.

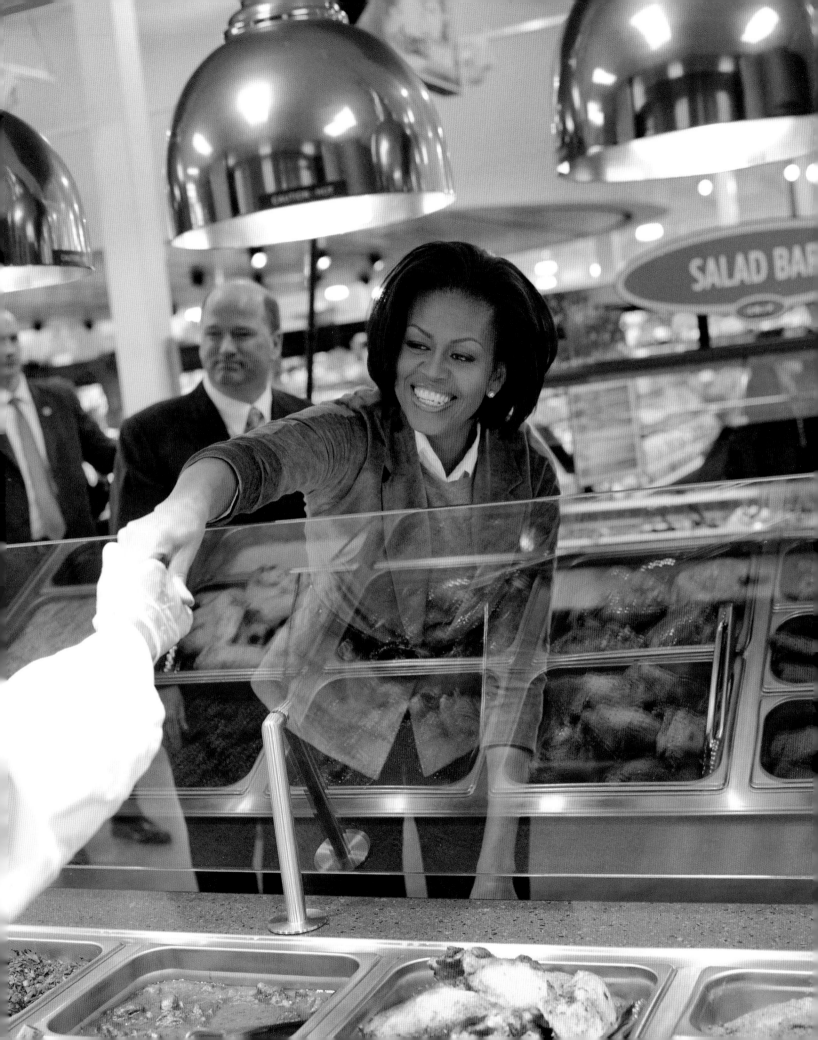

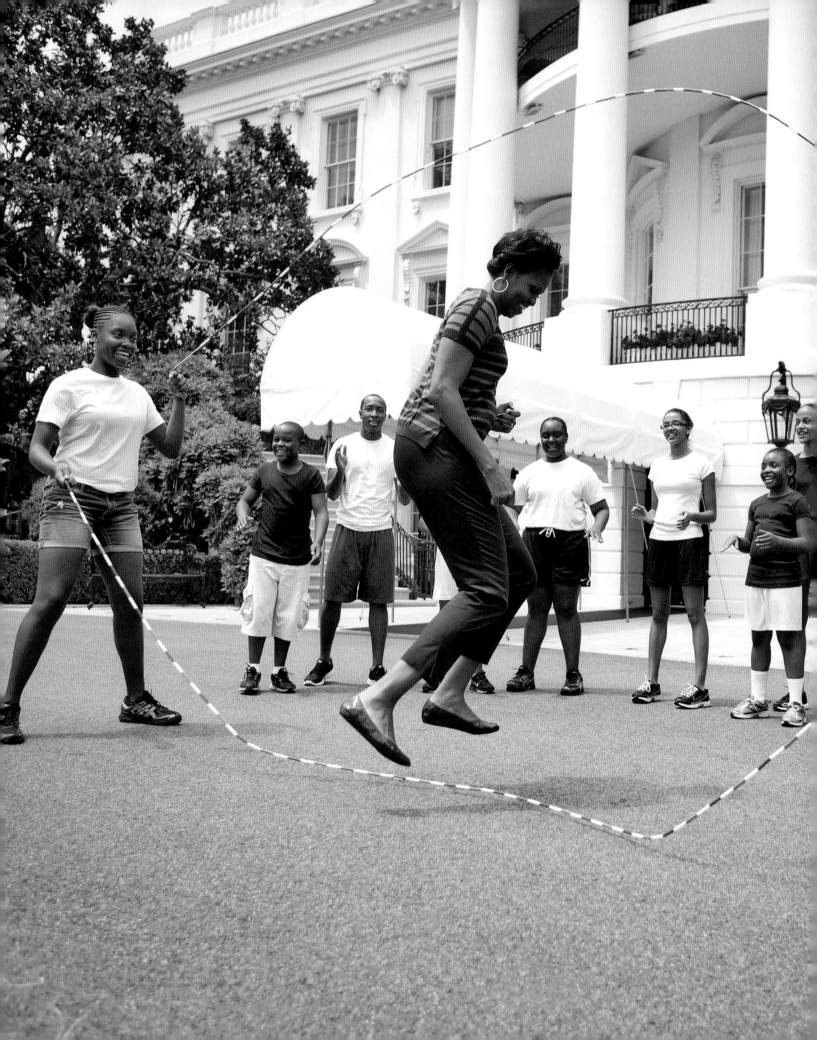

"In the end, as First Lady, this isn't just a policy issue for me. This is a passion. This is my mission. I am determined to work with folks across this country to change the way a generation of kids thinks about food and physical activity."

—MICHELLE OBAMA

◀ Showing off her double-dutch skills on the South Lawn of the White House during a taping for the Let's Move! Presidential Active Lifestyle Award challenge and Nickelodeon's Worldwide Day of Play, July 15, 2011.

109

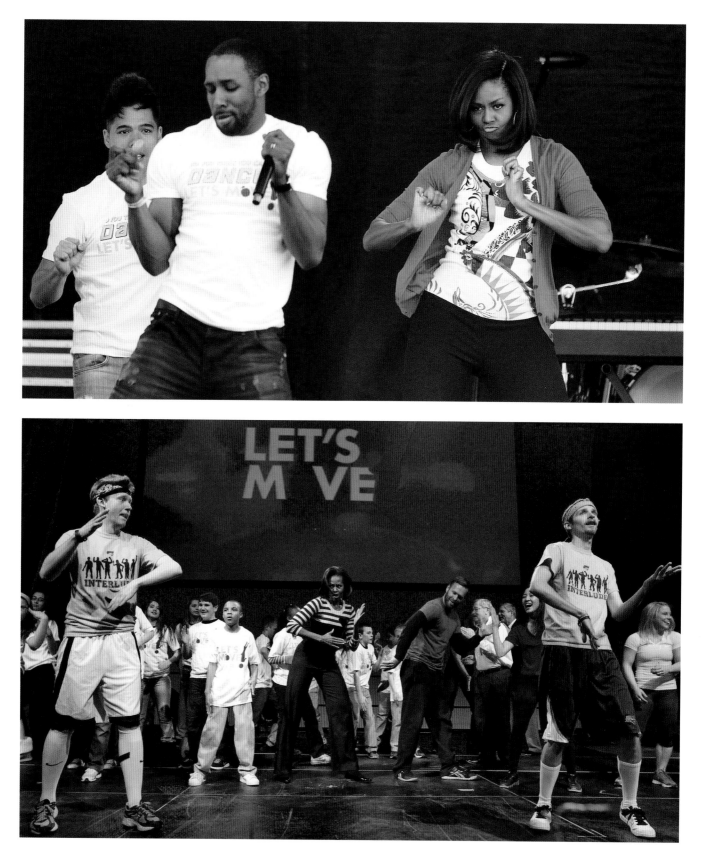

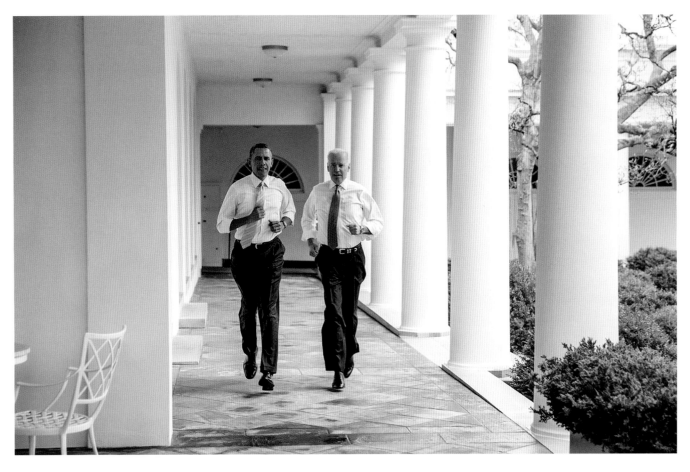

▽ Dancing with members of the All-Stars from the television show *So You Think You Can Dance* during the 137th annual White House Easter Egg Roll, 2015. ◁ Performing the Interlude Dance during an event highlighting her Let's Move! initiative in Des Moines, Iowa, February 2012. ▲▷ President Barack Obama and Vice President Joe Biden participate in a "Let's Move!" videotaping on the Colonnade of the White House, February 2014. (Following pages) The First Lady getting physical with local schoolchildren on the South Lawn of the White House, 2010.

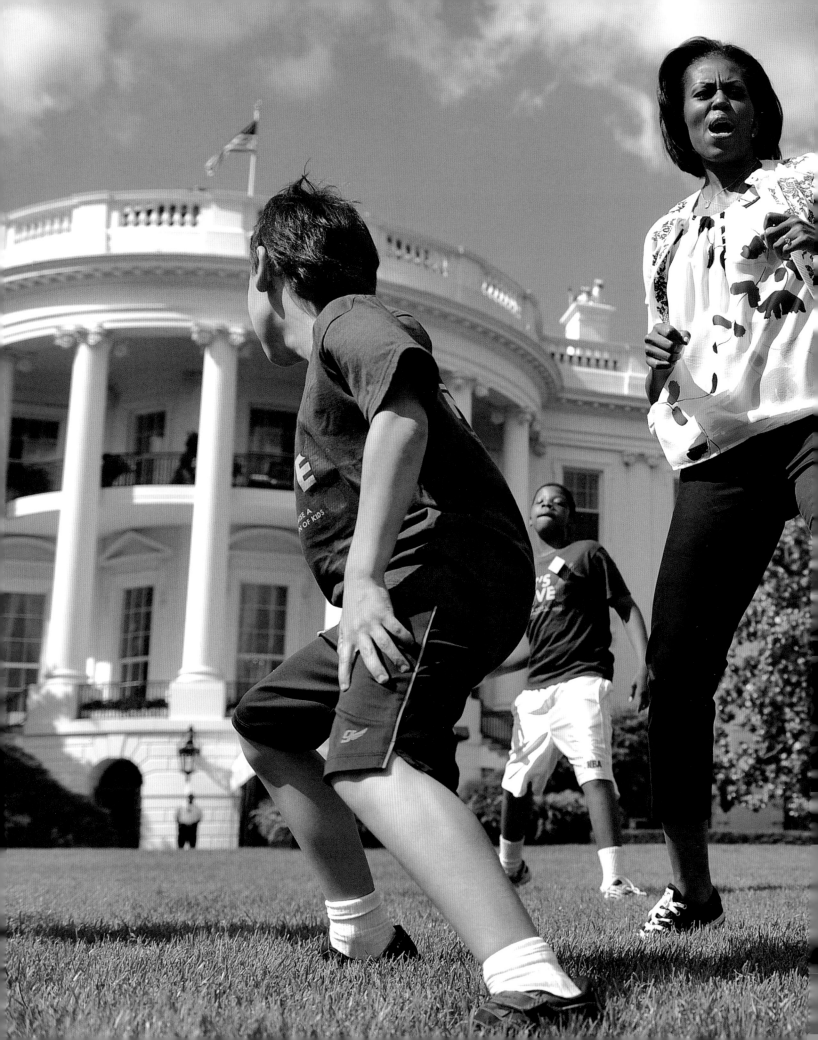

"I've always been a closet jock. With exercising, the more you do it, the more you get into it. And the more you see results, the more you're pushing for the next level."
—MICHELLE OBAMA

REMARKS BY THE FIRST LADY AT THE
LET'S MOVE! LAUNCH [abridged]

State Dining Room, the White House
Washington, D.C.
February 9, 2010

WE'RE HERE TODAY because we care deeply about the health and well-being of these kids and kids like them all across the country. And we're determined to finally take on one of the most serious threats to their future: the epidemic of childhood obesity in America today—an issue that's of great concern to me not just as a first lady, but as a mom.

Often, when we talk about this issue, we begin by citing sobering statistics like the ones you've heard today—that over the past three decades, childhood obesity rates in America have tripled; that nearly one-third of children in America are now overweight or obese—one in three.

But these numbers don't paint the full picture. These words—"overweight" and "obese"—they don't tell the full story. This isn't just about inches and pounds or how our kids look. It's about how our kids feel, and how they feel about themselves. It's about the impact we're seeing on every aspect of their lives.

Pediatricians like Dr. Palfrey are seeing kids with high blood pressure and high cholesterol—even Type 2 diabetes, which they used to see only in adults. Teachers see the teasing and bullying; school counselors see the depression and low self-esteem; and coaches see kids struggling to keep up, or stuck on the sidelines.

Military leaders report that obesity is now one of the most common disqualifiers for military service. Economic experts tell us that we're spending outrageous amounts of money treating obesity-related conditions like diabetes, heart disease, and cancer. And public health experts tell us that the current generation could actually be on track to have a shorter life span than their parents.

None of us wants this kind of future for our kids—or for our country. So instead of just talking about this problem, instead of just worrying and wringing our hands about it, let's do something about it. Let's act . . . let's move.

Let's move to help families and communities make healthier decisions for their kids. Let's move to bring together governors and mayors, doctors and nurses, businesses, community groups,

"It wasn't that long ago that I was a working mom, struggling to balance meetings and deadlines. . . . And there were some nights when everyone was tired and hungry, and we just went to the drive-thru because it was quick and cheap, or went with one of the less healthy microwave options, because it was easy."

educators, athletes, moms and dads to tackle this challenge once and for all. And that's why we're here today—to launch "Let's Move"—a campaign that will rally our nation to achieve a single, ambitious goal: solving the problem of childhood obesity in a generation, so that children born today will reach adulthood at a healthy weight.

But to get where we want to go, we need to first understand how we got here. So let me ask the adults here today to close your eyes and think back for a moment . . . think back to a time when we were growing up.

Like many of you, when I was young, we walked to school every day, rain or shine—and in Chicago, we did it in wind, sleet, hail, and snow too. Remember how, at school, we had recess twice a day and gym class twice a week, and we spent hours running around outside when school got out. You didn't go inside until dinner was ready—and when it was, we would gather around the table for dinner as a family. And there was one simple rule: you ate what Mom fixed—good, bad, or ugly. Kids had absolutely no say in what they felt like eating. If you didn't like it, you were welcome to go to bed hungry. Back then, fast food was a treat, and dessert was mainly a Sunday affair.

In my home, we weren't rich. The foods we ate weren't fancy. But there was always a vegetable on the plate. And we managed to lead a pretty healthy life.

Many kids today aren't so fortunate. Urban sprawl and fears about safety often mean the only walking they do is out their front door to a bus or a car. Cuts in recess and gym mean a lot less running around during the school day, and lunchtime may mean a school lunch heavy on calories and fat. For many kids, those afternoons spent riding bikes and playing ball until dusk have been replaced by afternoons inside with TV, the Internet, and video games.

And these days, with parents working longer hours, working two jobs, they don't have time for those family dinners. Or with the

115

price of fresh fruits and vegetables rising 50 percent higher than overall food costs these past two decades, they don't have the money. Or they don't have a supermarket in their community, so their best option for dinner is something from the shelf of the local convenience store or gas station.

So many parents desperately want to do the right thing, but they feel like the deck is stacked against them. They know their kids' health is their responsibility—but they feel like it's out of their control. They're being bombarded by contradictory information at every turn, and they don't know who or what to believe. The result is a lot of guilt and anxiety—and a sense that no matter what they do, it won't be right, and it won't be enough.

I know what that feels like. I've been there. While today I'm blessed with more help and support than I ever dreamed of, I didn't always live in the White House.

It wasn't that long ago that I was a working mom, struggling to balance meetings and deadlines with soccer and ballet. And there were some nights when everyone was tired and hungry, and we just went to the drive-thru because it was quick and cheap, or went with one of the less healthy microwave options, because it was easy. And one day, my pediatrician pulled me aside and told me, "You might want to think about doing things a little bit differently."

That was a moment of truth for me. It was a wake-up call that I was the one in charge, even if it didn't always feel that way.

And today, it's time for a moment of truth for our country; it's time we all had a wake-up call. It's time for us to be honest with ourselves about how we got here. Our kids didn't do this to themselves. Our kids don't decide what's served to them at school or whether there's time for gym class or recess. Our kids don't choose to make food products with tons of sugar and sodium in supersized portions, and then to have those products marketed to them everywhere they turn. And no matter how much they beg for pizza, fries, and candy, ultimately, they are not, and should not, be the ones calling the shots at dinnertime. We're in charge. We make these decisions.

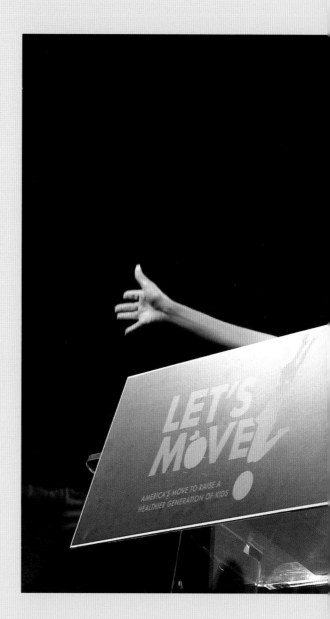

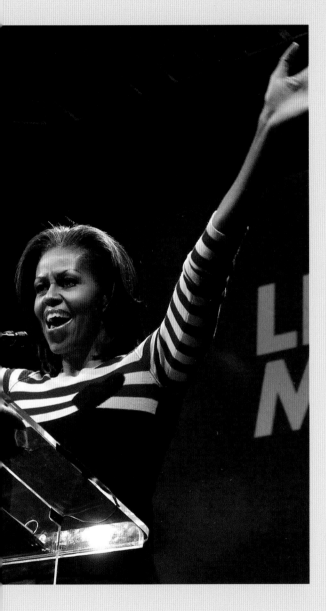

▲ Celebrating the second anniversary of Let's Move! in Des Moines, Iowa, February 2012.

But that's actually the good news here. If we're the ones who make the decisions, then we can decide to solve this problem. And when I say "we," I'm not just talking about folks here in Washington. This isn't about politics. There's nothing Democratic or Republican, liberal or conservative, about doing what's best for our kids. And I've spoken with many experts about this issue, and not a single one has said that the solution is to have government tell people what to do. Instead, I'm talking about what we can do. I'm talking about commonsense steps we can take in our families and communities to help our kids lead active, healthy lives.

This isn't about trying to turn the clock back to when we were kids, or preparing five-course meals from scratch every night. No one has time for that. And it's not about being 100 percent perfect 100 percent of the time. Lord knows I'm not. There's a place for cookies and ice cream, burgers and fries—that's part of the fun of childhood.

Often, it's just about balance. It's about small changes that add up—like walking to school, replacing soda with water or skim milk, trimming those portion sizes a little—things like this can mean the difference between being healthy and fit or not.

There's no one-size-fits-all solution here. Instead, it's about families making manageable changes that fit with their schedules, their budgets, and their needs and tastes.

And it's about communities working to support these efforts. Mayors like Mayors Johnson and Curtatone, who are building sidewalks, parks, and community gardens. Athletes and role models like Tiki Barber, who are building playgrounds to help kids stay active. Community leaders like Will Allen, who are bringing farmers' markets to underserved areas. Companies like the food industry leaders, who came together last fall and acknowledged their responsibility to be part of the solution. But there's so much more to do.

And that's the mission of Let's Move!—to create a wave of efforts across this country that get us to our goal of solving childhood obesity in a generation.

We kicked off this initiative this morning when my husband signed a presidential memorandum establishing the first ever government-wide Task Force on Childhood Obesity. The task force is composed of representatives from key agencies—including many who are here today. Over the next 90 days, these folks will review every program and policy relating to child nutrition and physical activity. And they'll develop an action plan marshaling these resources to meet our goal. And to ensure we're continuously on track to do so, the Task Force will set concrete benchmarks to measure our progress.

But we can't wait 90 days to get going here. So let's move right now, starting today, on a series of initiatives to help achieve our goal.

First, let's move to offer parents the tools and information they need—and that they've been asking for—to make healthy choices for their kids. We've been working with the FDA and several manufacturers and retailers to make our food labels more customer-friendly, so people don't have to spend hours squinting at words they can't pronounce to figure out whether the food they're buying is healthy or not. In fact, just today, the nation's largest beverage companies announced that they'll be taking steps to provide clearly visible information about calories on the front of their products—as well as on vending machines and soda fountains. This is exactly the kind of vital information parents need to make good choices for their kids.

We're also working with the American Academy of Pediatrics, supporting their groundbreaking efforts to ensure that doctors not only regularly measure children's BMI, but actually write out a prescription detailing steps parents can take to keep their kids healthy and fit.

In addition, we're working with the Walt Disney Company, NBC Universal, and Viacom to launch a nationwide public awareness campaign educating parents and children about how to fight childhood obesity.

And we're creating a one-stop shopping website—LetsMove. gov—so with the click of a mouse, parents can find helpful tips and

"... what we don't want is a situation where parents are taking all the right steps at home—and then their kids undo all that work with salty, fatty food in the school cafeteria."

step-by-step strategies, including healthy recipes, exercise plans, and charts they can use to track their family's progress.

But let's remember: 31 million American children participate in federal school meal programs—and many of these kids consume as many as half their daily calories at school. And what we don't want is a situation where parents are taking all the right steps at home—and then their kids undo all that work with salty, fatty food in the school cafeteria.

So let's move to get healthier food into our nation's schools. That's the second part of this initiative. We'll start by updating and strengthening the Child Nutrition Act—the law that sets nutrition standards for what our kids eat at school. And we've proposed an historic investment of an additional $10 billion over ten years to fund that legislation.

With this new investment, we'll knock down barriers that keep families from participating in school meal programs and serve an additional one million students in the first five years alone. And we'll dramatically improve the quality of the food we offer in schools—including in school vending machines. We'll take away some of the empty calories, and add more fresh fruits and vegetables and other nutritious options.

We also plan to double the number of schools in the HealthierUS School Challenge—an innovative program that recognizes schools doing the very best work to keep kids healthy—from providing healthy school meals to requiring physical education classes each week. To help us meet that goal, I'm thrilled to announce that for the very first time, several major school food suppliers have come together and committed to decrease sugar, fat, and salt; increase whole grains; and double the fresh produce in the school meals they serve. And also for the first time, food service workers—along with principals, superintendents, and school board members across America—are coming together to support these efforts. With these commitments, we'll reach just about every schoolchild in this country with better information and more nutritious meals to put them on track to a healthier life.

"I'm thrilled to announce that for the very first time, several major school food suppliers have come together and committed to decrease sugar, fat, and salt; increase whole grains; and double the fresh produce in the school meals they serve."

These are major steps forward. But let's not forget about the rest of the calories kids consume—the ones they eat outside of school, often at home, in their neighborhoods. And when 23.5 million Americans, including 6.5 million American children, live in "food deserts"—communities without a supermarket—those calories are too often empty ones. You can see these areas in dark purple in the new USDA Food Environment Atlas we're unveiling today. This atlas maps out everything from diabetes and obesity rates across the country to the food deserts you see on this screen.

So let's move to ensure that all our families have access to healthy, affordable food in their communities. That's the third part of this initiative. Today, for the very first time, we're making a commitment to eliminate food deserts in America—and we plan to do so within seven years. Now, we know this is ambitious. And it will take a serious commitment from both government and the private sector. That's why we plan to invest $400 million a year in a Healthy Food Financing initiative that will bring grocery stores to underserved areas and help places like convenience stores carry healthier food options. And this initiative won't just help families eat better; it will help create jobs and revitalize neighborhoods across America.

But we know that eating right is only part of the battle. Experts recommend that children get 60 minutes of active play each day. If this sounds like a lot, consider this: kids today spend an average of seven and a half hours a day watching TV, and playing with cell phones, computers, and video games. And only a third of high school students get the recommended levels of physical activity.

So let's move. And I mean that literally. Let's find new ways for kids to be physically active, both in and out of school. That's the fourth, and final, part of this initiative. . . .

So this is a pretty serious effort. And I know that in these challenging times for our country, there are those who will wonder whether this should really be a priority. They might view things like healthy school lunches and physical fitness challenges as "extras"—as things we spring for once we've taken care of the necessities. . . .

▼ One of seven activity stations the First Lady visited during a President's Council on Fitness, Sports and Nutrition event held on the South Lawn of the White House, 2011.

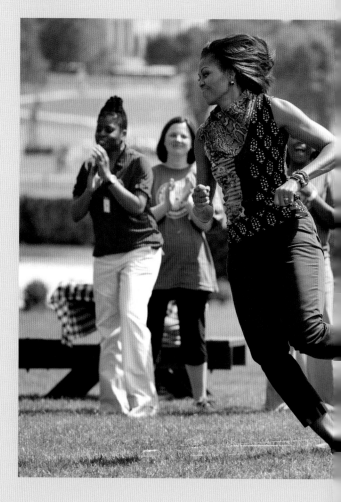

> "Rarely in the history of this country have we encountered a problem of such magnitude and consequence that is so eminently solvable. So let's move to solve it."

But when you step back and think about it, you realize—these are false choices. If kids aren't getting adequate nutrition, even the best textbooks and teachers in the world won't help them learn. If they don't have safe places to run and play, and they wind up with obesity-related conditions, then those health care costs will just keep rising. . . .

In the end, we know that solving our obesity challenge won't be easy—and it certainly won't be quick. But make no mistake about it, this problem can be solved.

This isn't like a disease where we're still waiting for the cure to be discovered—we know the cure for this. This isn't like putting a man on the moon or inventing the Internet—it doesn't take some stroke of genius or feat of technology. We have everything we need, right now, to help our kids lead healthy lives. Rarely in the history of this country have we encountered a problem of such magnitude and consequence that is so eminently solvable. So let's move to solve it.

I don't want our kids to live diminished lives because we failed to step up today. I don't want them looking back decades from now and asking us, Why didn't you help us when you had a chance? Why didn't you put us first when it mattered most?

So much of what we all want for our kids isn't within our control. We want them to succeed in everything they do. We want to protect them from every hardship and spare them from every mistake. But we know we can't do all of that. What we can do . . . what is fully within our control . . . is to give them the very best start in their journeys. What we can do is give them advantages early in life that will stay with them long after we're gone. As President Franklin Roosevelt once put it: "We cannot always build the future for our youth, but we can build our youth for the future."

That is our obligation, not just as parents who love our kids, but as citizens who love this country. So let's move. Let's get this done. Let's give our kids what they need to have the future they deserve.

Thank you so much.

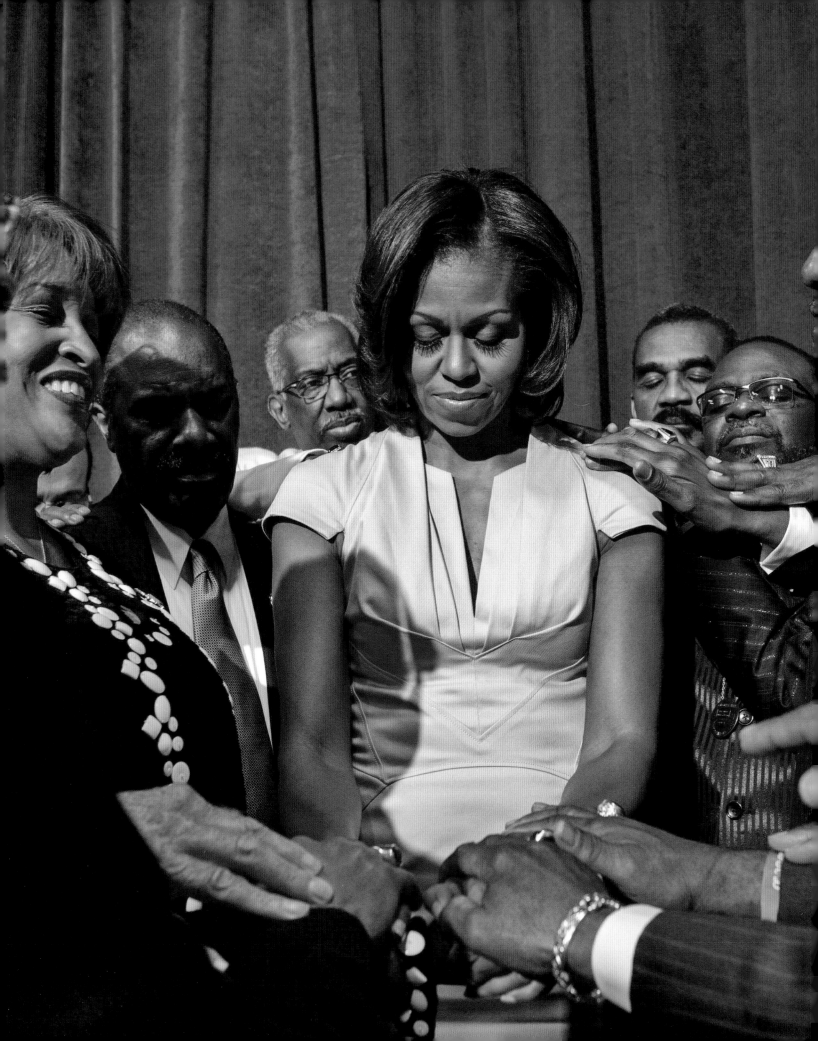

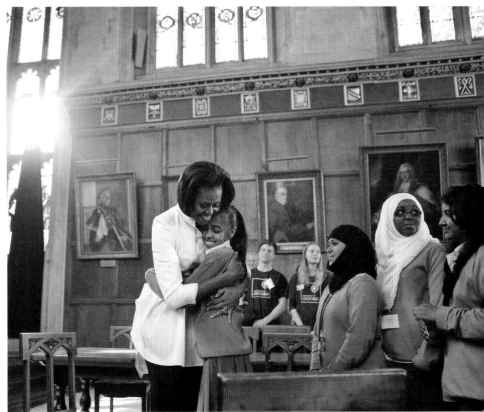

MICHELLE Obama describes her religious roots
as coming from a family with "a strong connection to faith and
religion." Her parents exposed her and her brother, Craig, to
Christian values and beliefs to help guide them into their own faith.
"That is important to me," Michelle said, "and we're trying to give
our girls a basic foundation, understanding, and respect for [a]
higher being . . . because [that's] what I grew up with."

◀ Praying with African Methodist Episcopal Church bishops at the Gaylord Opryland
Resort in Nashville, Tennessee, June 2012. ▲ With students from Elizabeth Garrett
Anderson School during a visit to Christ Church College, Oxford University, England,
2011. (Following pages) In Ocoee, Florida, praying with the Halls family, who were
inspired to replace junk food in their diet with healthier choices, February 2012.

"Educating girls doesn't just transform their life prospects—it transforms the prospects of their families, communities, and nations as well. Studies show that . . . sending more girls to school and into the workforce can boost an entire country's GDP. Educated girls also marry later, have lower rates of infant and maternal mortality, and are more likely to immunize their children and less likely to contract malaria and HIV. That's why. . . . President Obama and I launched Let Girls Learn, an initiative to help adolescent girls worldwide attend school.

—MICHELLE OBAMA

◄ In East London talking about her Let Girls Learn initiative at the Mulberry School for Girls, 2015. ▼ Speaking on the importance of mentoring, at the White House, 2010.

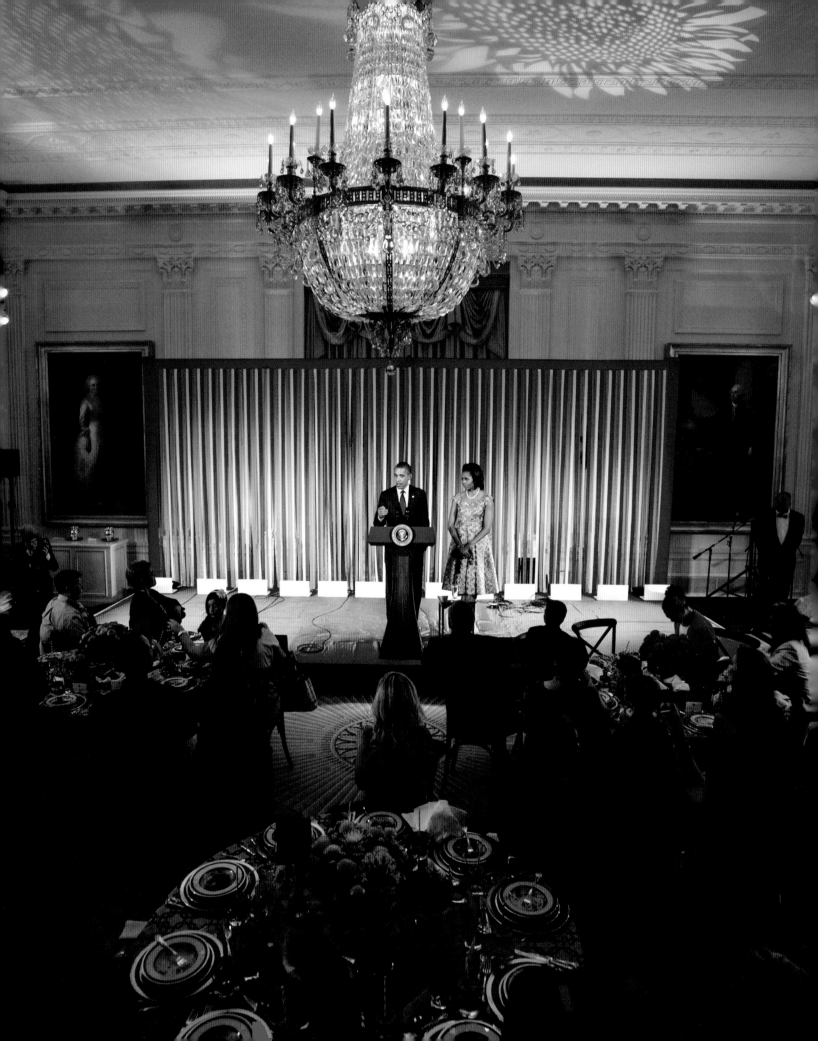

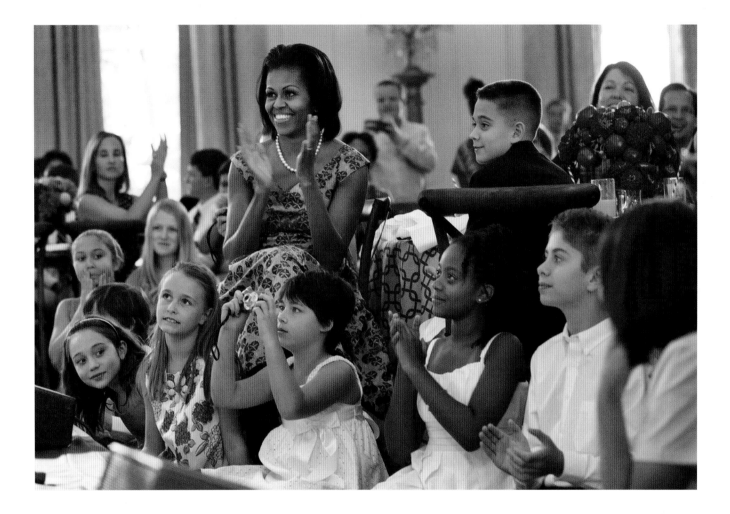

◀ The first ever Kids' "State Dinner," where kids ages 8–12 representing all fifty states, three territories, and the District of Columbia, dined on a selection of healthy recipes in the East Room of the White House, August 2012. ▲ Watching boy band Big Time Rush perform during the Kids' State Dinner.

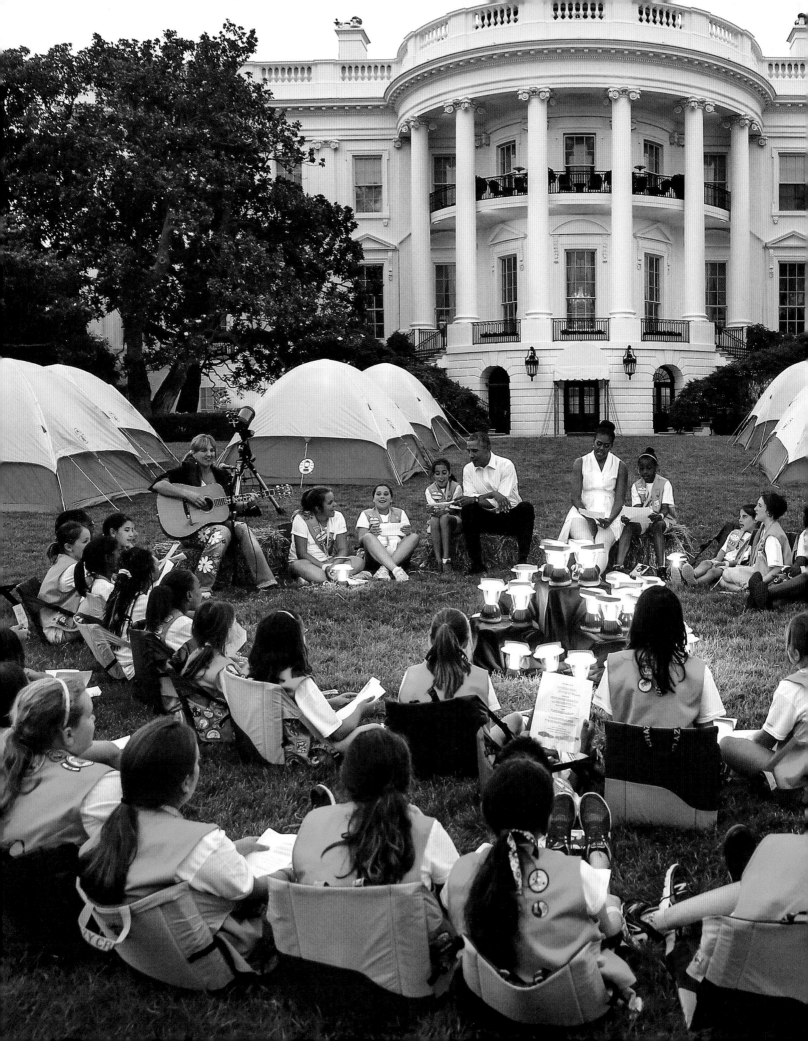

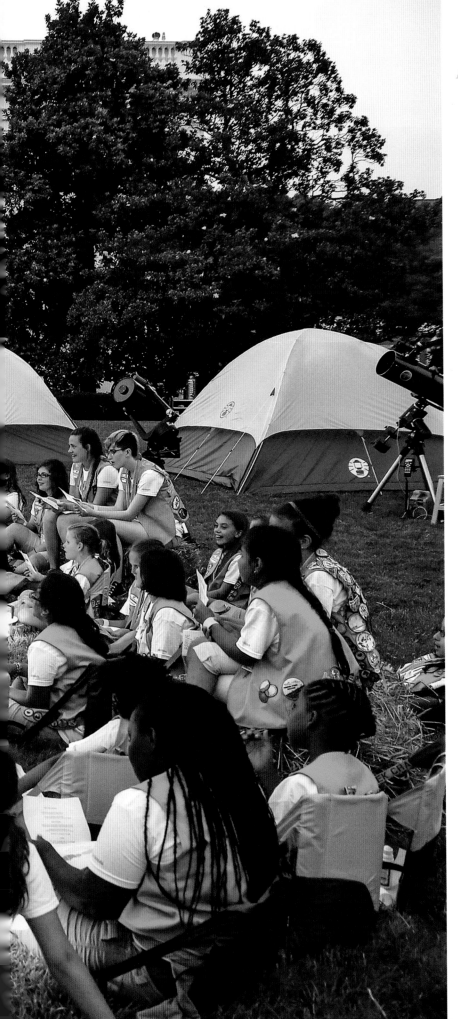

"With every word we utter, with every action we take, we know our kids are watching us. We as parents are their most important role models and . . . Barack and I . . . know that our words and actions matter not just to our girls, but to children across this country."

—MICHELLE OBAMA

◄ Hosting a group of Girl Scouts for a campout on the South Lawn as part of the Let's Move! Outside initiative and the chance to earn the Girls' Choice Outdoor badge, June 2015.

REMARKS BY THE FIRST LADY ANNOUNCING MAYORS CHALLENGE TO END VETERAN HOMELESSNESS [abridged]

East Room, the White House
Washington, D.C.
June 4, 2014

I WANT TO THANK all of you here today—our guests, our mayors, our community leaders; the county and city, federal employees who work day in and day out to repay our debt to our veterans.

Unfortunately, homelessness among our veterans is an issue that we're all too familiar with. Sometimes we see these folks on our way to work or when we're walking our kids home from school. We might pass them—someone as we're strolling through the park sitting on a bench and not even realize that he or she is a veteran. Maybe we say hello, offer to buy a sandwich, but often we just keep on going, rushing off to the next meeting, burying our heads into our smartphones. It's not that we don't care, it's just that we think, well, there's no way we'll ever solve this problem, that's just the way things go.

But that kind of thinking starts to melt away when we better understand the stories of these veterans. The man who lost his arm in Vietnam, and when he and his wife's medical bills kept piling up they lost their home. The Gulf War vet who injured her back and lost her job, and then her house, and spent months on the streets. The Army veteran from the Iraq War who survived cancer, but when she and her two kids were evicted from their home they had nowhere to go. These are just three stories.

Altogether, roughly 58,000 veterans are experiencing homelessness in America today—a number that, fortunately, has fallen sharply in the past few years. But whatever the number, these brave men and women have served this country with courage and grace. Some volunteered to serve; many others were drafted. They went off to faraway jungles and deserts and mountain regions; they saw their best friends fall in ambush, or because of a suicide bomb. Some of them were left wondering why they were the ones who survived.

And after all that, too many of them have come home only to fight a new battle—a battle to keep a roof over their head, a battle

"Tens of thousands of veterans who risked their lives for our country are sleeping in their cars, or in a shelter, or next to a subway vent. We should be horrified because that's not who we are as Americans."

just to have somewhere to go when it rains. Now, I want to be very clear: The vast majority of our veterans return home in good health and good spirits. They go on to build good families, find good jobs. They keep serving this nation in their communities through their congregations and schools and neighborhoods. In fact, the percentage of veterans who are homeless today is actually just 0.3 percent of the total veteran population. But even one homeless veteran is a shame. And the fact that we have 58,000 is a moral outrage. We should all be horrified. Tens of thousands of veterans who risked their lives for our country are sleeping in their cars, or in a shelter, or next to a subway vent. We should be horrified because that's not who we are as Americans. And so we can't just throw up our hands and say that this problem is too big for us. Because the truth is, it's not.

When you break down the numbers, you see that those 58,000 homeless veterans are spread out across all of our cities and states. So even in some of our largest metropolitan areas, we're often only talking about a few hundred people. For example, as of a year and a half ago, New Orleans had a total of 211 homeless veterans, and they've been driving that number down ever since. In Indianapolis, the most recent count of vets still out on the streets was 11.

These numbers are still too high, because any number above zero is too much. And that's why as president, my husband vowed to end this problem once and for all. . . . And he has directed record levels of funding toward helping homeless veterans, achieving historic success in getting our men and women in uniform into housing.

Almost 90 percent of today's homeless veterans served before 9/11, but this is the first time anyone has made this a government-wide priority. We've got HUD and the VA and the Interagency Council leading the way, and we're also working with the Department of Health and Human Services, the Department of Labor and nonprofits and community leaders

on the ground.. . . We've cut through red tape and streamlined efforts across agencies, and together, we have made some extraordinary progress. . . .

In the last few years, more than 40 times as many veterans have been helped than during most of the program's entire history. And . . . the Supportive Services for Veteran Families, the SSVF, is a new program started by this administration three years ago to prevent low-income veteran families from falling into homelessness. And last year alone, it served more than 60,000 veterans and their family members, and next year, we expect that number to grow to over 100,000.

But we know that we are nowhere near finished. As I said before, any number above zero is way too high, and we still have tens of thousands of vets without a home. So we can't rest, not even for a moment. And that's why I am so thrilled and everyone in this building is so happy to announce a new effort called the Mayors Challenge to End Veteran Homelessness. We have got 77 mayors, four governors, four county officials on board already. . . .

And all of these leaders are involved because this isn't just the right thing to do for our veterans; it's also the right thing to do for their budgets. Recent studies have shown that just one chronically homeless person can cost communities between $30,000 to $50,000 per year in emergency room visits, medical bills, and law enforcement. For some individuals, it can be even higher. But the cost to give someone a home of their own is only about $20,000. So this makes sense on so many different levels. And that's why I want to applaud everyone who is already leading the way in this effort. . . .

We have the power to change lives here. . . . [And] we have another example. We have a wonderful man named Doran Hocker, who's here with us today. Doran served in the Air Force for three years, including a deployment to Korea during the Vietnam War. Now, he never saw combat, but he saw more death and devastation than most of us ever will. So when he got back to the States, Doran says the first thing he did was kneel down on a patch

▼ Having lunch with midshipmen in King Hall at the U.S. Naval Academy in Annapolis, Maryland, 2013.

of grass and kiss the ground. But in the months and years that followed, Doran just couldn't shake the things he'd experienced. He started drinking more and isolated himself from his wife and his baby daughter. He ended up getting a divorce and falling in with the wrong people. And for almost three decades, Doran was homeless. As he says now, he says, "I tried to kill myself for 30 years, slowly." He said, "It got so bad that people were throwing change at my feet in the streets."

And finally, Doran decided to turn his life around. He wrote down a list of 21 things he wanted to accomplish—things like opening a bank account, cooking in his own kitchen. He moved from Detroit to St. Paul, Minnesota, and once he got there he walked across town to a local nonprofit that he knew could help him. With their help and the help of the Minnesota Assistance Council for Veterans, he got into housing and a substance abuse treatment program. And today, Doran has checked off all 21 items on that list. . . . And like so many of our veterans, Doran continues to give back. . . . He's dedicating his life to making sure that every veteran who comes home will never have to go through what he did. . . .

We have made great progress over the past few years because of leaders like all of you who refuse to accept veteran homelessness as a fact of life. And now we have to finish the job once and for all, because when a veteran comes home kissing the ground, it is unacceptable that he should ever have to sleep on it. So just like it's our country's duty to bring back all of our men and women from the battlefield, we've also got a duty to make sure that every single veteran has a place to call home when they get here—and for the rest of their lives. . . .

So let's get to work. Thank you all. God bless.

"When a veteran comes home kissing
the ground, it is unacceptable that he
should ever have to sleep on it."
—MICHELLE OBAMA

▼ Michelle Obama greeting Marines as part of the launch of Joining Forces, a national initiative supporting and honoring America's service members and their families at Camp Lejeune, North Carolina, April 13, 2011. ▲ With General Roger Brady serving the troops at Ramstein Air Base, Germany, on November 11, 2010.

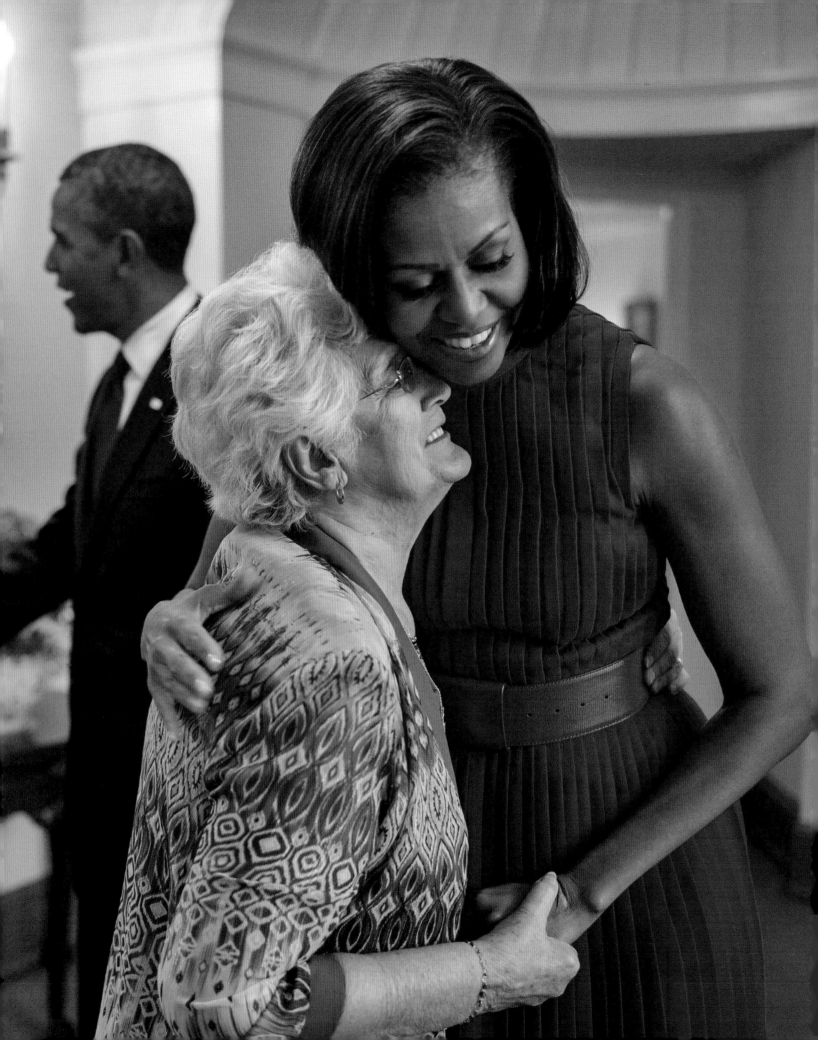

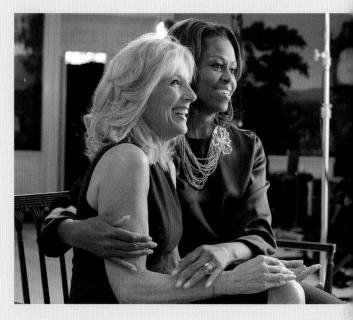

"Dr. Biden and Mrs. Obama have done such an amazing job elevating the conversation. It's very gratifying to be in the community and hear civilians talk about supporting military families, when they didn't do that before."

—KELLY HRUSKA, NATIONAL MILITARY FAMILY ASSOCIATION

AS a wartime first lady, Michelle Obama worked on veterans' programs such as Joining Forces that made a difference in millions of lives. When she and Jill Biden launched Joining Forces in 2011, almost one in three of the youngest veterans who wanted to work could not find a job. On the fifth anniversary of the program, more than 1.2 million veterans and military spouses had been hired or trained.

◀ Michelle Obama welcomes the family of Specialist Leslie H. Sabo Jr., who was awarded the Medal of Honor forty-two years after giving his life to save his fellow soldiers on May 10, 1970 in Vietnam. ◀ With Dr. Jill Biden taping a Super Bowl message honoring troops and veterans.

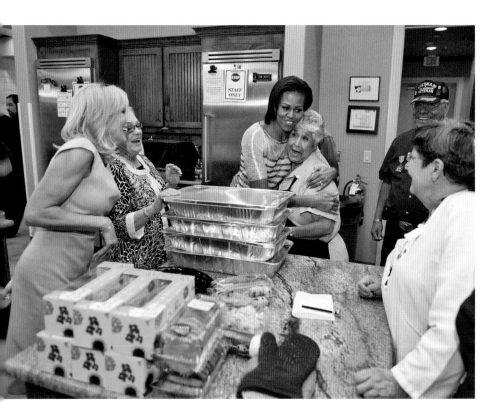

▲ Michelle Obama and Dr. Jill Biden (in blue) greeting facility manager Judith
Markelz (second left) and volunteers at the Warrior and Family Support Center,
which helps care for family members of Wounded Warriors in San Antonio, Texas,
April 2011. ▶ Having a laugh with participants in the Wounded Warrior Soldier Ride
in the Diplomatic Reception Room of the White House, 2010. (Following pages)
Michelle Obama shares the love at the Naval Air Station Oceana Summer Camp in
Virginia Beach, Virginia, July 21, 2011.

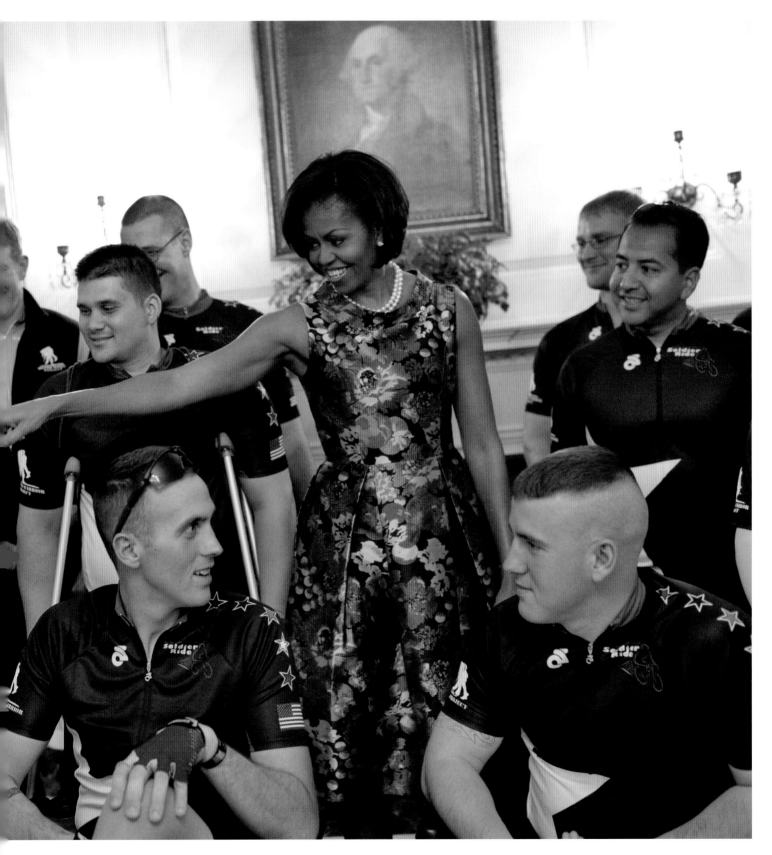

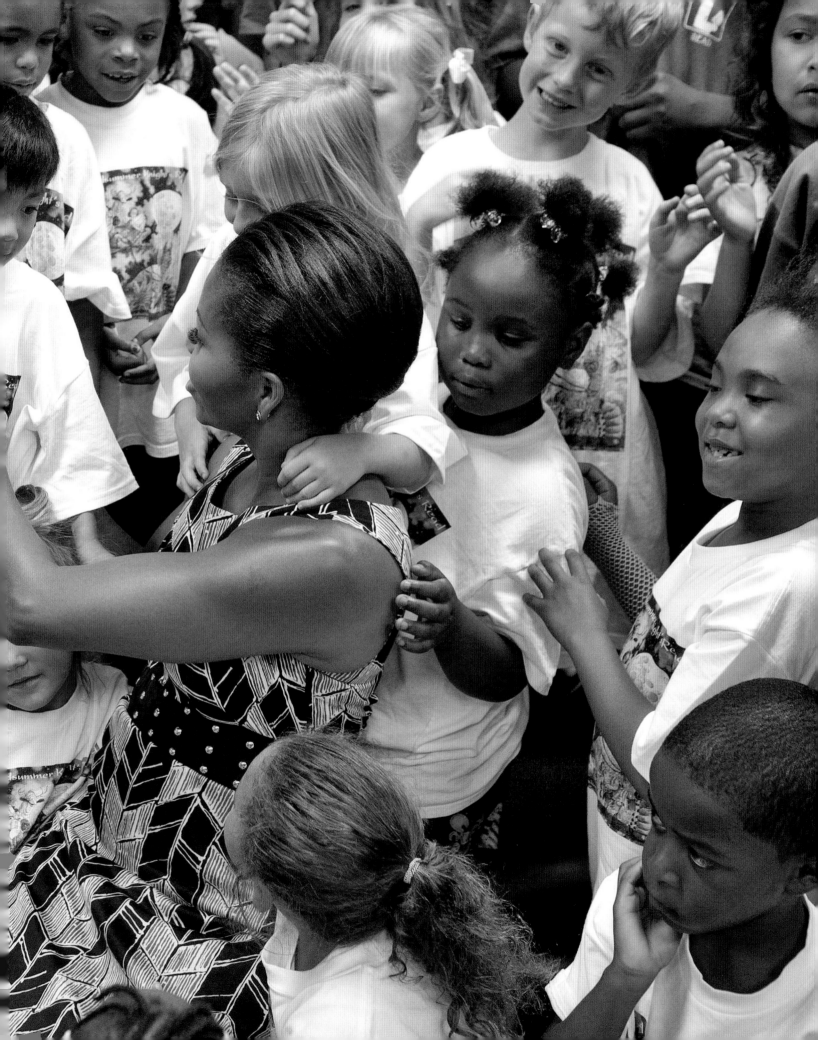

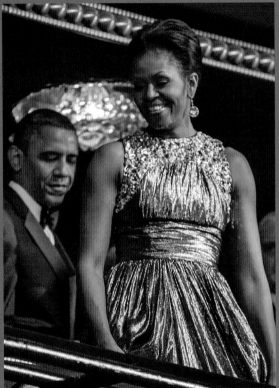

FASHION
ICON

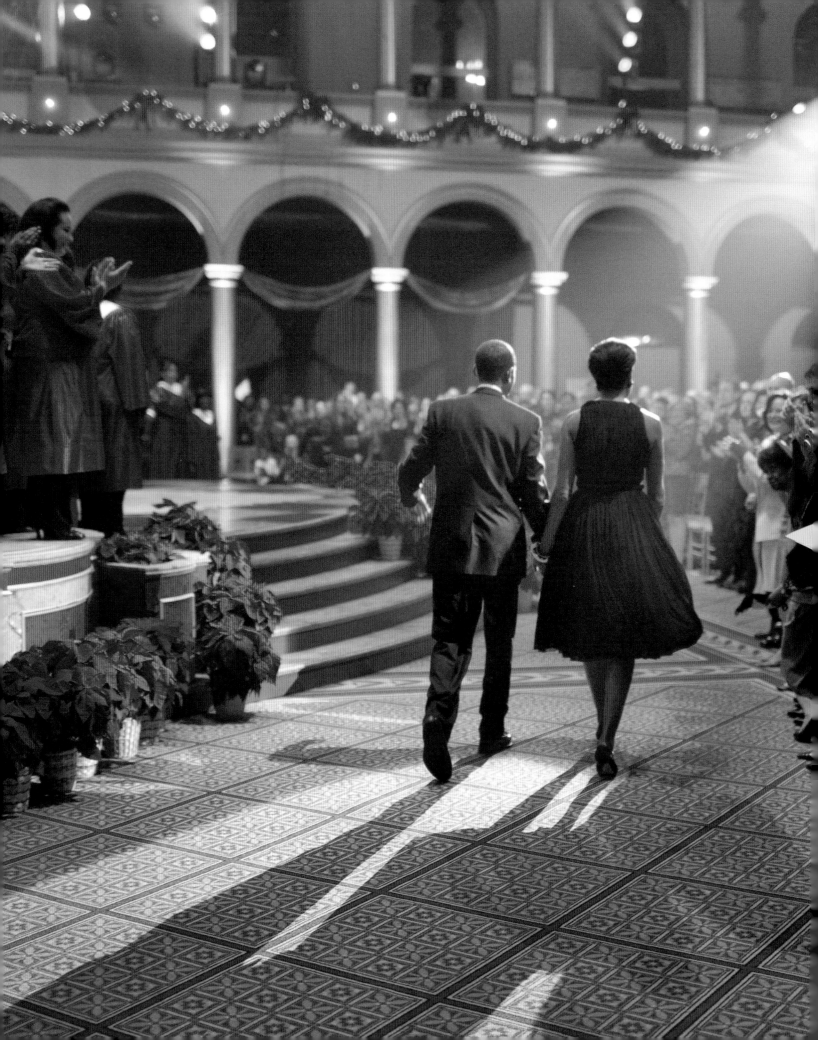

MICHELLE Obama's daring, fresh, and globally

admired fashion sense brought a new era of glamour to the
White House. After the last state dinner in the Obama White
House in October 2016, *Vogue* magazine lamented the upcoming
absence of "one of the most glamorous women in the world" and
announced the Internet's "collective mourning over the fact that
there will be no more Michelle Obama fashion moments to obsess
about." Justin Thornton, of the label Preen by Thornton Bregazzi,
reflected that by promoting younger designers and small fashion
houses Michelle changed the fashion landscape and "taught
people that you don't have to follow the traditional rules for
formal dressing."

(Previous pages) In gold lamé by Michael Kors at the Kennedy Center Honors, 2012.

◀ In a black party dress by Isabel Toledo at the 2009 *Christmas in Washington* taping
in Washington, D.C.

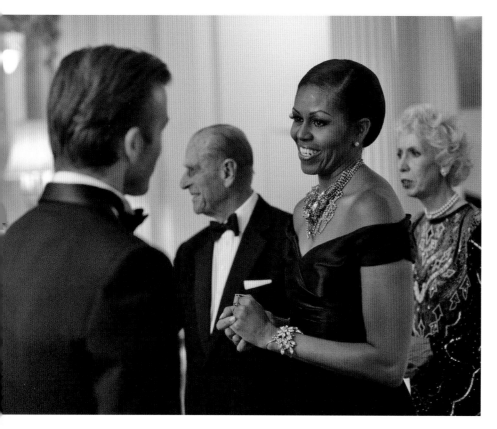

▲ Greeting soccer star David Beckham in a portrait-collared Ralph Lauren gown at a dinner in honor of Queen Elizabeth II at Winfield House in London, England, May 25, 2011. ▶ Announcing the Best Picture Oscar for *Argo* live from the Diplomatic Reception Room of the White House in a smoke gray and silver deco-beaded gown by Naeem Khan, February 24, 2013.

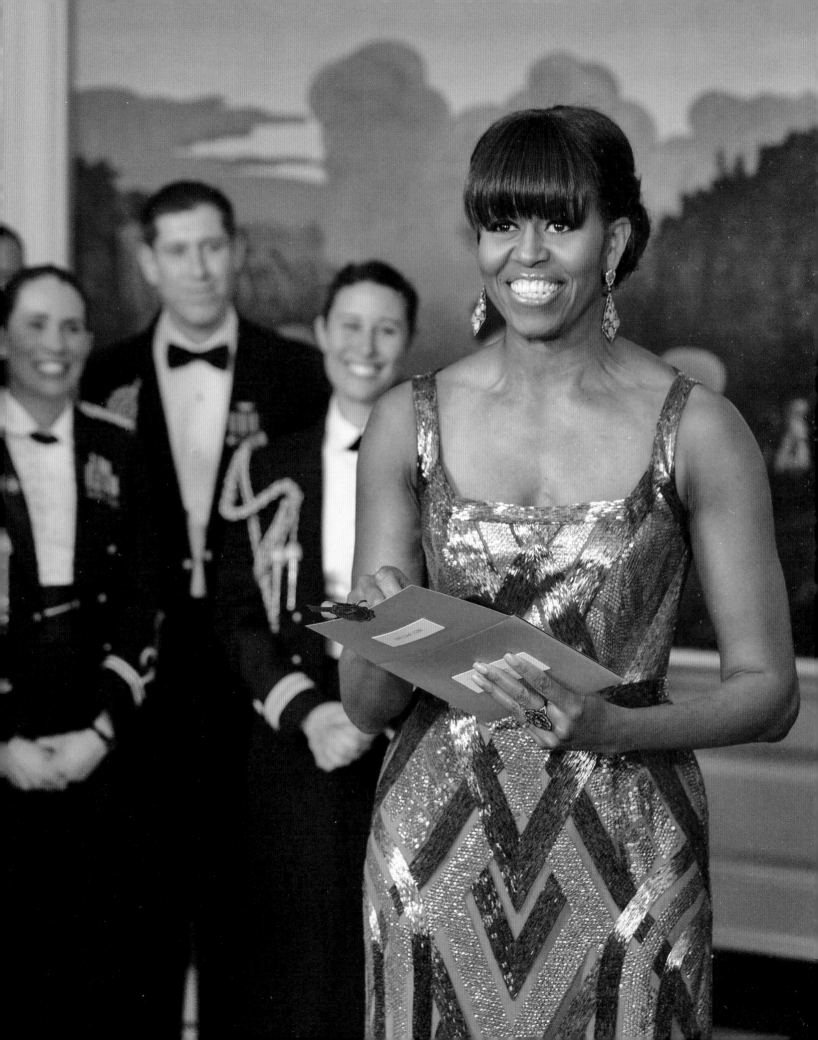

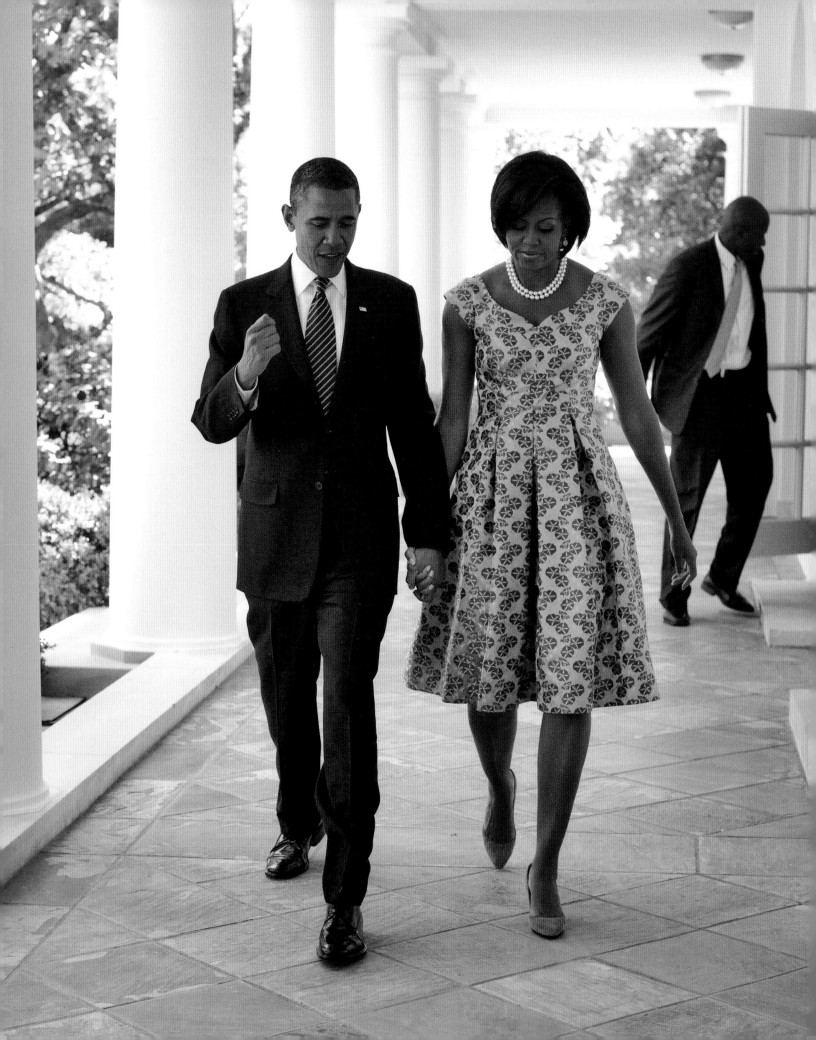

" I pick the clothes that make me happy— sometimes people like them, sometimes they don't. I try to listen to my own internal guide. My message to women: Do what makes you feel good, because there'll always be someone who thinks you should do it differently. Whether your choices are hits or misses, at least they're your own. "

—MICHELLE OBAMA

◄ The President and First Lady, wearing Barbara Tfank, walk along the Colonnade of the White House, September 2010. ◄ Dressed in yellow chiffon by Prabal Gurung, the First Lady talks with President Ali Bongo Ondimba of the Gabonese Republic during the U.S.-Africa Leaders Summit dinner at the White House, 2014.

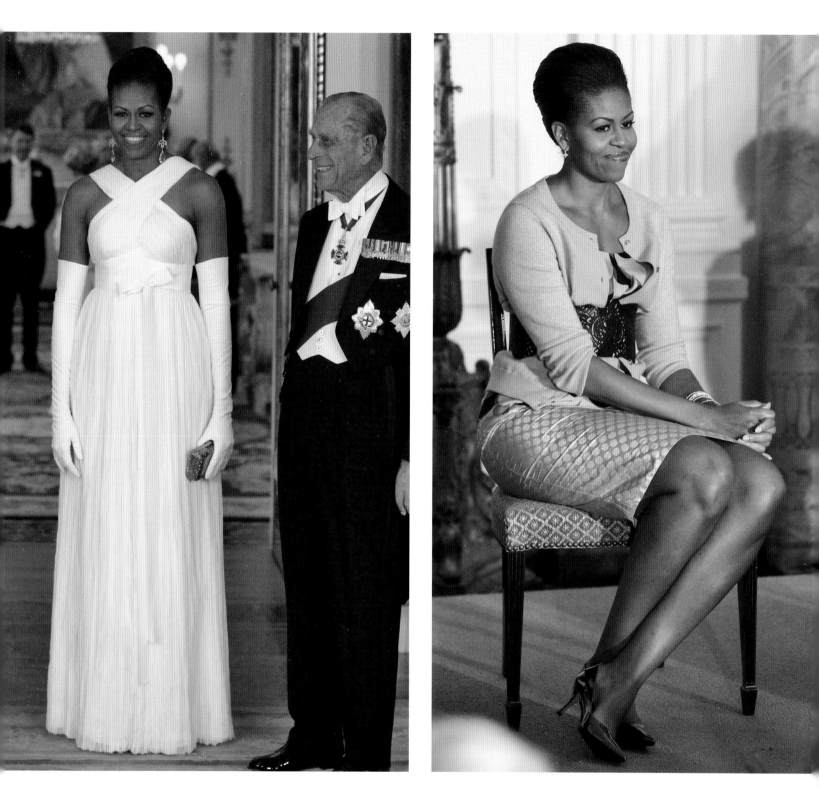

▲ In a Tom Ford gown with Prince Philip in the Music Room of Buckingham Palace, 2011.

▲ Wearing a J.Crew ensemble, waiting to speak at an event addressing the difficulties older women face in the health insurance market, 2009.

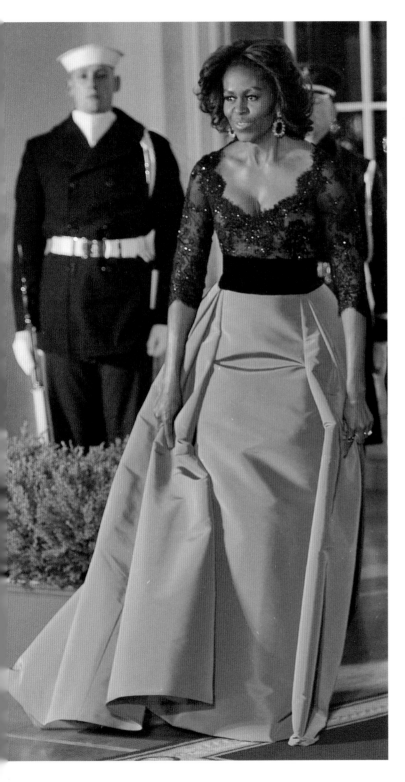

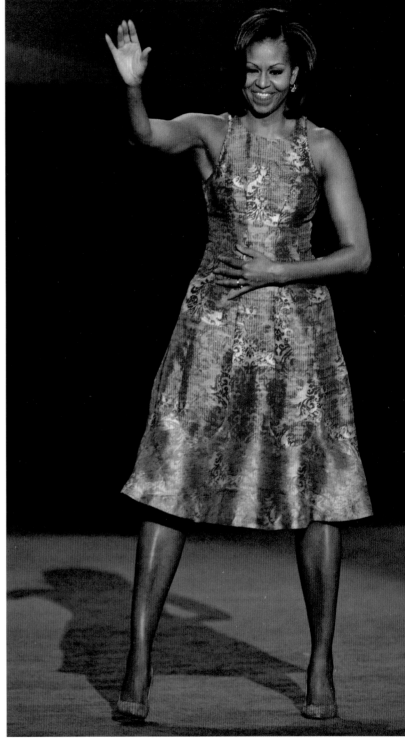

▲ Ball gown by Carolina Herrera at a state dinner for French president François Hollande at the White House, 2014.

▲ After speaking at the 2012 Democratic National Convention in Charlotte, North Carolina, dressed in Tracy Reese.

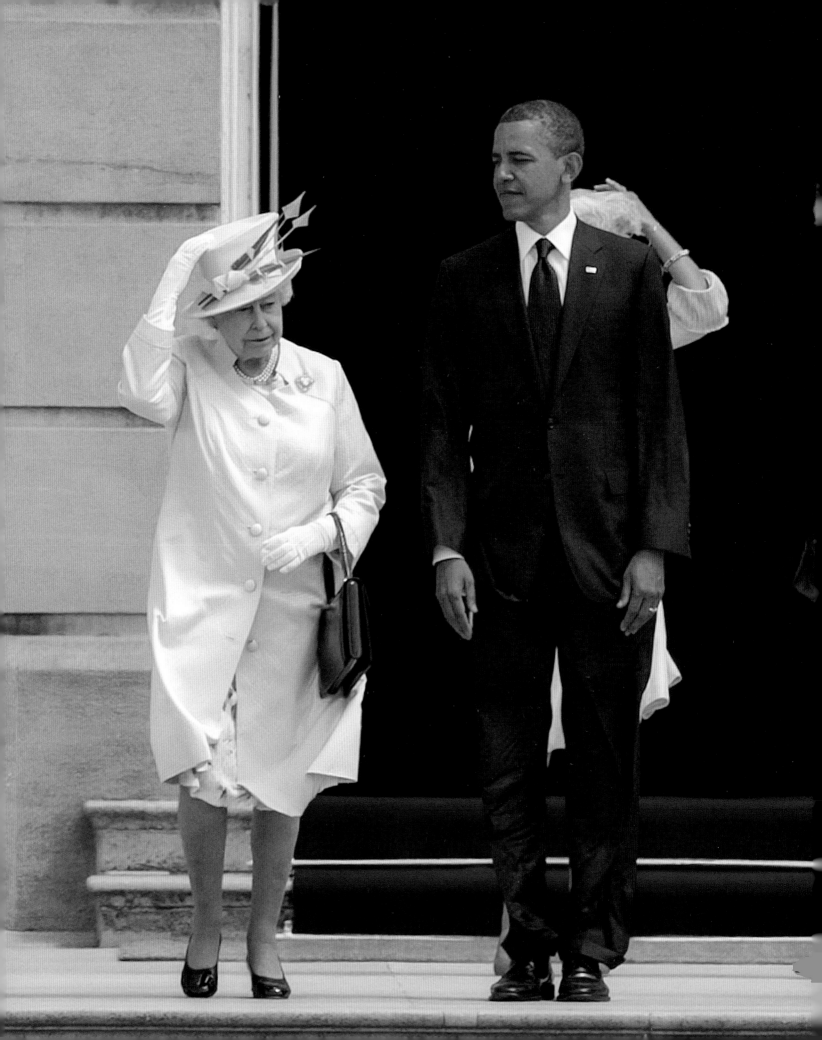

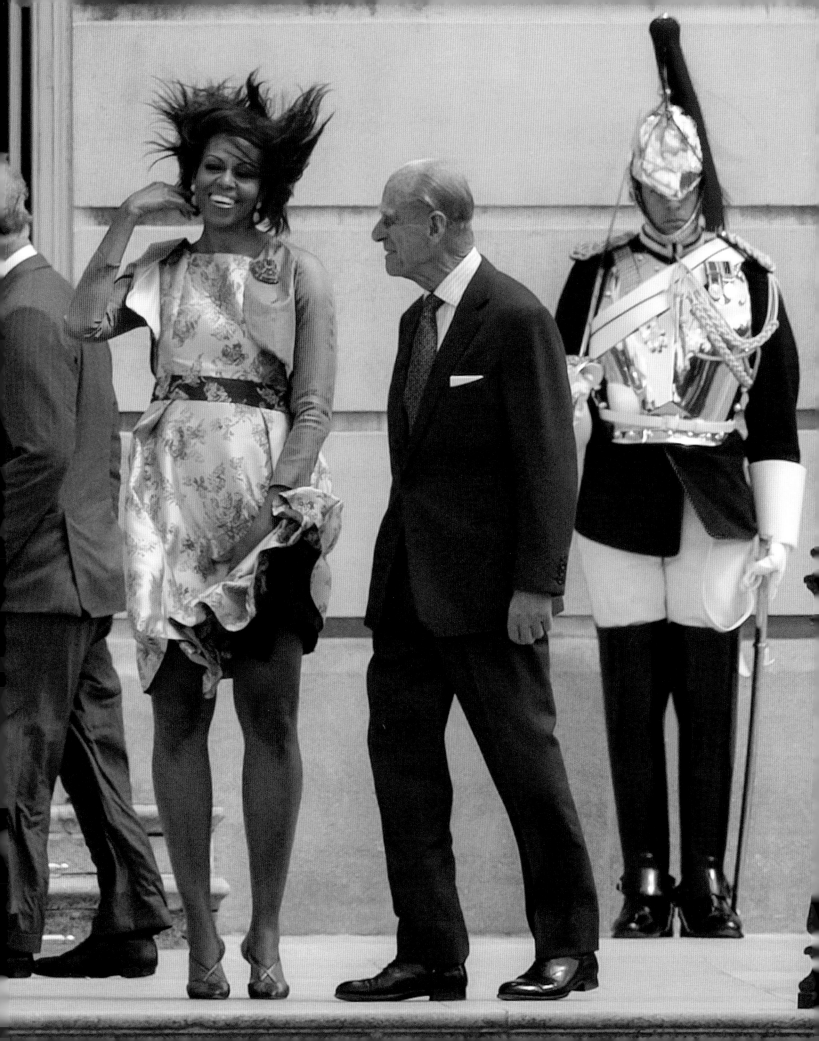

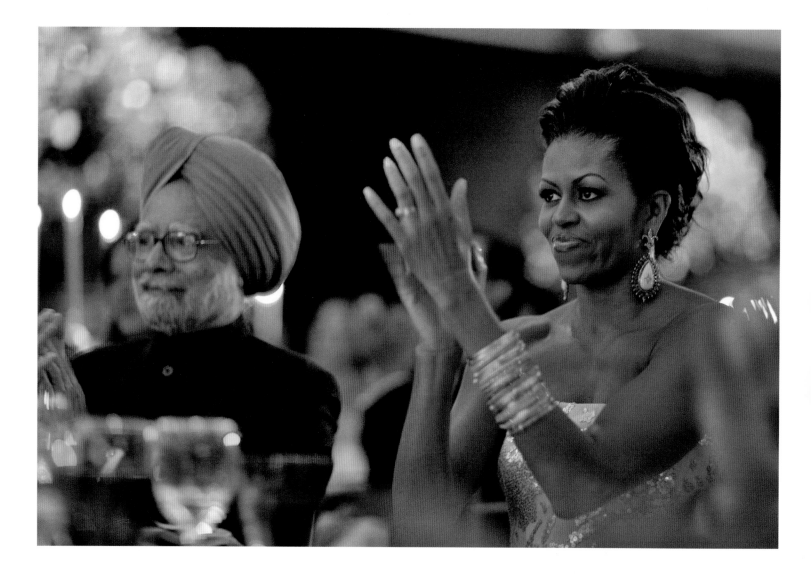

(Previous pages) (from left to right) Britain's Queen Elizabeth II, Barack Obama, Camilla Parker Bowles (behind the president), Prince Charles (facing the back), Michelle Obama, wearing a floral Barbara Tfank dress, and Prince Philip at Buckingham Palace on a blustery day, May 24, 2011. ▲ The First Lady, wearing a strapless silver-sequined gown by Naeem Khan, and Prime Minister Manmohan Singh of India during a State Dinner held in a tent on the South Lawn, 2009. ▶ The Obamas awaiting the arrival of Prime Minister Manmohan Singh of India and his wife, Mrs. Gursharan Kaur, for the State Dinner.

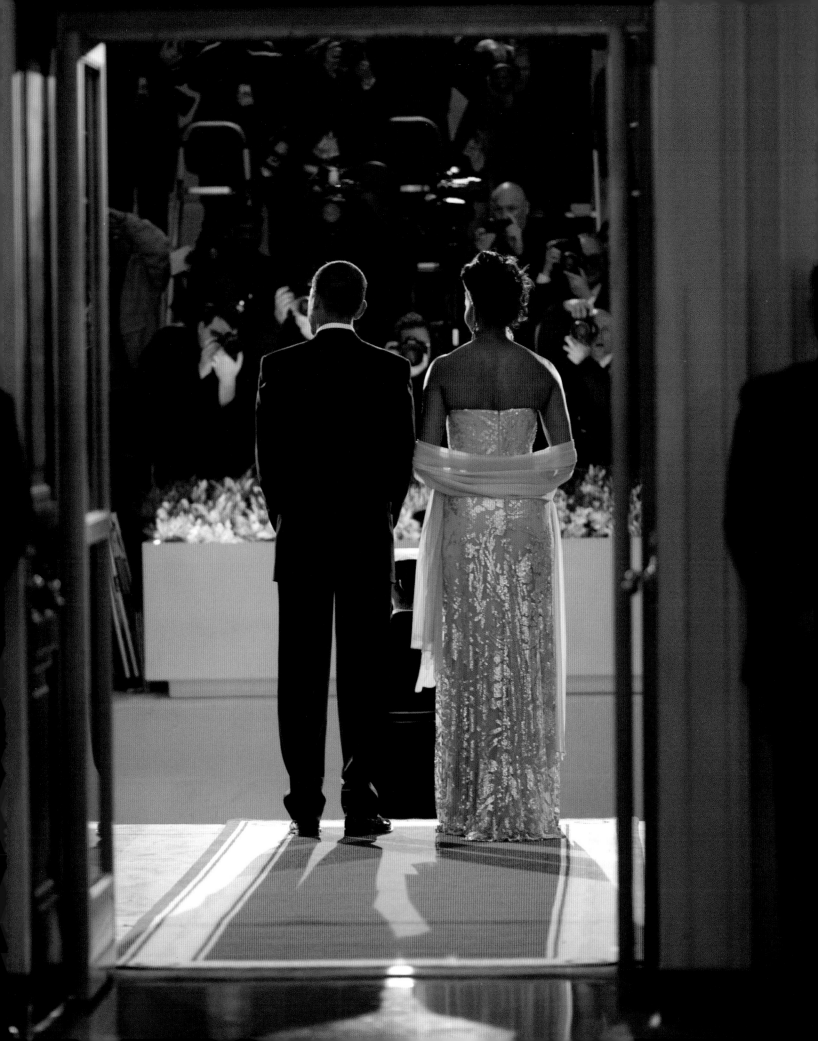

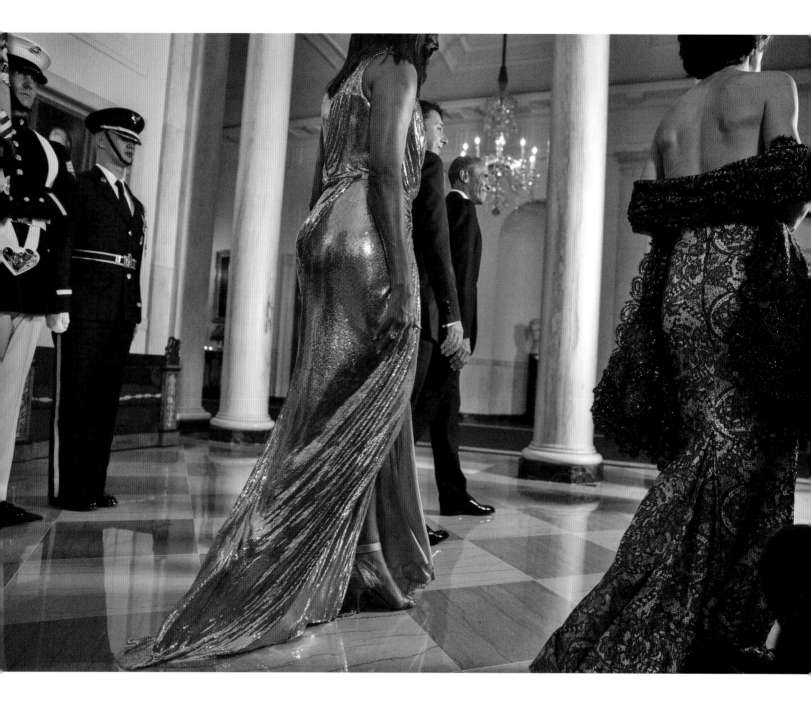

▲ At the final state dinner, the First Lady, in a rose gold chainmail gown by Donatella Versace, with (from left to right) Italian president Matteo Renzi, President Obama, and Renzi's wife, Agnese Landini, October 18, 2016.

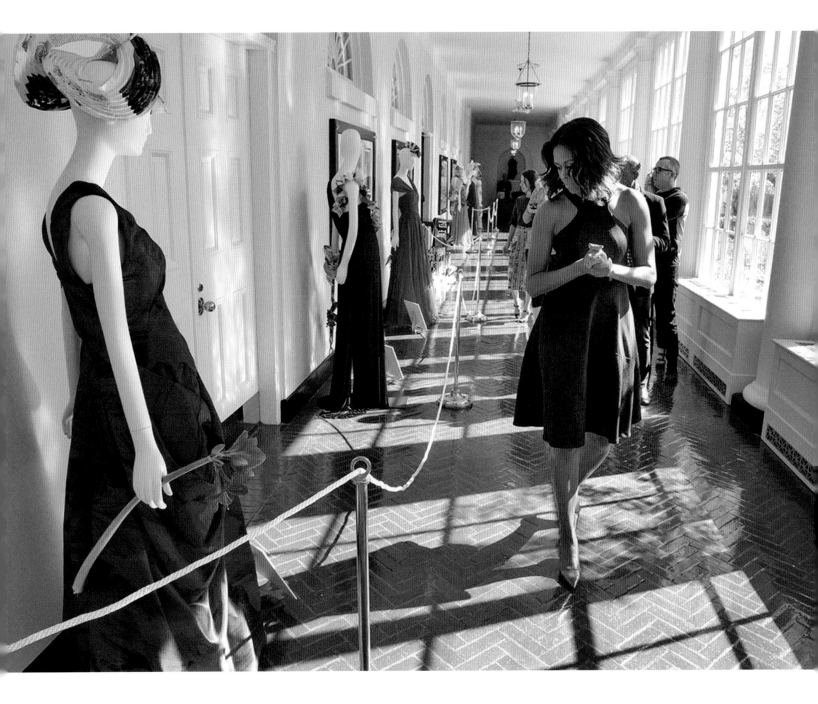

▲ Michelle Obama, in a dress designed for her by FIT student Natalya Koval, looking at her dresses on display in the East Colonnade of the White House during the Fashion Education Workshop, 2014.

▶ President Barack Obama and the First Lady, in a
paisley-print organza ball gown by Naeem Khan, arrive
for an official dinner at the Presidential Palace in Dakar,
Senegal, June 27, 2013.

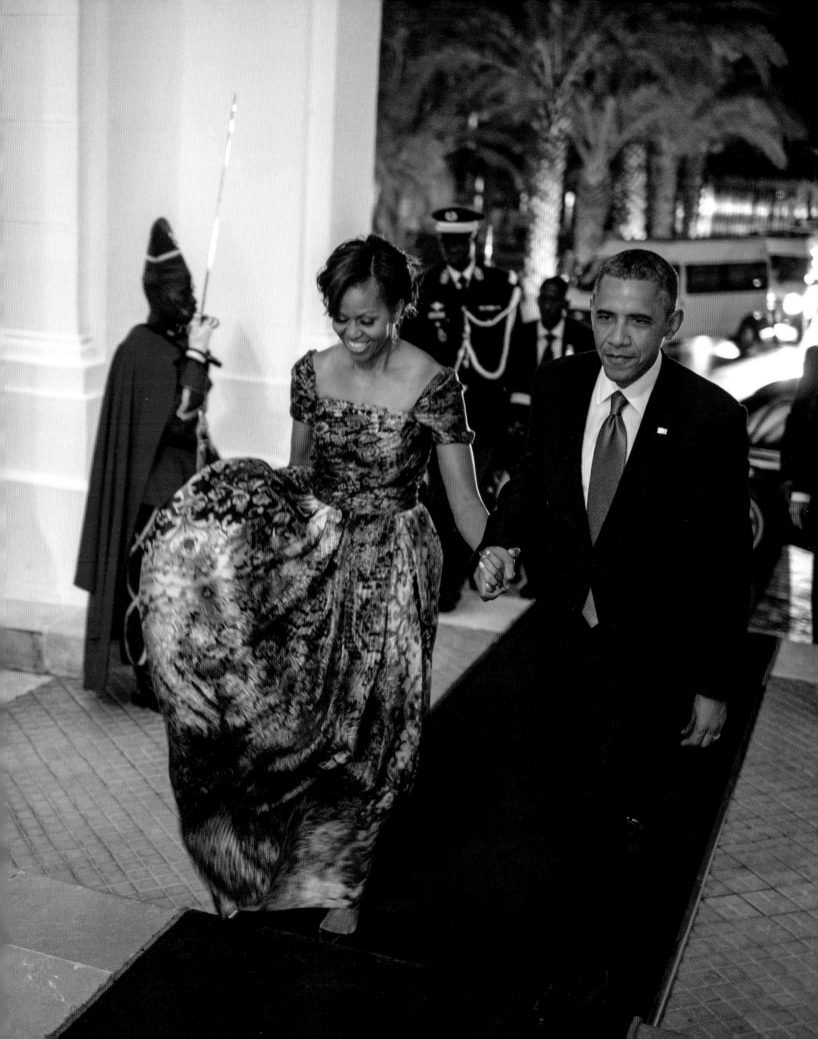

◀ The President and First Lady descending the Grand Staircase of the White House, 2010. ▲ Michelle Obama, wearing Thakoon, in a tête-à-tête with Carla Bruni-Sarkozy, wife of French president Nicolas Sarkozy, at the Palais Rohan, in Strasbourg, France, 2009.

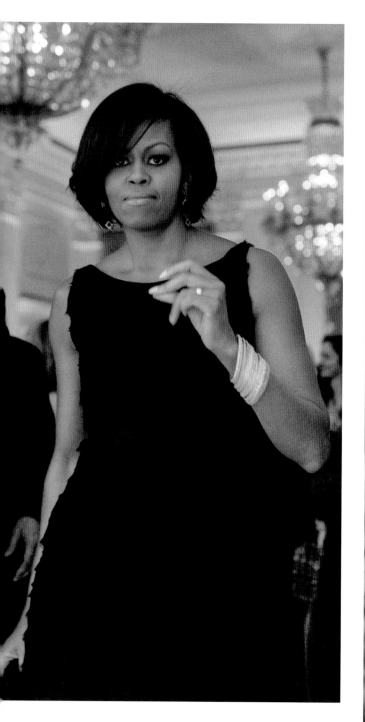

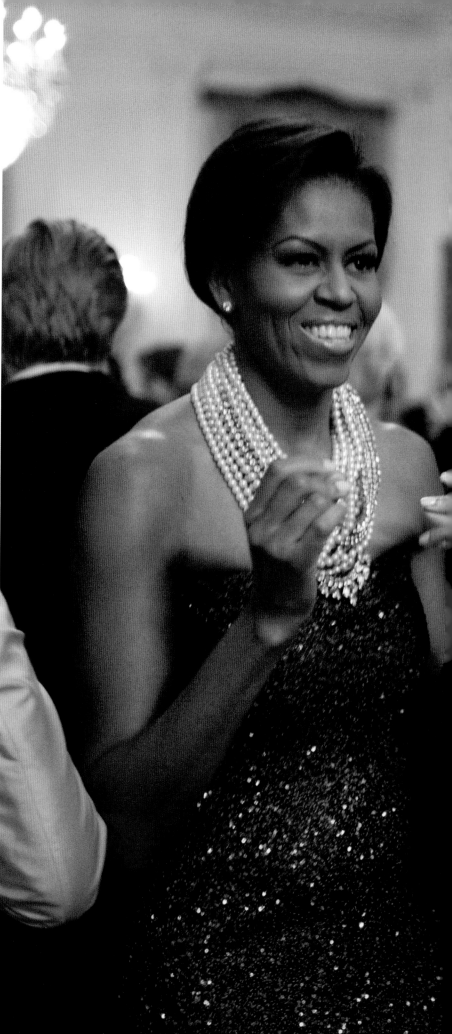

▲ The Governors' Ball in the East Room of the White House, February 21, 2010, dress by Thakoon.

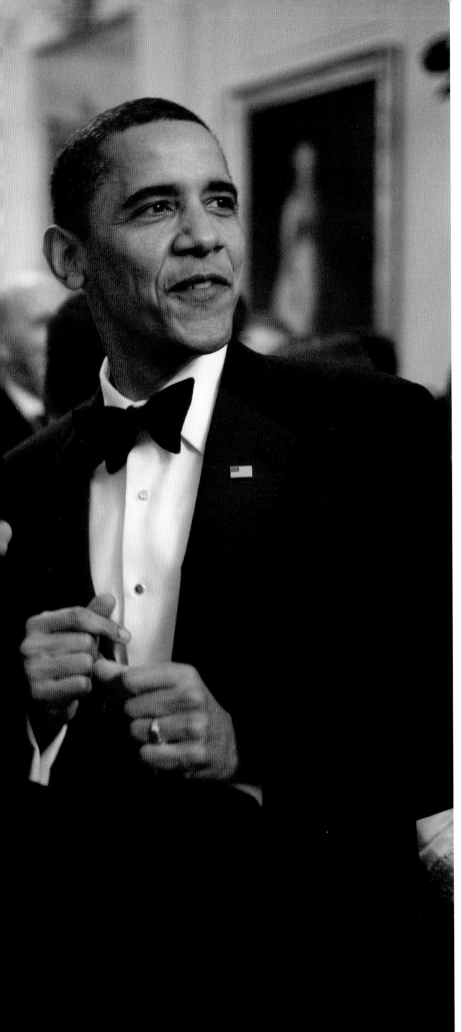

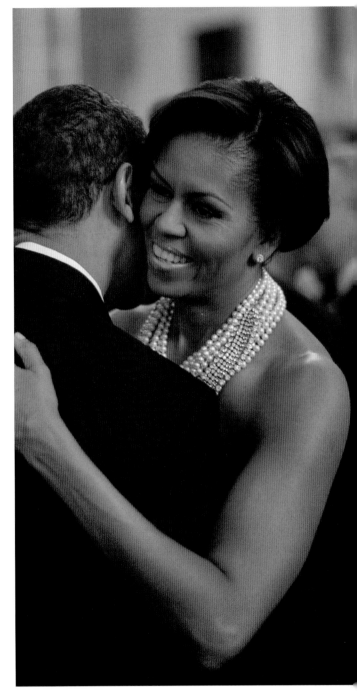

◀ ▲ Barack and Michelle Obama boogying as Earth
Wind & Fire plays at the Governors' Ball at the White
House, February 2009, gown by Peter Soronen.

165

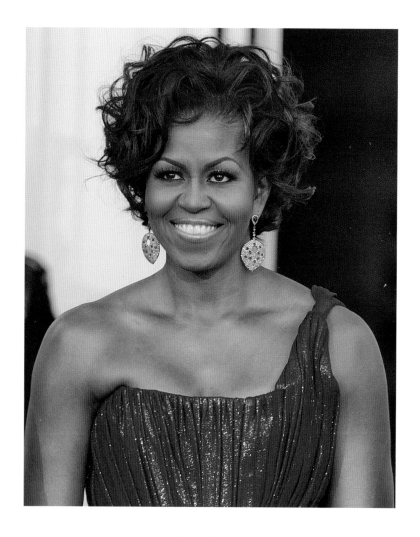

"I look at my mom—she's 72, and she's happy and looks great. To me, with age, everything has gotten better. You have way more control; you know yourself better. My goal is to be a great-looking 70-year-old! I won't mind being 70, but I want people to say, 'You're 70?'"

—MICHELLE OBAMA

▲ Wearing Peter Soronen on the North Portico of the White House at a State Dinner for Mexico, May 2010.

▶ Looking fresh in ASOS at the end of a three-day, nine-city campaign trip across Iowa, 2012.

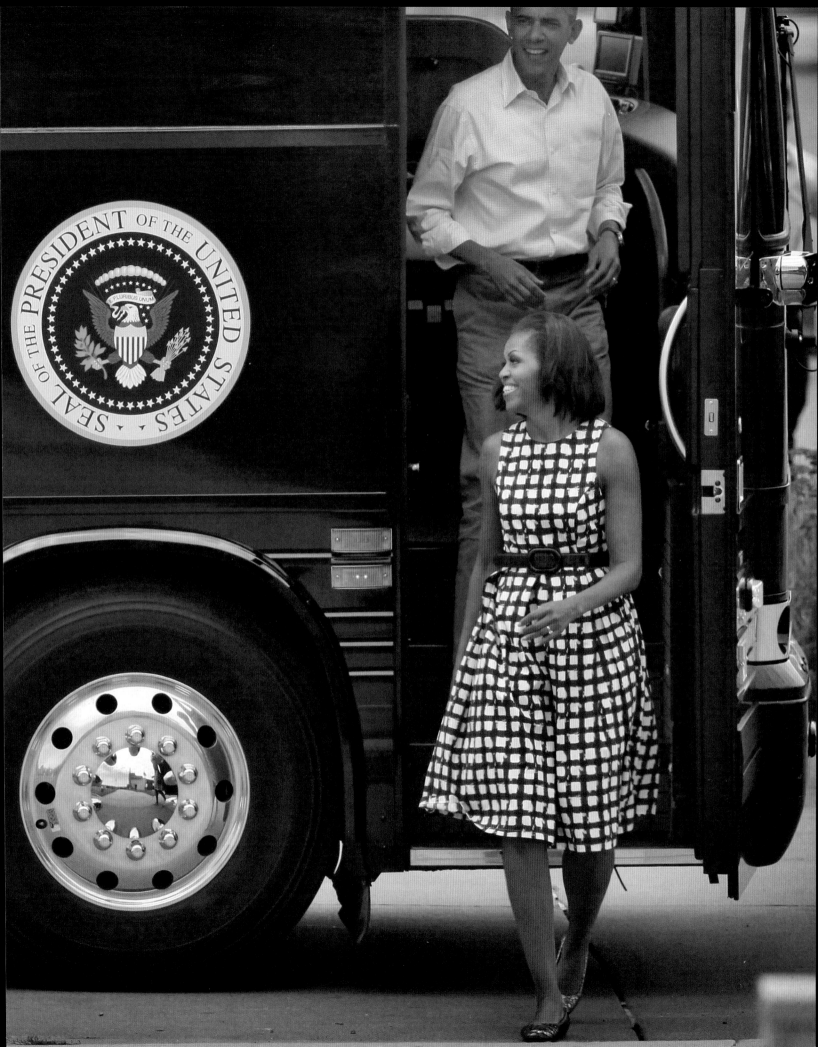

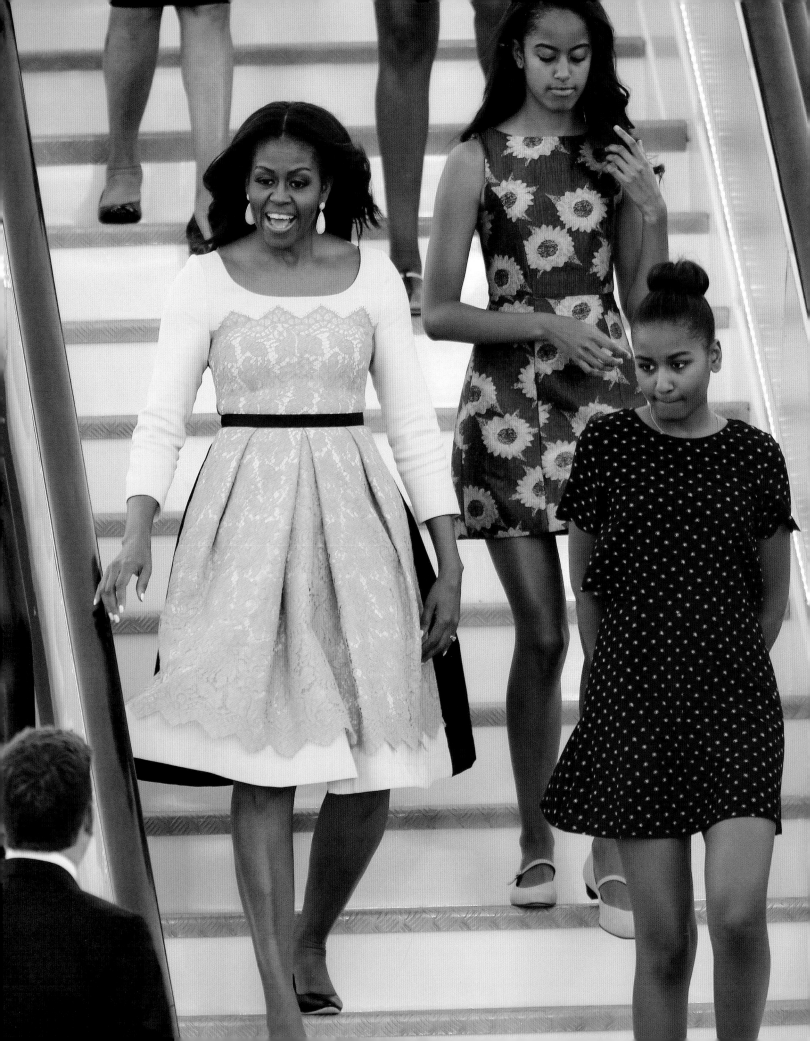

◀ Michelle, wearing Preen by Thornton Bregazzi, with daughters Malia and Sasha (front right) on a visit to the United Kingdom to promote her initiatives, June 2015.

▲ Wearing J.Crew at the Prime Minister's house on Downing Street, London, in 2009 for the G20 summit dedicated to tackling the global financial crisis.

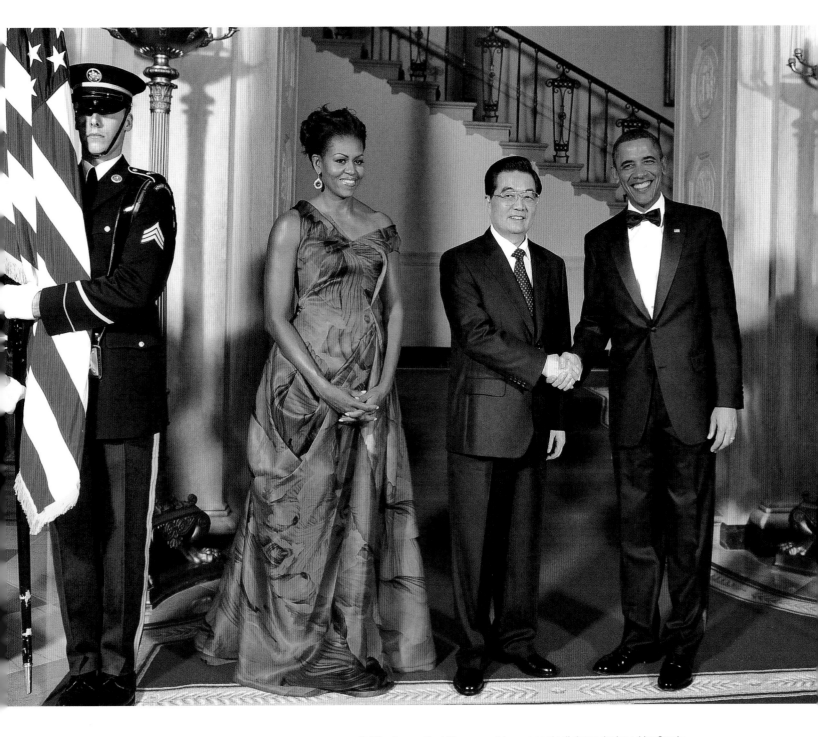

▼ Wearing a silk chiffon emerald green cocktail dress designed by Stevie
Wonder's wife, Kai Milla, at a White House concert honoring Stevie Wonder, 2009.
▲ The First Lady, in Alexander McQueen, with Chinese president Hu Jintao, and
President Obama at the White House before a state dinner, January 2011.

"

Liz Vaccariello: President Obama looks at you as if you're the most beautiful woman on the planet. Do you feel that?

Michelle Obama: One of the things that attracted me to Barack was his emotional honesty. Right off the bat he said what he felt. There are no games with him—he is who he appears to be. I feel fortunate as a woman to have a husband who loves me and shows me in every way. So yes, I do know that.

—*PREVENTION* MAGAZINE INTERVIEW, NOVEMBER 2011

"

▶ President Barack Obama and First Lady Michelle Obama, in an off-the-rack Talbots dress, leaving the White House for a trip to Orlando, Florida, to address injured veterans at the Disabled American Veterans National Convention in 2013.

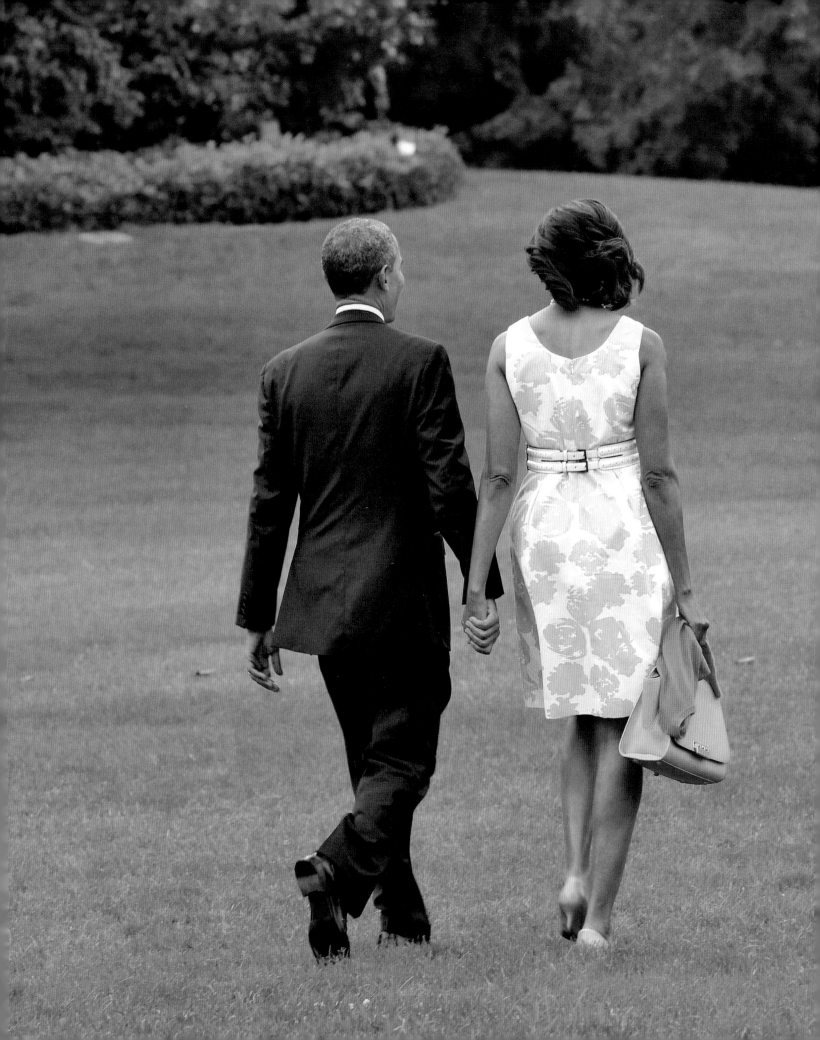

THE
CLOSER

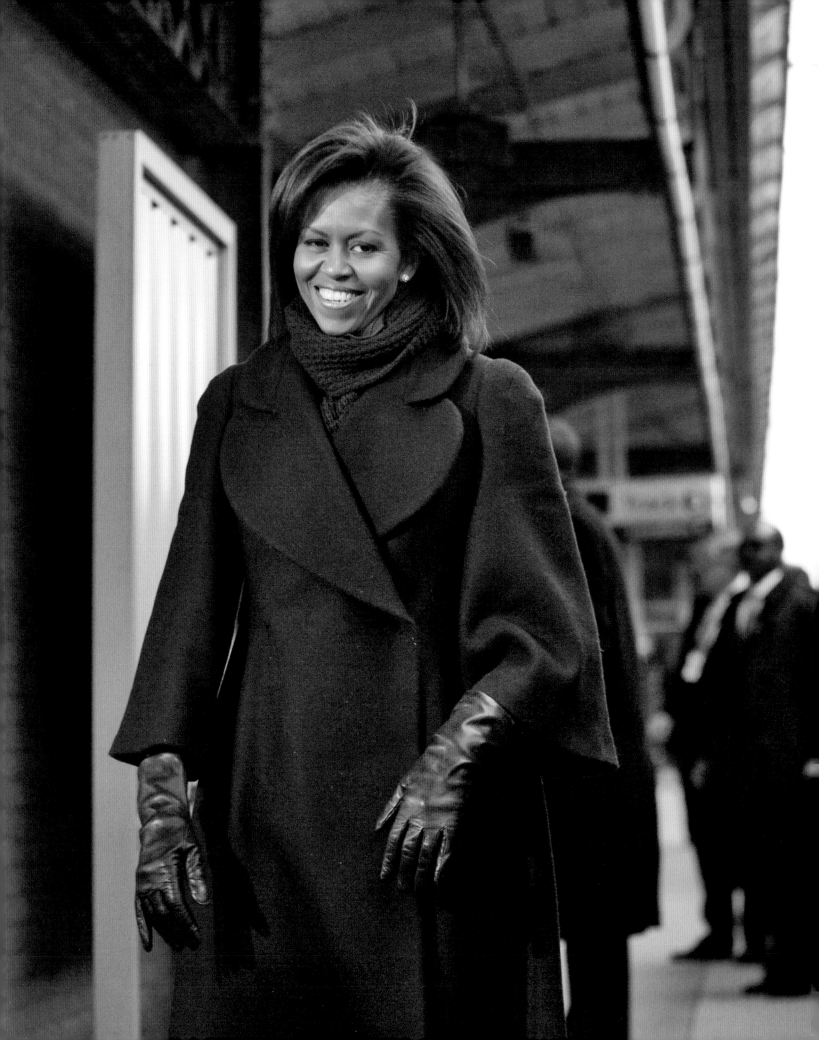

This isn't a politician's articulation of what's going on here. This isn't a man's articulation. It is a woman who never asked for this platform using it to say what she thinks.

— CELINDA LAKE ON MICHELLE OBAMA'S 2016
SPEECHES SUPPORTING HILLARY CLINTON
AND REACTING TO DONALD TRUMP

MICHELLE Obama has a proven record as a leader and a change maker, but she has never been interested in politics. As she once explained to her husband: "I try to organize my life not to have a lot of mess around, and politics is just a big mess." But during Barack Obama's 2008 Democratic primary campaign, staffers soon discovered that she was a priceless asset. Within the campaign, Michelle's success in winning hearts and minds with her natural relatedness and passionate public speaking earned her the nickname "The Closer."

(Previous page) Michelle Obama addressing the 2016 Democratic National Convention. ◀ In Wilmington, Delaware, during the 2009 pre-inaugural whistle-stop tour to Washington—a trip echoing the historic journey taken by Abraham Lincoln in 1861.

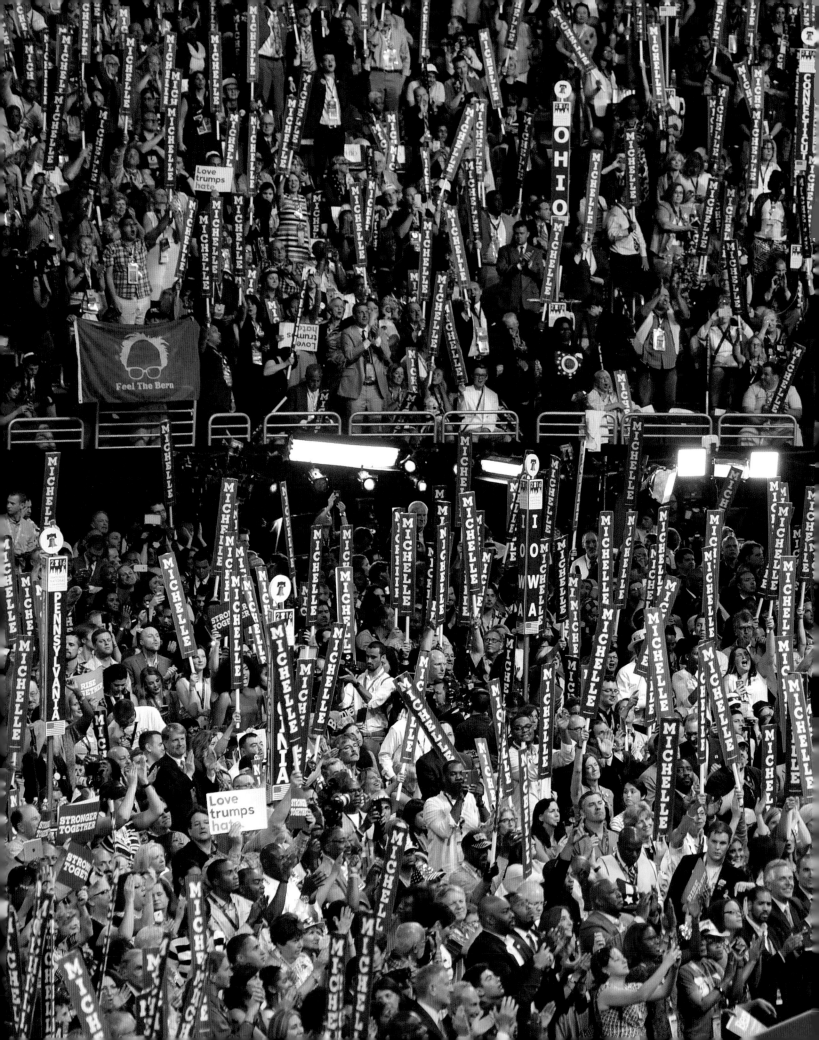

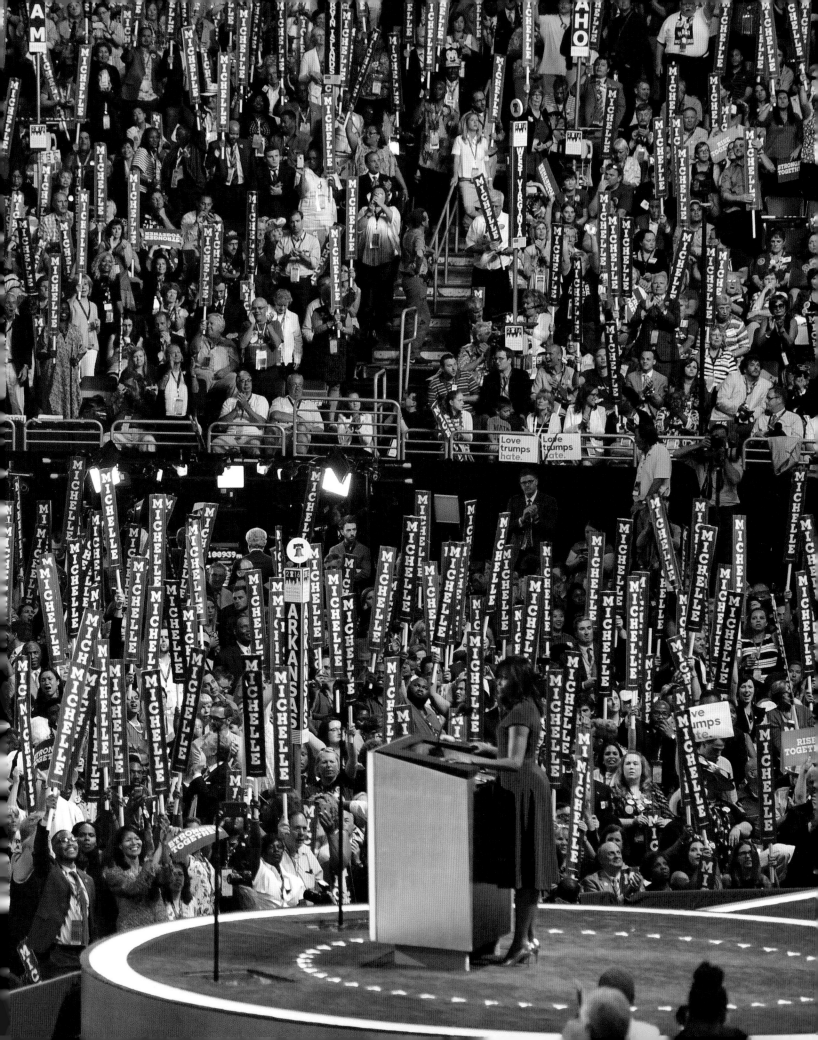

REMARKS BY THE FIRST LADY AT THE DEMOCRATIC NATIONAL CONVENTION

Wells Fargo Center
Philadelphia, Pennsylvania
July 25, 2016

THANK YOU ALL. Thank you so

much. You know, it's hard to believe that it has been eight years since I first came to this convention to talk with you about why I thought my husband should be president. Remember how I told you about his character and conviction, his decency and his grace—the traits that we've seen every day that he's served our country in the White House.

I also told you about our daughters—how they are the heart of our hearts, the center of our world. And during our time in the White House, we've had the joy of watching them grow from bubbly little girls into poised young women—a journey that started soon after we arrived in Washington, when they set off for their first day at their new school.

I will never forget that winter morning as I watched our girls, just seven and ten years old, pile into those black SUVs with all those big men with guns. And I saw their little faces pressed up against the window, and the only thing I could think was, "What have we done?" See, because at that moment, I realized that our time in the White House would form the foundation for who they would become, and how well we managed this experience could truly make or break them.

That is what Barack and I think about every day as we try to guide and protect our girls through the challenges of this unusual life in the spotlight—how we urge them to ignore those who question their father's citizenship or faith. How we insist that the hateful language they hear from public figures on TV does not represent the true spirit of this country. How we explain that when someone is cruel, or acts like a bully, you don't stoop to their level—no, our motto is, when they go low, we go high.

With every word we utter, with every action we take, we know our kids are watching us. We as parents are their most important role models. And let me tell you, Barack and I take that same approach to our jobs as president and first lady, because we know that our words and actions matter not just to our girls, but to

(Previous pages) Michelle Obama addressing delegates at the Democratic National Convention in Philadelphia, July 25, 2016.

180

"I will never forget that winter morning as I watched our girls, just seven and ten years old, pile into those black SUVs with all those big men with guns. And I saw their little faces pressed up against the window, and the only thing I could think was, 'What have we done?'"

children across this country—kids who tell us, "I saw you on TV, I wrote a report on you for school." Kids like the little black boy who looked up at my husband, his eyes wide with hope, and he wondered, "Is my hair like yours?"

And make no mistake about it, this November, when we go to the polls, that is what we're deciding—not Democrat or Republican, not left or right. No, this election, and every election, is about who will have the power to shape our children for the next four or eight years of their lives. And I am here tonight because in this election, there is only one person who I trust with that responsibility, only one person who I believe is truly qualified to be president of the United States, and that is our friend, Hillary Clinton.

See, I trust Hillary to lead this country because I've seen her lifelong devotion to our nation's children—not just her own daughter, who she has raised to perfection—but every child who needs a champion: Kids who take the long way to school to avoid the gangs. Kids who wonder how they'll ever afford college. Kids whose parents don't speak a word of English but dream of a better life. Kids who look to us to determine who and what they can be.

You see, Hillary has spent decades doing the relentless, thankless work to actually make a difference in their lives—advocating for kids with disabilities as a young lawyer. Fighting for children's health care as first lady and for quality child care in the Senate. And when she didn't win the nomination eight years ago, she didn't get angry or disillusioned. Hillary did not pack up and go home. Because as a true public servant, Hillary knows that this is so much bigger than her own desires and disappointments. So she proudly stepped up to serve our country once again as secretary of state, traveling the globe to keep our kids safe.

And look, there were plenty of moments when Hillary could have decided that this work was too hard, that the price of public service was too high, that she was tired of being picked apart for how she looks or how she talks or even how she laughs. But here's

the thing—what I admire most about Hillary is that she never buckles under pressure. She never takes the easy way out. And Hillary Clinton has never quit on anything in her life.

And when I think about the kind of president that I want for my girls and all our children, that's what I want. I want someone with the proven strength to persevere. Someone who knows this job and takes it seriously. Someone who understands that the issues a president faces are not black and white and cannot be boiled down to 140 characters. Because when you have the nuclear codes at your fingertips and the military in your command, you can't make snap decisions. You can't have a thin skin or a tendency to lash out. You need to be steady, and measured, and well-informed.

I want a president with a record of public service, someone whose life's work shows our children that we don't chase fame and fortune for ourselves, we fight to give everyone a chance to succeed—and we give back, even when we're struggling ourselves, because we know that there is always someone worse off, and there but for the grace of God go I.

I want a president who will teach our children that everyone in this country matters—a president who truly believes in the vision that our founders put forth all those years ago: That we are all created equal, each a beloved part of the great American story. And when crisis hits, we don't turn against each other—no, we listen to each other. We lean on each other. Because we are always stronger together.

And I am here tonight because I know that that is the kind of president that Hillary Clinton will be. And that's why, in this election, I'm with her.

You see, Hillary understands that the president is about one thing and one thing only—it's about leaving something better for our kids. That's how we've always moved this country forward— by all of us coming together on behalf of our children—folks who volunteer to coach that team, to teach that Sunday school class because they know it takes a village. Heroes of every color and creed who wear the uniform and risk their lives to keep passing down those blessings of liberty.

Delegates cheer Michelle Obama during her speech on the first day of the Democratic National Convention in Philadelphia.

Police officers and protestors in Dallas who all desperately want to keep our children safe. People who lined up in Orlando to donate blood because it could have been their son, their daughter in that club. Leaders like Tim Kaine—who show our kids what decency and devotion look like. Leaders like Hillary Clinton, who has the guts and the grace to keep coming back and putting those cracks in that highest and hardest glass ceiling until she finally breaks through, lifting all of us along with her.

That is the story of this country, the story that has brought me to this stage tonight, the story of generations of people who felt the lash of bondage, the shame of servitude, the sting of segregation, but who kept on striving and hoping and doing what needed to be done so that today, I wake up every morning in a house that was built by slaves—and I watch my daughters— two beautiful, intelligent, black young women—playing with their dogs on the White House lawn. And because of Hillary Clinton, my daughters—and all our sons and daughters—now take for granted that a woman can be president of the United States.

So don't let anyone ever tell you that this country isn't great, that somehow we need to make it great again. Because this, right now, is the greatest country on earth. And as my daughters prepare to set out into the world, I want a leader who is worthy of that truth, a leader who is worthy of my girls' promise and all our kids' promise, a leader who will be guided every day by the love and hope and impossibly big dreams that we all have for our children.

So in this election, we cannot sit back and hope that everything works out for the best. We cannot afford to be tired, or frustrated, or cynical. No, hear me—between now and November, we need to do what we did eight years ago and four years ago: We need to knock on every door. We need to get out every vote. We need to pour every last ounce of our passion and our strength and our love for this country into electing Hillary Clinton as president of the United States of America.

Let's get to work. Thank you all, and God bless.

"I wake up every morning in a house that was built by slaves— and I watch my daughters—two beautiful, intelligent, black young women—playing with their dogs on the White House lawn."

—MICHELLE OBAMA

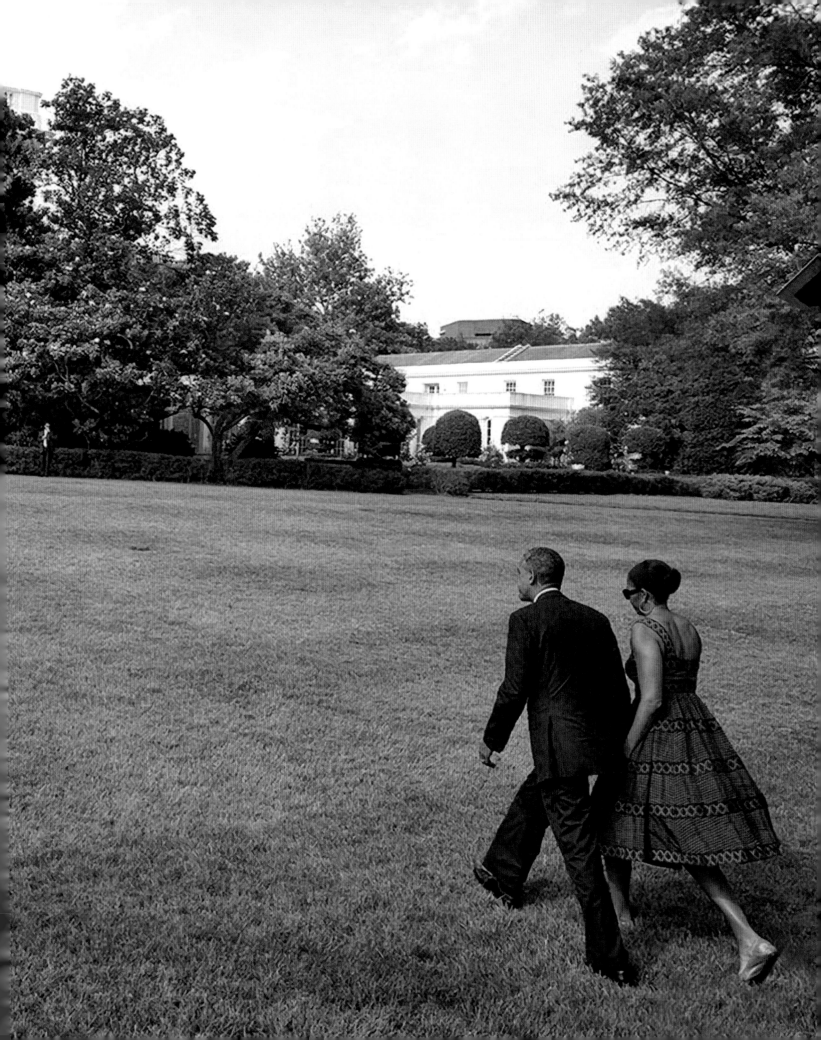

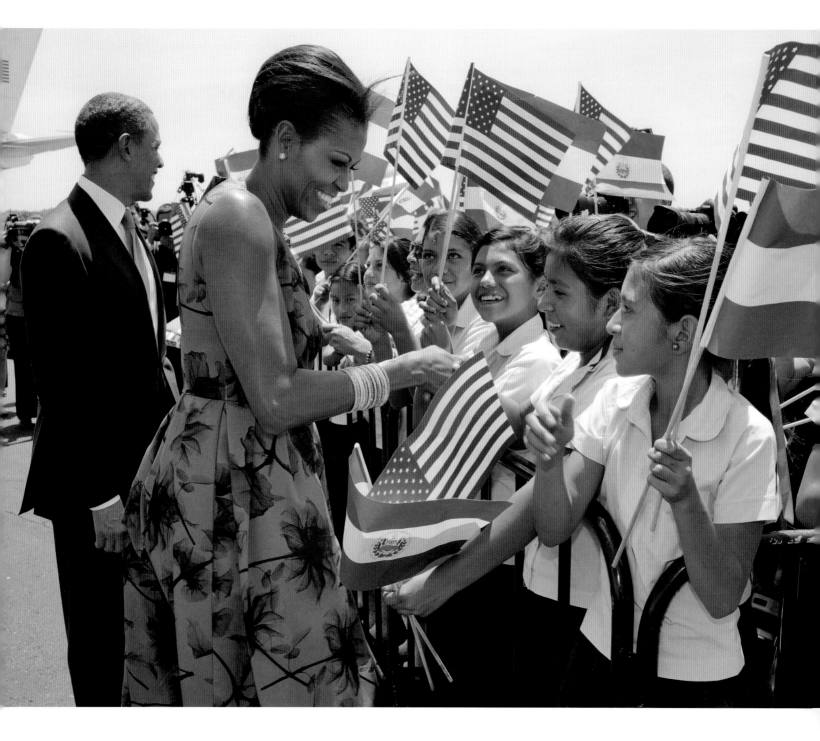

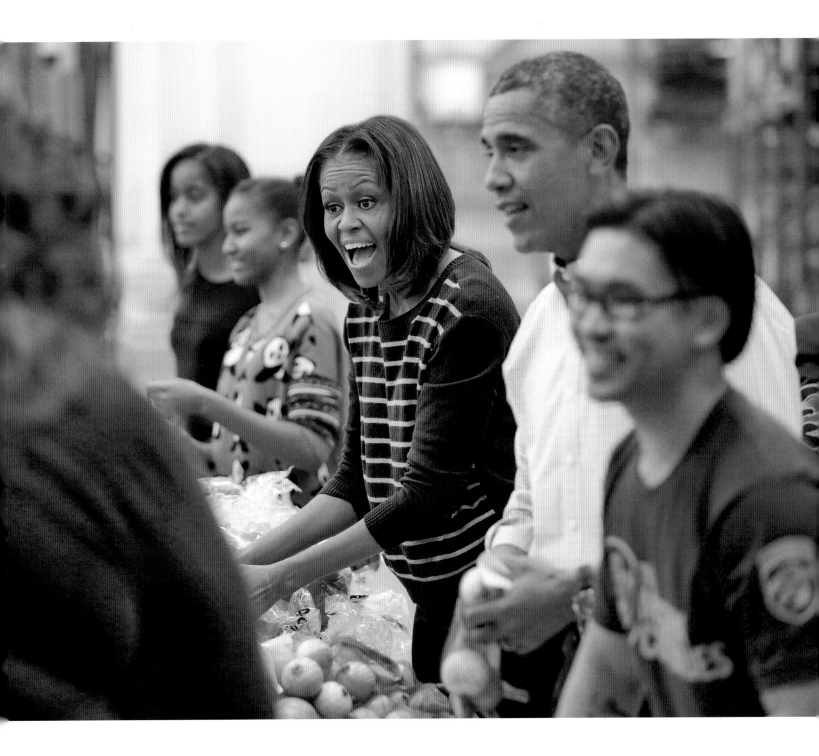

▼ Michelle Obama greeting children during the arrival ceremony at Comalapa International Airport in San Salvador, El Salvador, 2011. ▲ The First Family packing and distributing food for needy children and seniors at the Capital Area Food Bank.

REMARKS BY THE FIRST LADY AT THE NATIONAL SCHOOL COUNSELOR OF THE YEAR EVENT [abridged]

East Room, the White House
Washington, D.C.
January 6, 2017

MAY I SAY for the last time officially, welcome to the White House. . . . We are beyond thrilled to have you all here to celebrate the 2017 National School Counselor of the Year, as well as all of our State Counselors of the Year. . . . I want to start by thanking Terri [Tchorzynski, awardee] for that wonderful introduction and her right-on-the-spot remarks. I'm going to say a lot more about Terri in a few minutes, but first, I want to take a moment to acknowledge a few people who are here.

First, our outstanding secretary of education, John King, as well as our former education secretary, Arne Duncan. I want to take this time to thank you both publicly for your dedication and leadership and friendship. We couldn't do this without the support of the Department of Education under both of your leadership. So I'm grateful to you personally, and very proud of all that you've done for this country.

I also want to acknowledge a few other special guests we have in the audience. We've got a pretty awesome crew. As one of my staff said, "You roll pretty deep." I'm like, well, yeah, we have a few good friends. We have with us today Ted Allen, La La Anthony, Connie Britton, Andy Cohen . . . Carla Hall, Coach Jim Harbaugh and his beautiful wife, . . . Lana Parrilla, my buddy Jay Pharoah, Kelly Rowland, Usher . . . Wale is here. And of course, Allison Williams and her mom are here.

And all these folks are here because they're using their star power to inspire our young people. And I'm so grateful to all of you for stepping up in so many ways on so many occasions. I feel like I've pestered you over these years, asking time and time again, "Well, where are you going to be?" "I'm going to be in New York." "Can you come? Can you come here? Can you do this? Can you take that? Can you ask for that? Can you come? Can we rap? Can we sing?" So thank you all so much. It really means the world to this initiative to have such powerful, respected, and admired individuals speaking on behalf of this issue. So congratulations on the work that you've done, and we're going to keep working.

"We had one clear goal in mind: We wanted to make higher education cool. We wanted to change the conversation around what it means and what it takes to be a success in this country."

And today, I especially want to recognize [this] extraordinary leadership team that was behind Reach Higher from day one. And this isn't on the script so they don't know this. I want to take time to personally acknowledge a couple of people. Executive director Eric Waldo . . . I want to recognize our deputy director, Stephanie Sprow . . . And . . . our senior advisor, Greg Darnieder . . . Greg has been a leader in education his entire life. I've known him since I was a little organizer person. And it's just been just a joy to work with you all. These individuals, they are brilliant. They are creative. They have worked miracles with hardly any staff or budget to speak of—which is how we roll in the First Lady's Office. And I am so proud and so, so grateful to you all for everything that you've done. . . .

And finally, I want to recognize all of you who are here in this audience. We have our educators, our leaders, our young people who have been with us since we launched Reach Higher back in 2014. Now, when we first came up with this idea, we had one clear goal in mind: We wanted to make higher education cool. We wanted to change the conversation around what it means and what it takes to be a success in this country. Because let's be honest, if we're always shining the spotlight on professional athletes or recording artists or Hollywood celebrities, if those are the only achievements we celebrate, then why would we ever think kids would see college as a priority?

So we decided to flip the script and shine a big, bright spotlight on all things educational. For example, we made College Signing Day a national event. We wanted to mimic all the drama and excitement traditionally reserved for those few amazing football and basketball players choosing their college and university teams. We wanted to focus that same level of energy and attention on kids going to college because of their academic achievements. Because as a nation, that's where the spotlight should also be—on kids who work hard in school and do the right thing when no one is watching, many beating daunting odds. . . .

We are also very proud of all that this administration has done to make higher education more affordable. We doubled investments in Pell grants and college tax credits. We expanded income-based loan repayment options for tens of millions of students. We made it easier to apply for financial aid. We created a College Scorecard to help students make good decisions about higher education. And we provided new funding and support for school counselors. Altogether, we made in this administration the largest investment in higher education since the GI Bill. And today, the high school graduation rate is at a record high, and more young people than ever before are going to college. . . .

Our school counselors are truly among the heroes of the Reach Higher story. And that's why we created this event two years ago, because we thought that they should finally get some recognition. . . . And our 2017 School Counselor of the Year, Terri Tchorzynski, is a perfect example. . . . Terri works at the Calhoun Area Career Center, a career and technical education school in Michigan. And here's what Terri's principal said about her in his letter of recommendation. He said, "Once she identifies a systemic need, she works tirelessly to address it." . . .

And this is what each of you do every single day. You see the promise in each of your students. You believe in them even when they can't believe in themselves, and you work tirelessly to help them be who they were truly meant to be. . . . You all come in early, you stay late. You reach into your own pockets. . . . You stick with students in their darkest moments, when they're most anxious and afraid.

And as I end my time in the White House, I can think of no better message to send our young people in my last official remarks as first lady. So for all the young people in this room and those who are watching, know that this country belongs to you—to all of you, from every background and walk of life. If you or your parents are immigrants, know that you are part of a proud American tradition— the infusion of new cultures, talents, and ideas, generation after generation, that has made us the greatest country on earth.

If your family doesn't have much money, I want you to remember that in this country, plenty of folks, including me and

▼ First Lady Michelle Obama championing school counselors and their achievements at the School Counselor of the Year event, 2015.

"Something better is always possible if you're willing to work for it and fight for it."

TK

my husband—we started out with very little. But with a lot of hard work and a good education, anything is possible—even becoming president. That's what the American Dream is all about.

If you are a person of faith, know that religious diversity is a great American tradition, too. In fact, that's why people first came to this country—to worship freely. And whether you are Muslim, Christian, Jewish, Hindu, Sikh—these religions are teaching our young people about justice, and compassion, and honesty. So I want our young people to continue to learn and practice those values with pride. You see, our glorious diversity—our diversities of faiths and colors and creeds—that is not a threat to who we are, it makes us who we are. So the young people here and the young people out there: Do not ever let anyone make you feel like you don't matter, or like you don't have a place in our American story—because you do. And you have a right to be exactly who you are.

But I also want to be very clear: This right isn't just handed to you. No, this right has to be earned every single day. You cannot take your freedoms for granted. Just like generations who have come before you, you have to do your part to preserve and protect those freedoms. And that starts right now, when you're young.

Right now, you need to be preparing yourself to add your voice to our national conversation. You need to prepare yourself to be informed and engaged as a citizen, to serve and to lead, to stand up for our proud American values and to honor them in your daily lives. And that means getting the best education possible so you can think critically, so you can express yourself clearly, so you can get a good job and support yourself and your family, so you can be a positive force in your communities.

And when you encounter obstacles—because I guarantee you, you will, and many of you already have—when you are struggling and you start thinking about giving up, I want you to remember something that my husband and I have talked about since we first started this journey nearly a decade ago, something that has carried us through every moment in this White House and every moment of our lives, and that is the power of hope—the belief that something better is always possible if you're willing to work for it and fight for it.

It is our fundamental belief in the power of hope that has

allowed us to rise above the voices of doubt and division, of anger and fear that we have faced in our own lives and in the life of this country. Our hope that if we work hard enough and believe in ourselves, then we can be whatever we dream, regardless of the limitations that others may place on us. The hope that when people see us for who we truly are, maybe, just maybe they, too, will be inspired to rise to their best possible selves . . .

It's the hope of . . . folks like my dad who got up every day to do his job at the city water plant, the hope that one day his kids would go to college and have opportunities he never dreamed of.

That's the kind of hope that every single one of us—politicians, parents, preachers—all of us need to be providing for our young people. Because that is what moves this country forward every single day—our hope for the future and the hard work that hope inspires.

So that's my final message to young people as First Lady. It is simple. I want our young people to know that they matter, that they belong. So don't be afraid—you hear me, young people? Don't be afraid. Be focused. Be determined. Be hopeful. Be empowered. Empower yourselves with a good education, then get out there and use that education to build a country worthy of your boundless promise. Lead by example with hope, never fear. And know that I will be with you, rooting for you and working to support you for the rest of my life.

And that is true I know for every person who [is] here—is here today, and for educators and advocates all across this nation who get up every day and work their hearts out to lift up our young people. And I am so grateful to all of you for your passion and your dedication and all the hard work on behalf of our next generation. And I can think of no better way to end my time as first lady than celebrating with all of you.

So I want to close today by simply saying thank you. Thank you for everything you do for our kids and for our country. Being your first lady has been the greatest honor of my life, and I hope I've made you proud.

▶ Michelle Obama in the East Room of the White House, delivering her final speech as first lady on January 6, 2017.

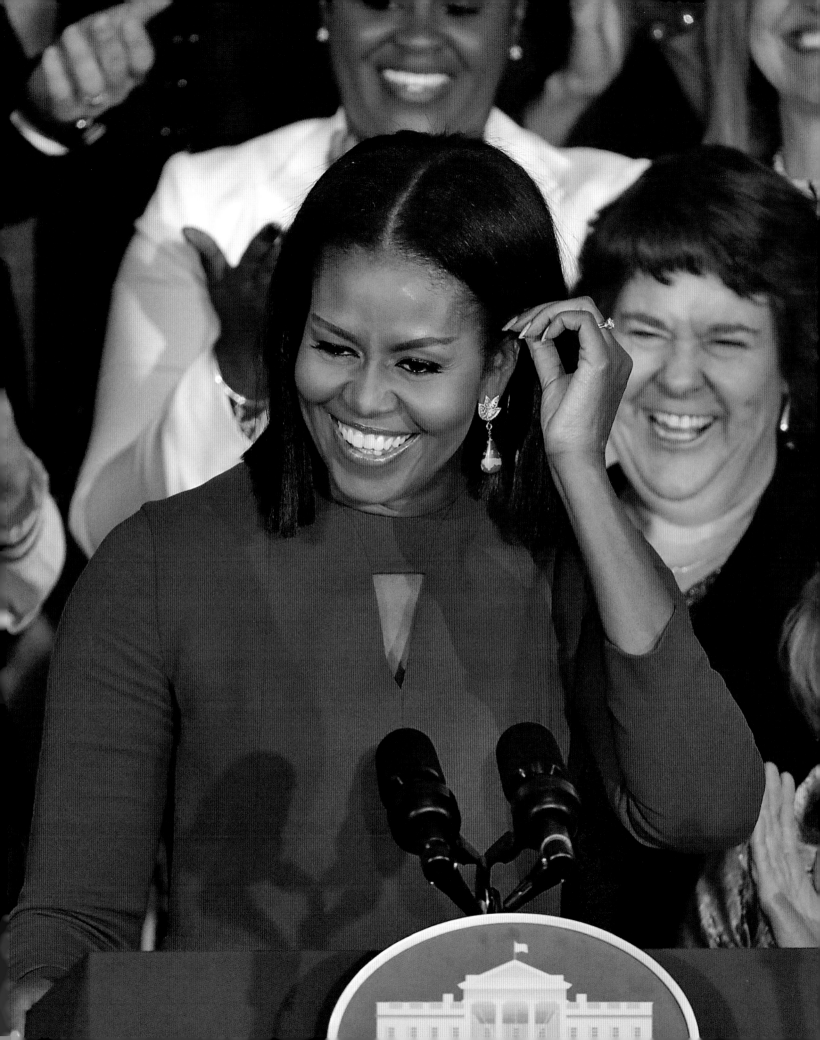

"For all the young people in this room and those who are watching, know that this country belongs to you—to all of you, from every background and walk of life. If you or your parents are immigrants, know that you are part of a proud American tradition—the infusion of new cultures, talents and ideas, generation after generation, that has made us the greatest country on earth."

—MICHELLE OBAMA

 Michelle Obama with children of U.S. Embassy staff in Jakarta, Indonesia, 2010.

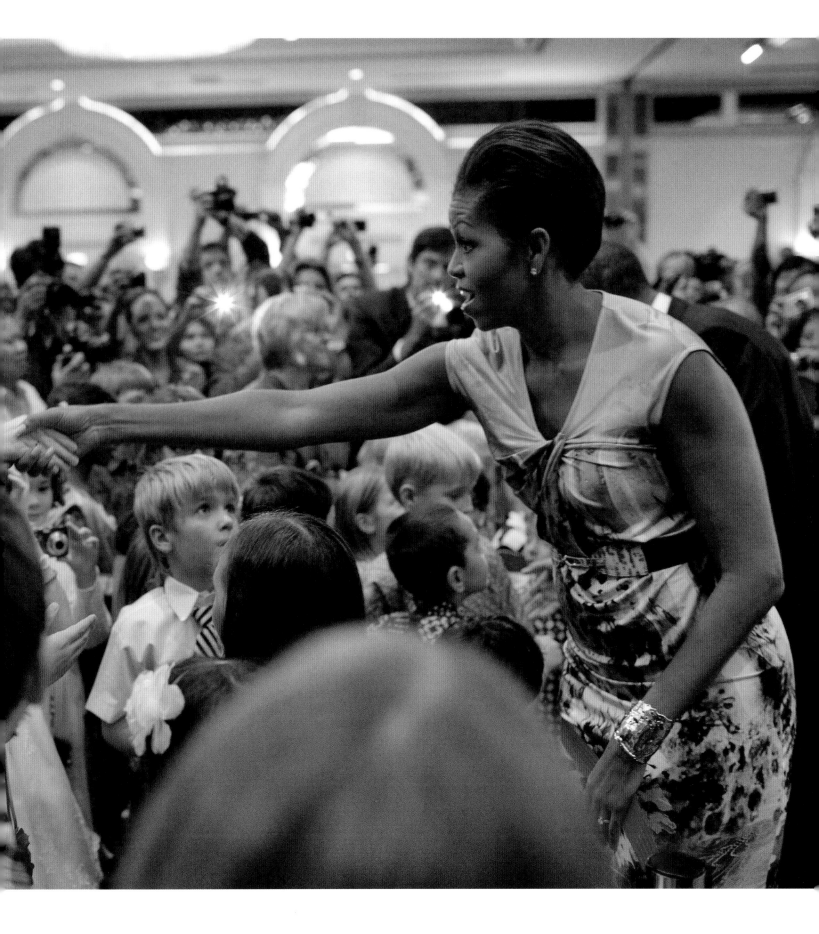

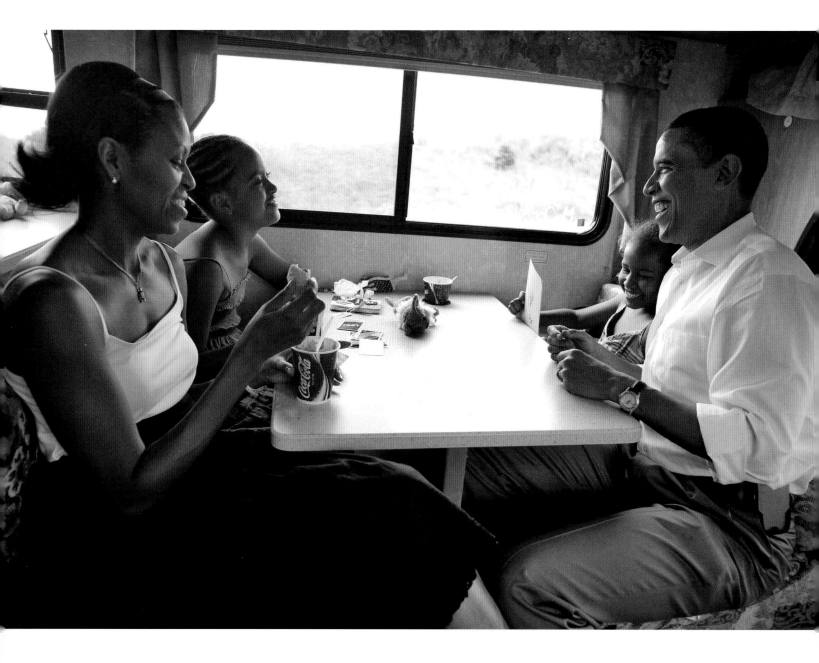

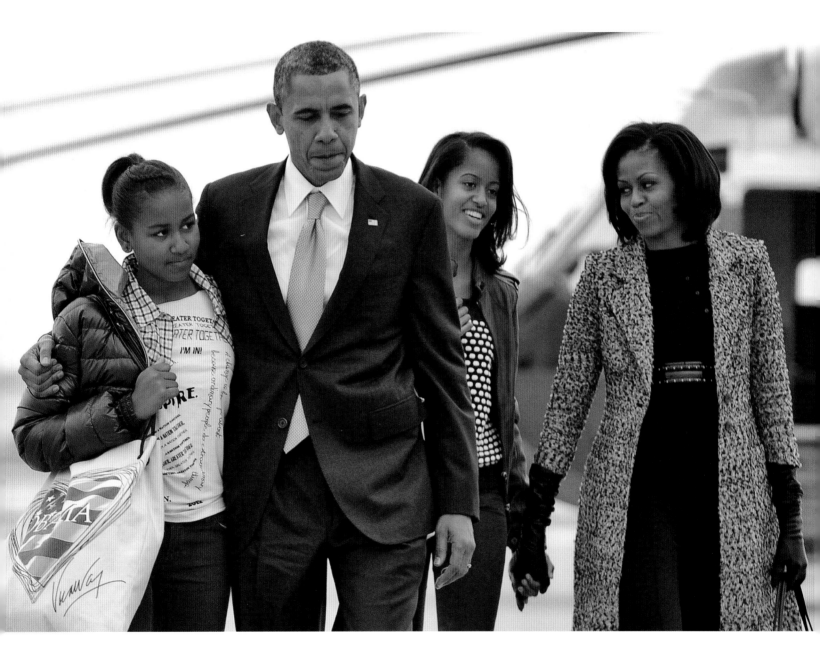

▽ Playing cards in their RV on a campaign trip in Iowa, July 4, 2007. ▲ The Obama family boarding *Air Force One* at Chicago O'Hare International Airport, 2012.

"It is our fundamental belief in the power of hope that has allowed us to rise above the voices of doubt and division, of anger and fear that we have faced in our own lives and in the life of this country. Our hope that if we work hard enough and believe in ourselves, then we can be whatever we dream, regardless of the limitations that others may place on us. . . . Lead by example with hope, never fear, and know that I will be with you, rooting for you and working to support you for the rest of my life.

—MICHELLE OBAMA

▶ Michelle Obama cheering as children pair up with top chefs to prepare low-cost healthy school lunches during a taping of the TV cooking show *Top Chef*, 2012.

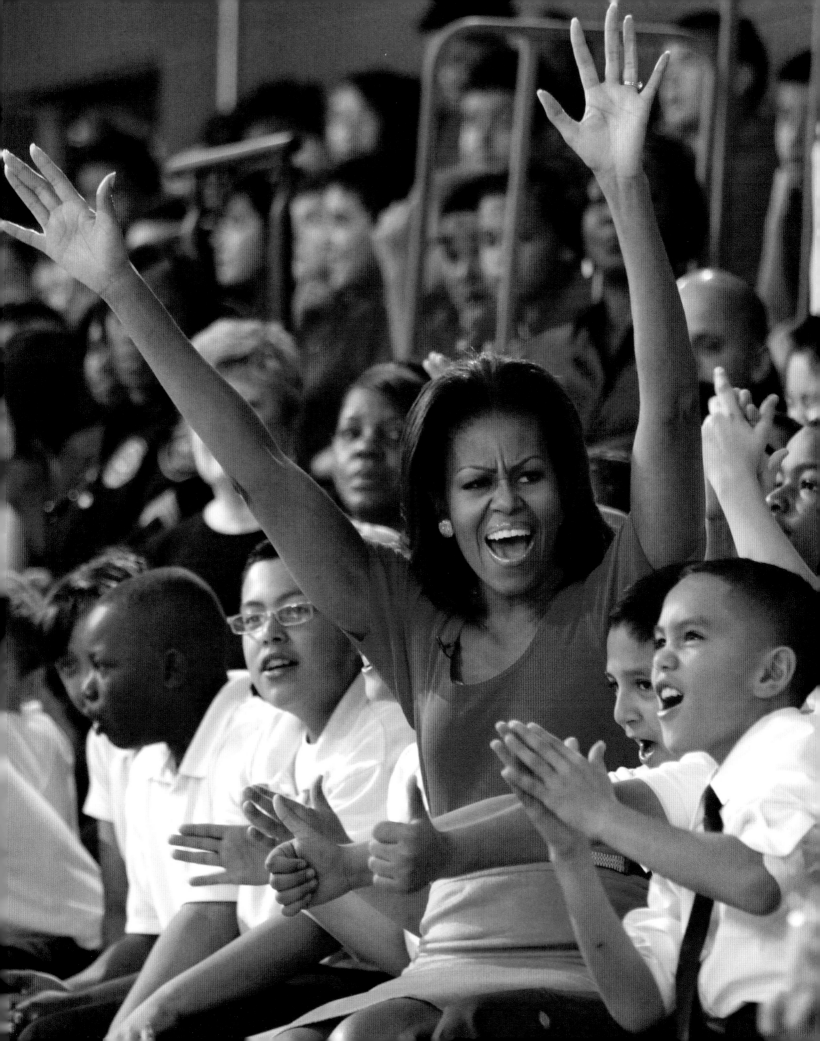

ACKNOWLEDGMENTS

Sterling Publishing is grateful to the following people who helped make this book possible: Esther Margolis of Newmarket Publishing Management Corporation, who expertly and seamlessly helped produce this book at lightning speed; Antonia Felix, for her insightful text and adept curation of Michelle Obama's words; and at Night & Day Design, designer Timothy Shaner and editor Christopher Measom for the stunning design, photo editing, and pulling it all together.

Kudos to Al Anderson and the White House Photo Office for their quick response and beautiful images.

NOTES

INTRODUCTION

Page 1: "too loud . . . career woman": "Remarks by the First Lady at Tuskegee University Commencement Address," White House, May 9, 2015.

Page 2: "No one can predict": Tonya Lewis Lee, "Your Next First Lady?," *Glamour*, September 2, 2007. **"their father was overflowing"**: Craig Robinson, *A Game of Character: A Family Journey from Chicago's Southside to the Ivy League and Beyond* (New York: Gotham Books, 2010), xi.

Page 3: "We didn't have much": "The First Lady Speaks in London on the Let Girls Live Initiative," video, White House, June 16, 2015, https://www.youtube.com/watch?v=d0sao_1gILs. **"It seemed like every paper"**: "Remarks by the First Lady at Martin Luther King Jr. Magnet High School Commencement," White House, May 18, 2013. **"What I learned"**: Ibid. **"warm and unpretentious"**: Ginger McKnight-Chavers, "Michelle Obama Was My Harvard Law Classmate and Her Convention Speech Floored Me," *Blue Nation Review*, July 25, 2016. **"Do not ever let"**: "First Lady Michelle Obama Remarks at Counselor of the Year Ceremony," video, C-Span, January 6, 2017, https://www.c-span.org/video/?421056-1/michelle-obama-delivers-final-speech-first-lady.

Page 4: "What are you going to do": Peter Slevin, "Michelle Obama, Race and the Ivy League," *Politico Magazine*, March 26, 2015. **"If I died"**: Richard Wolffe, "Who Is Michelle Obama?," *Newsweek*, February 16, 2008. **"Our glorious diversity"**: "First Lady Michelle Obama Remarks at Counselor of the Year Ceremony," video, C-Span, January 6, 2017, https://www.c-span.org/.video/?421056-1/michelle-obama-delivers-final-speech-first-lady

Page 5: "If we work hard": "First Lady Michelle Obama Remarks at Counselor of the Year Ceremony," video, C-SPAN, January 6, 2017, https://www.c-span.org/video/?421056-1/michelle-obama-delivers-final-speech-first-lady. **"She was very committed"**: "Michelle Obama," video, Politicstv, https://www.youtube.com/watch?v=ovulSyZmvn0&t=7s. **"We've both felt"**: "Remarks by the First Lady at Tuskegee University Commencement Address," White House, May 9, 2015.

SUCCESS STORY

Page 9: "Being your first lady": "First Lady Michelle Obama Remarks at Counselor of the Year Ceremony," video, C-SPAN, January 6, 2017, https://www.c-span.org/video/?421056-1/michelle-obama-delivers-final-speech-first-lady. **Their parents, Fraser Robinson and Marion Shields, taught:** Lauren Collins, "The Other Obama: Michelle Obama and the Politics of Candor," *New Yorker*, March 10, 2008.

Page 10: "Some of my teachers": "First Lady Michelle Obama Speaks on the Power of Education," video, White House, November 12, 2013, https://www.whitehouse.gov/photos-and-video/video/2013/11/12/first-lady-michelle-obama-speaks-power-education#transcript. **"the Shangri-La of upbringings"**: Craig Robinson, *A Game of Character: A Family Journey from Chicago's Southside to the Ivy League and Beyond* (New York: Gotham Books, 2010), 7. *Leave It to Beaver*: "Michelle Obama: A would-be first lady drifts into rock-star territory, tentatively," *Oakland Press News*, March 31, 2008. **"Michelle's father, Fraser Robinson"**: Peter Slevin, *Michelle Obama: A Life* (New York: Knopf, 2015), 17, 56, 57, 171. **"sweet and kindhearted . . . hope for the country"**: "Michelle Obama," video, Politicstv, https://www.youtube.com/watch?v=ovulSyZmvn0&t=7s. **"story-teller, motivator"**: Craig Robinson, *A Game of Character: A Family Journey from Chicago's Southside to the Ivy League and Beyond* (New York: Gotham Books, 2010), xi. **"What are you going to do"**: Peter Slevin, *Michelle Obama: A Life* (New York: Knopf, 2015), 97.

Page 12: "Six months after": Barack Obama, *The Audacity of Hope* (New York: Crown, 2006), 332. **Michelle met Barack:** Karen Springen, "First Lady in Waiting," *Chicago*, June 22, 2007. *Southside with You*: Directed by Richard Tanne, distributed by Miramax and Roadside Attractions, released August 26, 2016.

Page 14: "No matter how liberated": Barack Obama, *The Audacity of Hope* (New York: Crown, 2006), 340–41.

Page 17: "When we were young kids": Craig Robinson, speech to Democratic National Convention, August 26, 2008.

Page 18: "To have a family": Peter Slevin, "Her Heart's in the Race," *Washington Post*, November 28, 2007.

FIRST FAMILY

Page 33: "At the end of the day": Michelle Obama, "First Ladies Influence & Image," video, C-SPAN, http://firstladies.c-span.org/FirstLady/46/Michelle-Obama.aspx. **"The minute those kids"**: "Remarks by the First Lady During Conversation with Robin Roberts at The White House Working Families Summit," White House, June 23, 2014.

Page 40: "I am very proud": Zeba Blay, "Michelle Obama: My Proudest Achievement as First Lady Is My Daughters," *Huffington Post,* June 15, 2016.

Page 43: "She's an amazing mom": "Michelle Obama," video, Politicstv, https://www.youtube.com/watch?v=ovuISyZmvn0&t=7s.

Page 45: "When I'm unhappy": Liz Vaccariello, "Michelle Obama's Rules for Staying Healthy and Happy," *Prevention,* November 3, 2011. **When Barack was elected:** Craig Robinson, *A Game of Character: A Family Journey from Chicago's Southside to the Ivy League and Beyond* (New York: Gotham Books, 2010), x.

Page 50: "Who you see": Jonathan van Meter, "Michelle Obama: A Candid Conversation with America's Champion and Mother in Chief," *Vogue,* November 11, 2016.

Page 52: "An equal partnership": Jodi Kantor, "The Obamas' Marriage," *New York Times,* October 26, 2009.

Page 55: "Our extended family": Rebecca Macatee, "Michelle Obama: Christmas Talent Show Is Family Tradition—Barack Sings, Bo Performs and More!," *E! News,* November 25, 2013.

Page 57: "There's a lot more": "Michelle Obama: Presidential Candidates' Spouses, First Ladies Influence & Image," video, C-SPAN, http://firstladies.c-span.org/FirstLady/46/Michelle-Obama.aspx.

IN THE SPOTLIGHT

Page 63: "By far": Ree Hines, "Al Takes Garden Tour with Michelle Obama, Learns Where She'll Be on Inauguration Day," *Today,* April 8, 2016.

Page 64: "Every first lady": "Michelle Obama: Role of the First Lady, First Ladies Influence & Image," video, C-SPAN, http://firstladies.c-span.org/FirstLady/46/Michelle-Obama.aspx.

Page 68: "Soon, the world will": Robin Givhan, "The Age of Youth: Traveling Abroad, First Lady Michelle Obama Makes Kids Topic 1," *Washington Post,* April 15, 2010.

Page 71: "I always touch people": Jonathan van Meter, "Michelle Obama: A Candid Conversation with America's Champion and Mother in Chief," *Vogue,* November 11, 2016.

Page 73: "Words matter": Aleena Gardezi, "Michelle Obama: 'Words Matter,'" *Diverge,* December 21, 2016.

REACHING HIGHER

Page 95: "If kids aren't getting": "Remarks of First Lady Michelle Obama: Let's Move Launch," White House, February 9, 2010.

Page 96: "Our experience with children": Michelle Obama, *American Grown: The Story of the White House Kitchen Garden and Gardens Across America* (New York: Crown, 2012), 54.

Page 99: "I've always felt": "Remarks by the First Lady at Tuskegee University Commencement Address," White House, May 9, 2015.

Page 109: "In the end": "Let's Move: The Facts," *Let's Move,* http://www.letsmove.gov/sites/letsmove.gov/files/Let's_Move_Fact_Sheet.pdf.

Page 113: "I've always been": Liz Vaccariello, "Michelle Obama's Rules for Staying Healthy and Happy," *Prevention,* November 3, 2011.

Page 123: "a strong connection . . . I grew up with": Rosemary Ellis, "A Conversation with Michelle Obama," *Good Housekeeping,* October 30, 2008.

Page 127: "Educating girls": "Op-Ed by First Lady Michelle Obama for Girls, a Heartbreaking Loss—And an Opportunity," White House, July 1, 2016.

Page 131: "With every word": Michelle Obama, speech to Democratic National Convention, July 25, 2016.

Page 136: "When a veteran": "Remarks by the First Lady Announcing Mayors Challenge to End Veteran Homelessness," White House, June 4, 2014.

Page 139: "Dr. Biden and Mrs. Obama": "First Lady Michelle Obama and Dr. Jill Biden Launch Joining Forces," video, White House, April 12, 2011, www.whitehouse.gov/photos-and-video/video/2011/04/12/first-lady-michelle-obama-and-dr-jill-biden-launch-joining-forces. **"As a wartime first lady"**: "Fact Sheet: As Part of the 5th Anniversary of Joining Forces, First Lady Michelle Obama and Dr. Jill Biden Announce New Private Sector Hiring and Training Commitments for Veterans and Military Spouses," White House, May 5, 2016.

FASHION ICON

Page 147: "One of the most glamorous": Jonathan van Meter, "Michelle Obama: A Candid Conversation with America's Champion and Mother in Chief," *Vogue,* November 11, 2016. **"taught people"**: Caroline Leaper, "Michelle Obama Wears Preen for Her Last Interview as First Lady, Rounding Off a Stellar Year for the British Label," *Telegraph,* December 20, 2016.

Page 151: "I pick the clothes": Liz Vaccariello, "Michelle Obama's Rules for Staying Healthy and Happy," *Prevention,* November 3, 2011.

Page 166: "I look at my mom": Ibid.

Page 172: "President Obama looks at you": Ibid.

THE CLOSER

Page 177: "This isn't a politician's": Julie Hirschfeld Davis, "The Closer: Michelle Obama," *New York Times,* November 5, 2016. **"I try to organize"**: Ibid.

Page 184: "Every morning": Michelle Obama, speech to Democratic National Convention, July 25, 2016.

Page 194: "For all the young people": "First Lady Michelle Obama Remarks at Counselor of the Year Ceremony," video, C-SPAN, January 6, 2017, https://www.c-span.org/video/?421056-1/michelle-obama-delivers-final-speech-first-lady.

Page 198: "It is our fundamental belief": Ibid.

PICTURE CREDITS